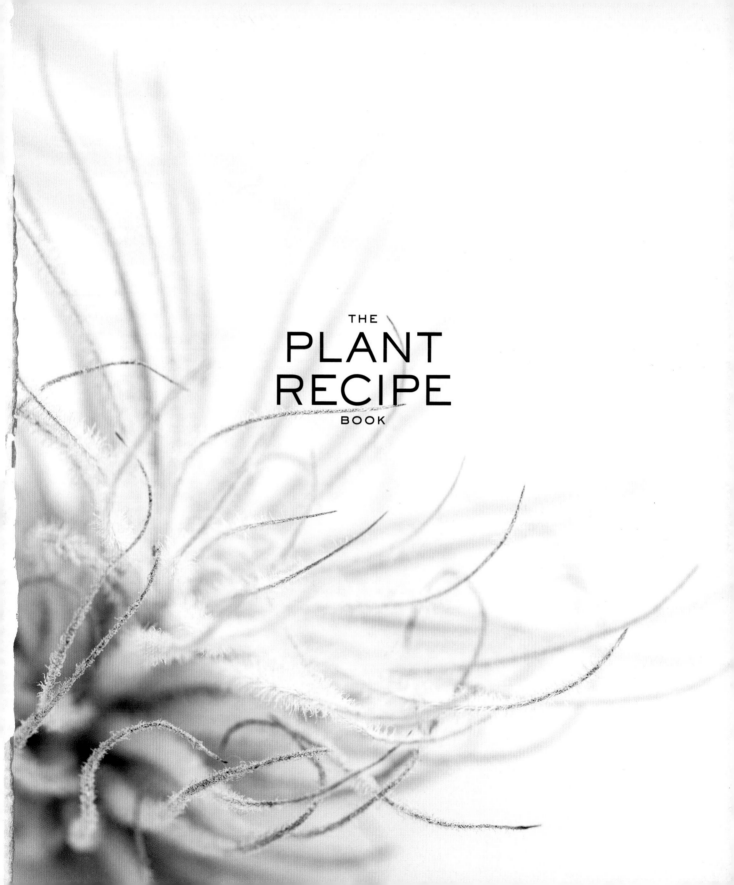

THE
PLANT
RECIPE
BOOK

THE
PLANT
RECIPE
BOOK

100 Living Arrangements
for Any Home in Any Season

Baylor Chapman
Photographs by Paige Green

ARTISAN
NEW YORK

Published by Artisan
A division of Workman Publishing Company, Inc.
225 Varick Street
New York, NY 10014-4381
artisanbooks.com
Published simultaneously in Canada by Thomas Allen & Son, Limited

Library of Congress Cataloging-in-Publication Data
Chapman, Baylor.
 The plant recipe book : 100 living arrangements for any home in
any season / Baylor Chapman.
 pages cm
 Other title: One hundred living arrangements for any home in any
season
 ISBN 978-1-57965-551-8
 1. Container gardening. 2. Arrangements. I. Title. II. Title: One
hundred living arrangements for any home in any season.
 SB418.C43 2014
 635.9'65—dc23
 2013042207

Design by Michelle Ishay-Cohen

Printed in China
First printing, March 2014

10 9 8 7 6 5 4 3 2 1

*To Lila for imparting her
love of natural beauty*

CONTENTS

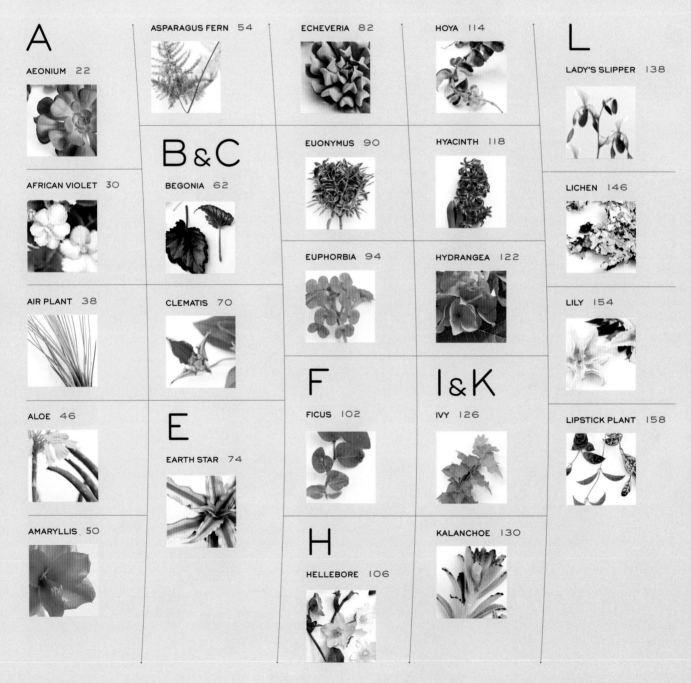

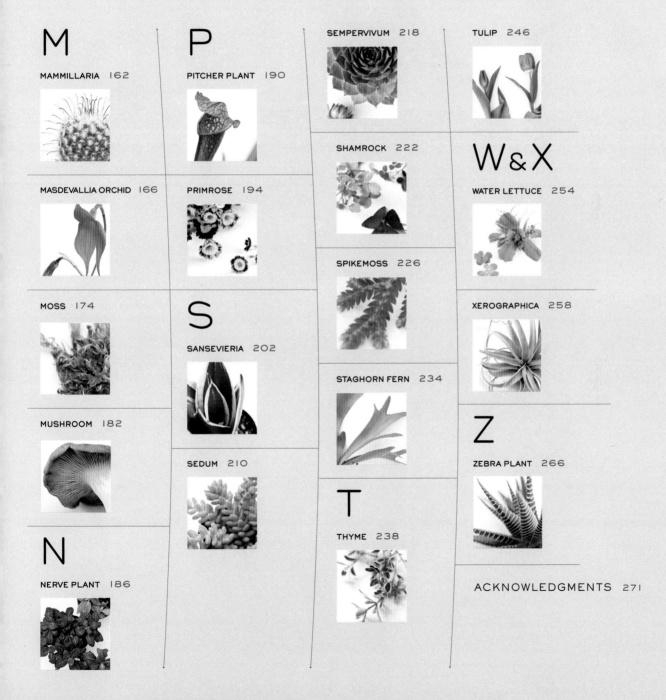

INTRODUCTION

I grew up with a view of green hills as far as the eye could see. At home I was surrounded by my mother's vegetable garden and my father's cornfields. Plants were everywhere, and they were everything to me. And still today, anything green makes me giddy. I love plants, plain and simple. The only problem is that I now live a deeply urban life, one in which greenery isn't always so readily available. My solution? I make it *abundant*. Whether I'm transforming a space to host a client's wedding or adding the final touch to make my house feel like home, plants give me a sense of peace and beauty.

When I first opened my company, Lila B. Design, I was surprised by how many people, like me, simply craved greenery. And not just for a few hours during an event. They wanted something they could take home, something that would last. So I found myself creating more and more living centerpieces, mini container gardens with the beauty to rival any cut arrangement, but that would last for weeks or months and whose plants could even be repurposed in gardens or other arrangements. The range of sizes and shapes of plants

meant I had tremendous freedom when choosing containers to put them in, and I started experimenting with all kinds of vessels to use as planters.

The living arrangements that are the heart of my work gave rise to the container gardens in this book. Some designs will last the life of the plants in them (years in some cases, when properly cared for), while others are more temporary—but even those can be disassembled and repotted or planted in a garden.

And while most of the plants used in this book are fairly easy to find, a few more unusual plants are added in for some variety. I've listed them alphabetically by common name or by genus (equate to last name) but have also provided botanical (scientific) names (sort of similar to first, middle, and last name) when it will help you find the specific plant used in the picture. Don't worry too much if you can't find the exact plant—using something of similar size and shape will create an arrangement that's slightly different but just as lovely. Or bust out and use a plant you think will add color, texture, or an interesting shape. Dive in, get your hands dirty, and create beautiful living art!

THE CONTAINER GARDEN TOOLBOX

These are the tools that were used to make the container gardens in this book.

COATED WIRE: If a stem is soft, coated wire is a little kinder; it won't cut the stems when used to tie them together or to a stake.

DROPPER/SQUEEZE BOTTLE: For watering tiny pots and terrariums.

GLUE DOTS: These help hold cellophane in place as well as an air plant or a leaf to a wall surface.

MISTER: Used to create humidity, and to water leaves gently.

PAINTBRUSHES/SHAVING BRUSHES: Good for dusting plants and cleaning the insides of terrariums.

PLASTIC LINER: Liners provide a watertight cup to protect surfaces from getting wet.

PRUNING SHEARS: Used to trim bigger stemmed plants.

SCISSORS: For cutting twine (they can also be used as pruning shears on most plants).

SCREEN: Covers drainage holes to stop roots from plugging up the hole and preventing drainage.

SKEWERS: Small stakes used to manipulate flower stems into a pleasing position, to hold up a floppy head of an orchid, or to create a stem for a succulent cutting.

SMALL ANGLED SNIPS: Angled to prune tiny plants in tiny places.

SMALL SCOOP OR TROWEL: Used to transfer soil or gravel from the bag to the pot.

SMALL SNIPS: Used for pruning delicate plants.

SPOON: Used as a small scoop.

TURKEY BASTER: Allows you to water in tight spaces, such as around leaves, and delivers a more precise amount of water.

TWEEZERS: Great for reaching into tiny terrariums to arrange small plants, sticks, and stones.

TWINE: Used to bind plants together, to tie on a moss ball, or to hang a plant in the air.

WATERING CAN: Designed precisely for watering; easy to fill and easy to pour.

WATERPROOF FLORIST TAPE: Used to seal cellophane or foil to double-protect pots and make them watertight.

WIRE: Used to tie branches together or to tie a stem to a stake.

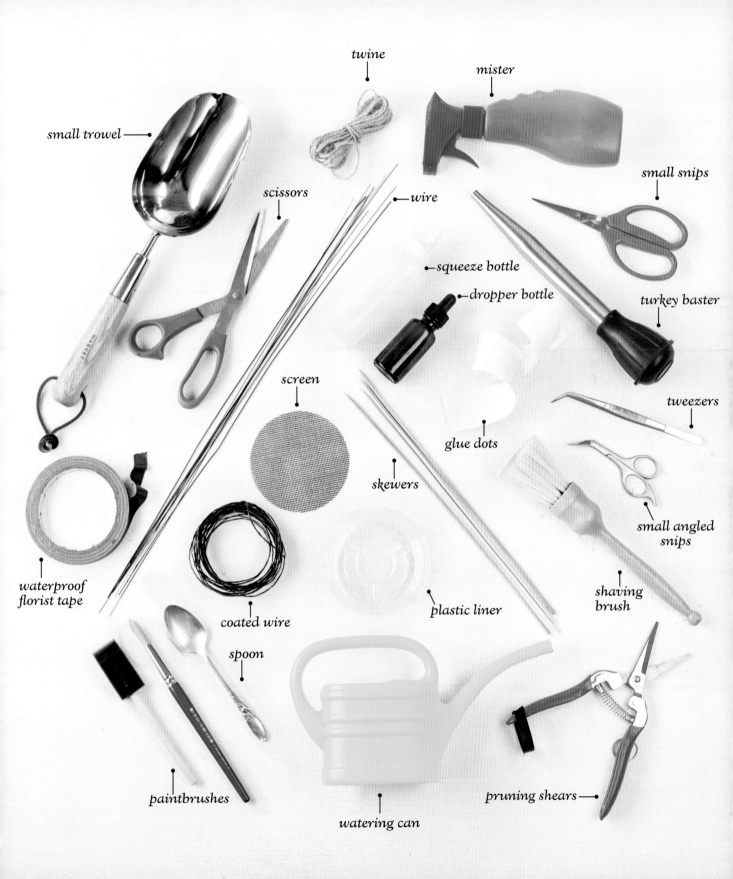

twine

mister

small trowel

scissors

wire

small snips

squeeze bottle

dropper bottle

turkey baster

screen

tweezers

glue dots

skewers

small angled snips

waterproof florist tape

coated wire

plastic liner

shaving brush

spoon

paintbrushes

watering can

pruning shears

CHOOSING YOUR CONTAINER

Don't be constrained by the notion that plants belong in traditional pots. Look around the house—almost any vessel (and you'll see that I use that term lightly!) can hold a plant. Bowls, cookware, even cups can house container gardens. Pieces of pipe, picture frames, and branches can all be fashioned so that they house gardens, too.

First, consider the growing conditions. The garden will do best and be easiest to care for when the container and the plant(s) in it match up to some extent. Does the plant like humidity? If so, using a glass jar as an ad hoc enclosed terrarium is a good bet. Does the plant like conditions that are dry? A widemouthed low bowl will do the trick. If the plant craves a pool of water to sit in, make sure the vase is watertight. Consider, too, the plant's growth habit. A twisting, swirling vine loves a trellis to climb—so give it a leg up with a handle to wrap itself around before it trails off in another direction.

Second, consider size. Will the plant(s) fit in the container? Think too about the needs of the soil and roots along with those of the plant itself. Like people, most plants can squeeze into something a bit small for a while, but they won't put up with it for very long. That's why I provide guidelines for sizes throughout the book.

Next, consider color. Sometimes the right color container can make your arrangement sing while another color can make it look drab. For example, the slight hint of pink in the hoya may pop if you place it in a pink vase, whereas it might disappear in a brown one.

Finally, think about the overall look. Is your plant design classic or woodsy? A mushroom may look more comfortable in a log vase than in a flashy neon bowl (although, I must say, sometimes such contrasts look fabulous—and I heartily believe that rules are meant to be broken).

Sometimes it's best to just let the plant(s) show off. The long, lean legs of the pitcher plant, for example, look spectacular when put in a tall vintage vase that mimics the regality of this carnivorous plant.

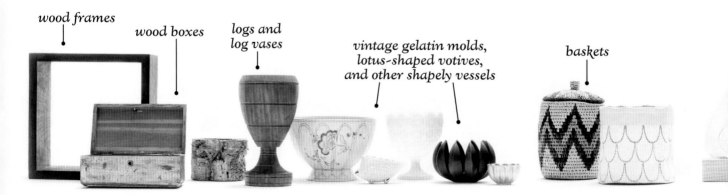

wood frames

wood boxes

logs and log vases

vintage gelatin molds, lotus-shaped votives, and other shapely vessels

baskets

WOOD FRAMES are great hosts for plants, whether inside or atop. These are fun to play with, and once plants take root, the frames can even be hung on a wall. They can also be simply set on the table as a cool low square container.

WOOD BOXES just need to be opened and lined, and away you go with a fun and decidedly unconventional planter.

LOGS AND LOG VASES bring even more of the outside in. Again, these need to be lined to avoid a puddle on the table.

VINTAGE GELATIN MOLDS, LOTUS-SHAPED VOTIVES, AND OTHER SHAPELY VESSELS are a chance to have fun and get super creative.

BASKETS feel casual, even a little bit country. Be sure to line them, since they aren't meant to get wet. Some are even flexible and can be stuffed nice and tight with plants.

GLASS TERRARIUMS provide a view from any angle, so be sure the soil and roots look pretty, too. They are best for humidity-loving plants— especially when you keep the lid on.

POTTERY is a classic choice and easy to come by. Most pieces have drainage holes predrilled into them, so be sure to line the inside or set them on top of a plate to protect furniture from moisture.

RUSTIC METAL VESSELS have a charming, weathered, and old-fashioned feel. They can be placed outside, too. Copper and tin, in particular, only look better with time.

PEDESTAL VASES look wonderful with plants that have some drape or droop to them and can add a romantic, even slightly formal, air.

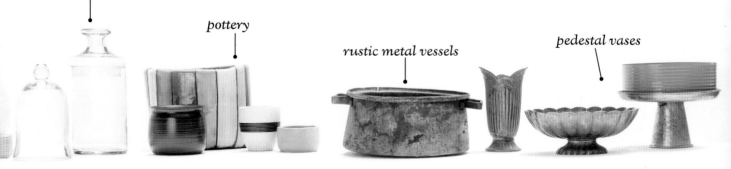

glass terrariums

pottery

rustic metal vessels

pedestal vases

SOIL AND AMENDMENTS

Each container in this book calls for a specific soil type to match the plants and make them happy. In addition to plants and containers, you'll need these things to create your living centerpieces.

SOILS: Soils are mixed with basically the same ingredients but at different proportions, which allows them to hold on to or let go of moisture at different rates. Cactus mix, for example, lets water drain quickly, while potting mix retains water for a bit longer. Some bagged potting mixes contain wetting agents or synthetic materials. I try to steer away from those and stick with organic ingredients. To simplify, the projects in this book call for five types: potting mix, cactus mix, carnivorous plant mix, violet mix, and orchid mix.

CHARCOAL: Think of charcoal as an air cleaner for your soil. Buy it at a pet store or a nursery—it's not the kind you use for a grill!

FERTILIZER: While I don't call for fertilizer in these recipes, it is nice to add some organic fertilizer to your plants. Always check the label for exact amounts and timing and also to make sure it's suitable for your specific plants.

TOP DRESSING: These are pretty additions to top off plant designs and add a bit of polish (they cover the plain old dirt!). These recipes call for gravel, moss, sand, and bark, but the possibilities are endless, so get creative! Tumbled glass, buttons, and beads, for example, all work beautifully.

PLANT SELECTION AND CARE

BUYING THE PERFECT PLANT

Of course plants are available at garden centers—whose reliably knowledgeable staff and large selection will make the trip worthwhile—but they are also increasingly sold at grocery stores, boutiques, pharmacies, and even pet stores (check out the design on page 228). Online nurseries can be a good option for hard-to-find plants. They too can provide a wealth of information. Keep these considerations in mind to ensure that the container garden you create will look its best and last as long as possible:

• Each recipe in this book provides information to help you locate the right plants, including the scientific and common names and plant type (vine, succulent, etc.). Basic care information, taking into account the specific plant(s) and container, is also provided.

• When in doubt, consult the small plastic tag tucked into the plant's soil to find out how much light the plant wants, how much water it likes, and even when and how often it will bloom.

• Plants can vary greatly in size depending on how and where they are grown. This book calls for a few standard sizes to keep things simple. Some come in round grow pots; some come in square ones. Some will have deep roots and others shallow ones, but if you refer to the size of the grow pot the plant comes in, replicating the effect of each container garden should be a snap. Most of the plants called for in this book are available in 2-inch, 4-inch, or 6-inch grow pots. A few use larger 8-inch and 1-gallon pots, and one even calls for bigger plants (see page 108). There are a few recipes that use succulent cuttings, which are literally the cut-off pieces of a succulent plant.

• No matter the plant's size, always inspect its foliage (leaves). If the plant is supposed to be green, make sure the leaves are actually green, not yellow or brown. Are they upright? Full of life? Avoid plants with wilting or tearing leaves, as well as ones with notched leaves or nibbled bits, both signs of bugs. Check the leaves carefully on both sides for the black or white specks of bugs.

• If you're choosing a plant with flowers, look for one with blooms in various stages. Tight buds and blossoming buds promise a future payoff, and full, open flowers give instant gratification.

• Remember, some plants are seasonal and may be tricky to find at certain times of the year. Though garden centers with greenhouses do allow for a wide selection year-round (some plants are even tricked into blooming out of season), not everything is available everywhere all the time. No matter where you buy plants, some will last for months or even years when taken care of properly, but others, by their nature, will last only a short while.

Note: Though some of the plants' common names (as in the case of asparagus fern) make them sound appetizing, the plants in this book are, for the most part, not edible. Some are even toxic.

PLANT CARE

Because container gardens are composed of plants that will live together in one place, it's best to choose plants that like the same conditions. While some of the designs in this book break that rule, this is a helpful tip to keep in mind. Even if it is a sustainable composition, you might still get an itch to break up and rearrange your containers, or decide to move plants from container arrangements into a garden.

When combining different plants in a single container, always consider the soil, the water, and the light. Each of the recipes in this book lists that information for the main plant and offers tips on how best to care for that specific container garden. Some plants, like hydrangeas and hellebores, can even be transferred to your garden. Because the information I provide here is very general, I recommend pairing this book with a reliable horticulture reference so you can learn how to care for these plants where you live.

Note: When arranging or caring for plants, be aware that many plants, not just those with obvious thorns, can irritate skin. People with sensitive skin should wear gloves and everyone should wash their hands thoroughly after gardening, whether indoors or out.

TECHNIQUES

Follow these general planting principles for all the container gardens in this book unless the instructions specifically state otherwise.

PREPPING THE CONTAINER

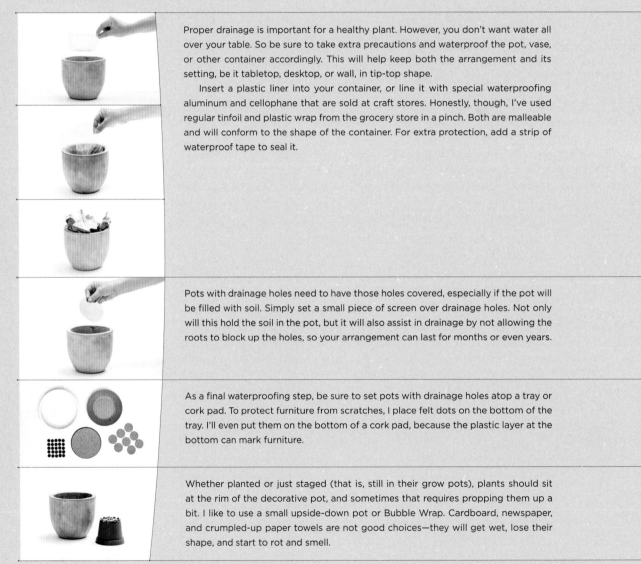

Proper drainage is important for a healthy plant. However, you don't want water all over your table. So be sure to take extra precautions and waterproof the pot, vase, or other container accordingly. This will help keep both the arrangement and its setting, be it tabletop, desktop, or wall, in tip-top shape.

Insert a plastic liner into your container, or line it with special waterproofing aluminum and cellophane that are sold at craft stores. Honestly, though, I've used regular tinfoil and plastic wrap from the grocery store in a pinch. Both are malleable and will conform to the shape of the container. For extra protection, add a strip of waterproof tape to seal it.

Pots with drainage holes need to have those holes covered, especially if the pot will be filled with soil. Simply set a small piece of screen over drainage holes. Not only will this hold the soil in the pot, but it will also assist in drainage by not allowing the roots to block up the holes, so your arrangement can last for months or even years.

As a final waterproofing step, be sure to set pots with drainage holes atop a tray or cork pad. To protect furniture from scratches, I place felt dots on the bottom of the tray. I'll even put them on the bottom of a cork pad, because the plastic layer at the bottom can mark furniture.

Whether planted or just staged (that is, still in their grow pots), plants should sit at the rim of the decorative pot, and sometimes that requires propping them up a bit. I like to use a small upside-down pot or Bubble Wrap. Cardboard, newspaper, and crumpled-up paper towels are not good choices—they will get wet, lose their shape, and start to rot and smell.

PLANTING ESSENTIALS

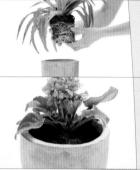

MEASURE THE DEPTH
Set the plants next to the pot. Are they the right size? Size it up before you plant so you add enough soil. If you will be staging a pot, measuring the depth will tell you how much prop material you'll need.

MASSAGE THE ROOTS
When you unpot a plant, there may be a tightly bound root system. If so, gently massage the roots to give them space to grow. This technique also works if you need to plant in a pot that is slightly smaller than the original.

PLANT AT THE CROWN
Gently make a small hole in the soil and place the plant inside. Fill in with soil around the base, but don't bury the stem. The soil should hit where the stem ends and meets the roots. Roots don't like to be in the air and stems don't want to live under the soil. Gently tamp down the soil.

USE A FUNNEL OR A SCOOP
If you don't have a trowel, a small flexible cup will help you scoop your soil or gravel into the pot. In a pinch, you can also make your own funnel with a piece of paper and some tape.

ADVANCED PLANTING TECHNIQUES

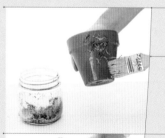

Moss is often used as a top dressing, but it can also be used to help your arrangements pack a punch by adding age to a pot or even replacing a pot altogether!

PAINTING A MOSS POT
Blend moss with buttermilk, beer, and/or yogurt to create a soupy mixture, then apply it to your pot with a paintbrush. Keep the pot moist and in the shade, and watch your moss pot grow.

MAKING A MOSS BALL
Cut a section of sheet moss bigger than your plant's rootball and lay it facedown on your work surface. Unpot the plant and gently massage its roots, keeping some of the soil intact. Place the plant on top of the moss, then gather the moss sheet up around the roots to create a ball. Wrap it tightly with string, wire, or fishing line to secure the ball.

ARRANGING CONTAINER GARDENS

These are a few of my favorite tricks of the trade to manipulate the placement or position of the plants.

MOUND THE SOIL
Arrangements are more interesting with some varied height and movement. You can achieve this by mounding the soil in specific sections of the design.

TILT PLANTS
Angles surprise the eye and let you put leaves, stems, and flowers where you want them to be. Let flowers dangle off the edge with a bit more purpose by placing them at an angle.

STAKE PLANT FLOWERS AND STEMS
If the container is planted and something just isn't behaving the way you'd like it to, give it a nudge with a skewer or a plant stake. Place the stake in the soil, then gently tug at the flower head and move it in the direction that you want it to go. Stick the stake in the soil and attach the stems to the stake.

TRELLIS VINES
Use a long stick, hoop, or teepee shape to let vines climb up and/or over. You can even lead the vine toward another trellis on which it will climb.

PRUNE AND DEADHEAD
Dead flowers are sad. Cut them off when they start to droop. You'll be happier, and so will the plant—pruning encourages new growth. Pruning off buds or branches can also shift the shape of the plant.

HOW TO WATER

Some useful tips to keep in mind:

USE A FINGER

There are many contraptions out there to test the moisture level. The easiest is your finger. Stick a finger in the soil to feel if it's wet or dry.

MIST

Some plants like high humidity. A good way to create humidity is to mist.

USE YOUR KITCHEN UTENSILS

Have a spot too small for the spout of a watering can? Use a turkey baster, a dropper, or a spoon for accuracy and to lessen the chance of adding too much water.

TIP IT OUT

If the container doesn't have a drainage hole, there's no way for water to escape. And one thing most plants hate is soggy roots. Gently tip arrangements to pour out any extra water.

BOTTOM-SOAK

If a plant dries out entirely, it might need a good soak. Set it in a dish and water it enough so that water pools in the bottom. Let it soak for a while, then let the plant drain before resetting it. Sometimes I'll put the plants in the kitchen sink and give them a good shower with the spray hose before I soak them.

NO WATER

If you've planted in a closed environment, most likely it'll keep moist on its own. The downside? Sometimes it'll fog up a bit.

THE INGREDIENT CHART

INGREDIENT ROLES

When I create a container garden, I always keep in mind these different design elements. Getting to know and categorizing the elements of your design in this way will help when you want to swap out some plants and are ready to start creating your own designs.

FOCAL SPECIMEN
This is the wow plant, the one to show off, whether it has a huge rosette or a bold color. Let it stand tall, front and center.

ARCHITECTURAL PLANTS
These provide structure and powerful movement with stern, comparatively tall leaves that set the frame of the design.

AIRY ELEMENTS
Fluffy plants provide a little air and give the design some room to breathe. Plus, they tend to be eye candy.

COLOR
If the focal plant isn't very colorful, a twinkling of yellow or a dangling tiny trumpet flower adds a bit of pop.

SUPPORTING CAST
Some might call these "filler," but they work just as hard as the other plants. By adding a range of texture (and color), they help the focal plant shine.

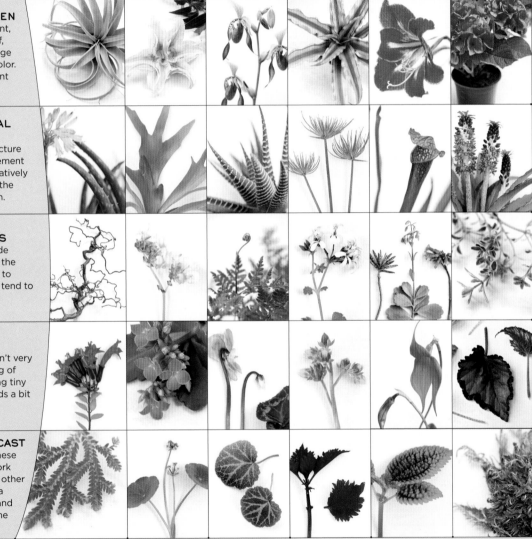

Focal Specimens, left to right: xerographica, lily, lady's slipper, earth star, amaryllis, hydrangea; Architectural Elements, left to right: aloe, staghorn fern, zebra plant, papyrus, pitcher plant, pineapple plant; Airy Elements, left to right: Harry Lauder's Walking Stick, begonia, fern, geranium, kalanchoe, thyme; Color, left to right: lipstick plant, flaming Katy, cyclamen, echeveria bloom, masdevallia orchid, begonia; Supporting Cast, left to right: spikemoss, pennywort, strawberry begonia, coleus, pilea, moss.

INGREDIENT TYPES: TEXTURAL

Since so many of the ingredients in a container garden are green, texture is incredibly important. These are the textural elements you'll want to include when creating your own designs.

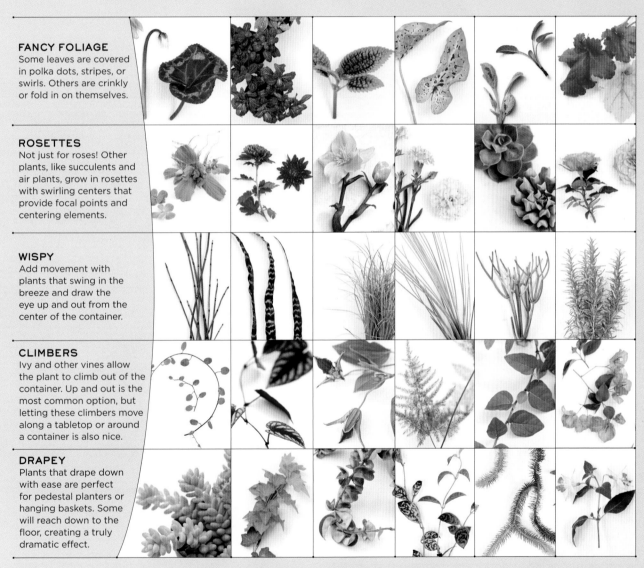

FANCY FOLIAGE
Some leaves are covered in polka dots, stripes, or swirls. Others are crinkly or fold in on themselves.

ROSETTES
Not just for roses! Other plants, like succulents and air plants, grow in rosettes with swirling centers that provide focal points and centering elements.

WISPY
Add movement with plants that swing in the breeze and draw the eye up and out from the center of the container.

CLIMBERS
Ivy and other vines allow the plant to climb out of the container. Up and out is the most common option, but letting these climbers move along a tabletop or around a container is also nice.

DRAPEY
Plants that drape down with ease are perfect for pedestal planters or hanging baskets. Some will reach down to the floor, creating a truly dramatic effect.

Fancy Foliage, left to right: cyclamen, nerve plant, pilea, elephant ear, sage, coral bells; Rosettes, left to right: water lettuce, mum, hellebore, carnation, echeveria, rose; Wispy, left to right: horsetail rush, earth star, sedge, air plant, euphorbia, rosemary; Climbers, left to right: wire vine, rex begonia vine, clematis, asparagus fern, ficus, bougainvillea; Drapey, left to right: sedum, ivy, hoya, lipstick plant, rock tassel fern, fuchsia.

AEONIUM

PLANT TYPE: succulent

SOIL: cactus mix

WATER: allow the surface soil to dry between waterings

LIGHT: bright direct

Some aeoniums are branchy stalks while others grow in a flatter, round form, but the many varieties are prized more for their large succulent rosettes than for their flowers. But when they do bloom, some put on quite a show with a yellow pyramid of blooms. They have a wonderful size range, too, and can hang out of soil for a long time.

RECIPE 1:
ON ITS OWN

PLANT
One 1-gallon *Aeonium* 'Sunburst'

CONTAINER AND MATERIALS
Glazed pot, 6 inches in diameter
and 7 inches tall, with a drainage
hole and a flat back drilled
for mounting on a wall

1-inch square of screen

1 to 3 cups of cactus mix

1. Choose a plant size that is close to the size of the decorative
 pot and complements its color. Set the plant next to the pot; it
 should be the same height and width. If not, you'll need to make
 adjustments in step 3. Line the bottom of the pot with the screen
 and add the cactus mix.

2. Unpot the plant and gently massage the roots to remove
 any extra soil.

3. Replant it in the decorative pot, making adjustments to the soil
 so that the plant sits at the rim of the pot, tipped toward the
 front. Gently tamp down the soil.

4. Mount the pot on a fence or wall. To water, remove the pot from
 the wall and water the plant in a sink, allowing the excess to drip
 through before remounting the pot. Make sure to let the plant
 dry between waterings.

RECIPE 2:
WITH COMPANY

PLANTS

One 2-inch dwarf tree aeonium
(*Aeonium arboreum* 'Tip Top' is a nice choice)

One 2-inch Mexican snowball
(*Echeveria elegans*)

One 2-inch crassula, in bloom
(try *Crassula pubescens* ssp. *radicans*)

Two 2-inch bear's paws
(*Cotyledon ladismithiensis*)

One 2-inch aloe
(*Aloe* 'Christmas Carol' is a good choice)

CONTAINER AND MATERIALS

Recycled glass vase, 4 inches in diameter
and 6 inches tall

1 cup of decorative gravel

2 cups of cactus mix

1 Pour a thin layer of decorative gravel into the vase (not only does this look cool, but it will also help you see any extra water, which you can then pour out by delicately tipping the vase).

2 Add 2 inches of cactus mix. Unpot the plants from their grow pots and massage the roots to remove extra soil. Start planting with the tallest plant, the aeonium, and fill in with the other plants around its base.

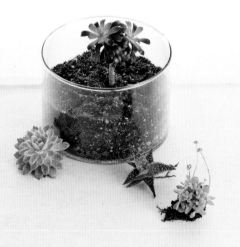

3 Use a spoon to spread the remaining colored gravel on top of the exposed soil for a polished look. Let the arrangement dry between waterings, and water until the soil is slightly damp. Make sure there is no standing water at the bottom. This arrangement should last between 6 and 12 months.

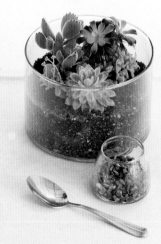

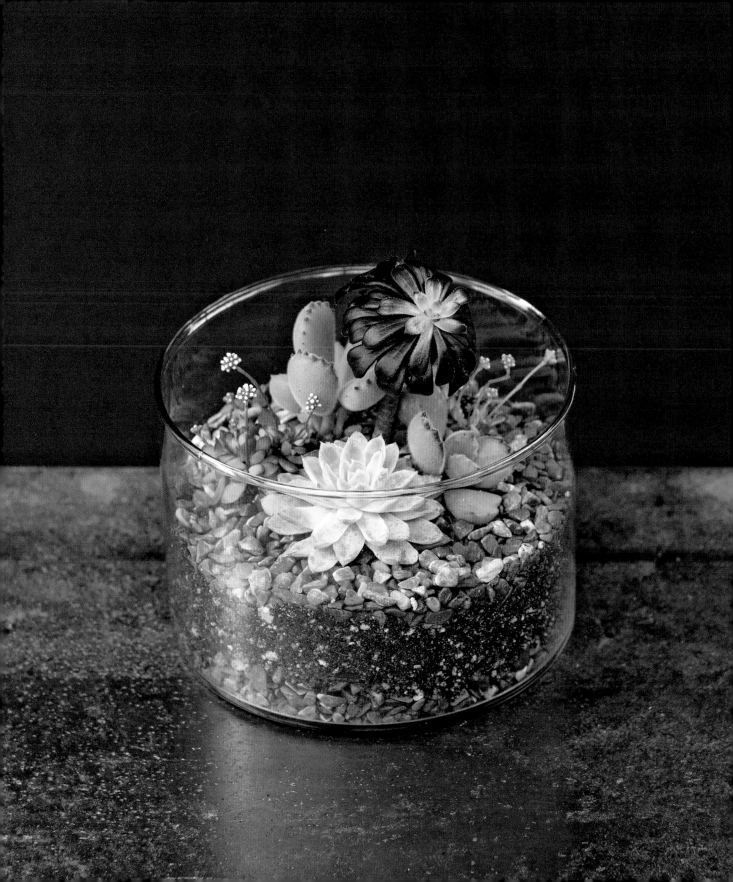

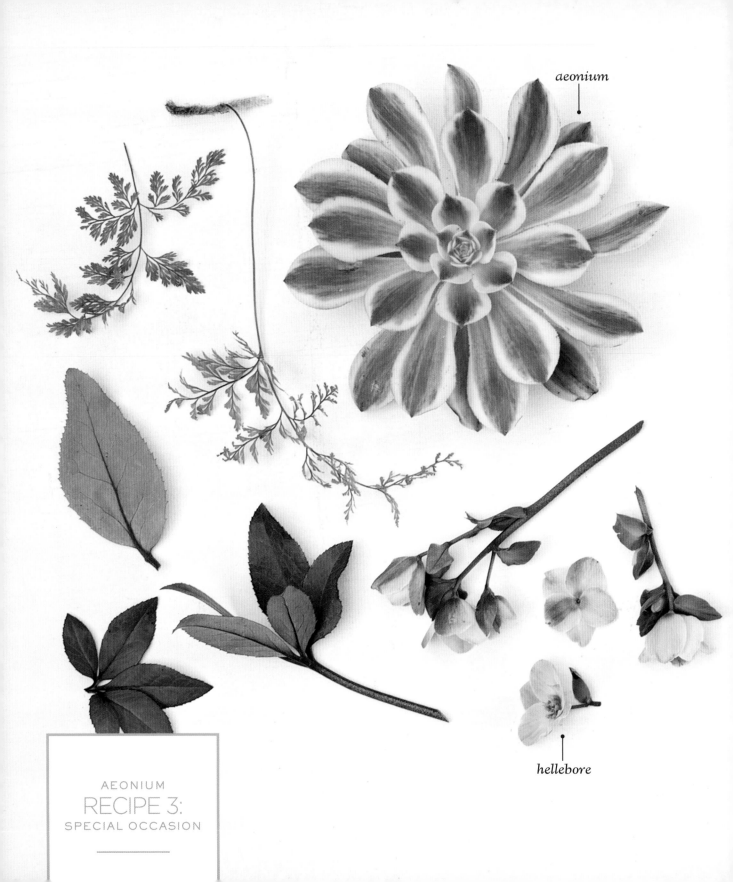

aeonium

hellebore

AEONIUM
RECIPE 3:
SPECIAL OCCASION

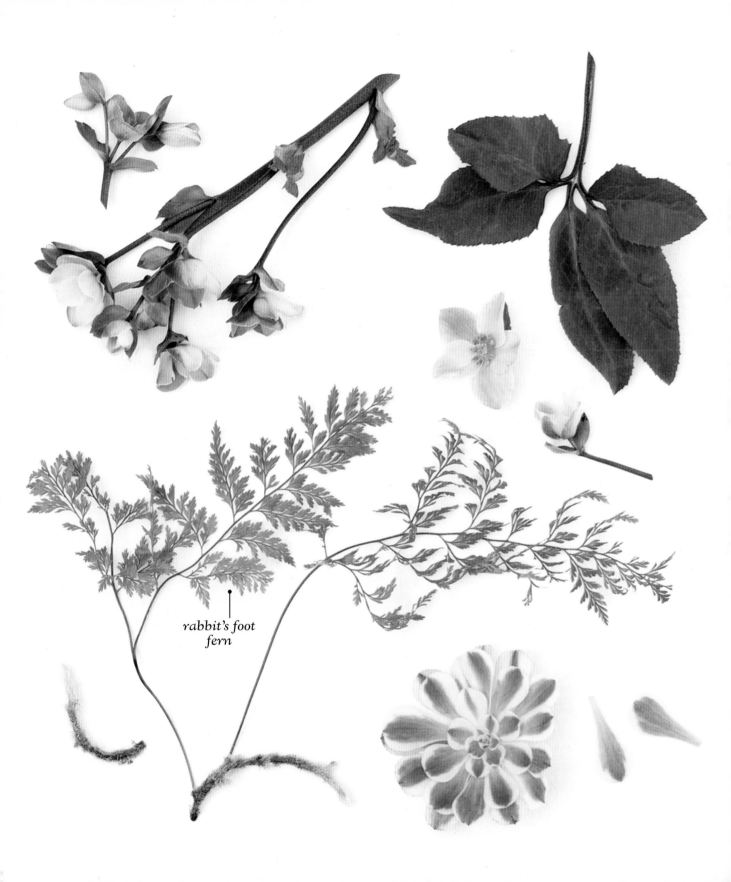

*rabbit's foot
fern*

AEONIUM
RECIPE 3:
SPECIAL OCCASION

PLANTS

Three 6-inch aeonium cuttings (*Aeonium* 'Sunburst')

One 6-inch hellebore (*Helleborus*)

One 6-inch rabbit's foot fern (*Humata tyermannii*)

CONTAINER AND MATERIALS

Porcelain bowl, 13 inches in diameter and 8 inches tall

3 cups of potting mix

1 Select a larger aeonium and snip off three rosettes with at least a 3-inch stem. (Perhaps a gift from a neighbor friend's garden, if not your own?) Let the stems dry out or harden off (scab over) for a few days. This helps prevent them from rotting and begins their rooting process.

2 Add the potting mix to the bowl, then unpot the hellebore and place it in the center. If its crown is too low, create a mound with the potting mix. This plant is the tallest in the design and needs to be planted the highest.

3 Unpot the rabbit's foot fern and insert it into the open space to the right of the hellebore. Slightly angle it so that it leans over the rim of the bowl.

4 If the stems of the aeoniums are too short, use a skewer as an extension. Attach it with coated wire or florist tape, or go ahead and skewer the thick stem for stability.

5 Place two of the aeoniums front and center and grouped for more impact. Place the third, and the largest of the three, resting off the left edge of the bowl.

6 Gently reach into the design and tug at the fern fronds, enticing them to weave through the hellebore and out the other side. Water lightly. After a few weeks, when the hellebore blooms fade and the aeonium cuttings begin to root, disassemble the arrangement and replant it.

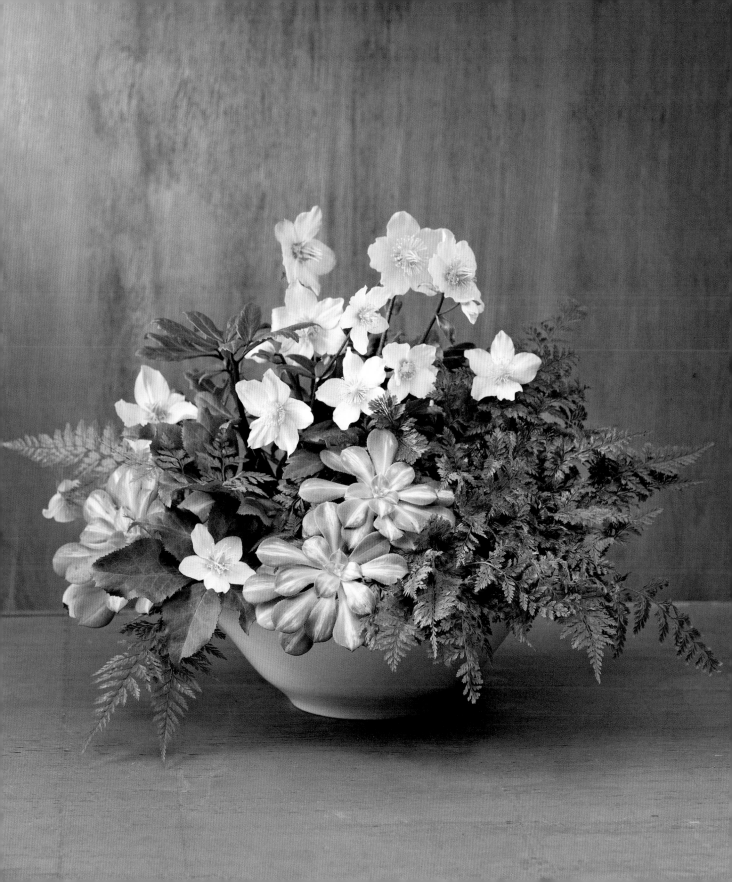

AFRICAN VIOLET

(*Saintpaulia*)

PLANT TYPE: perennial flowering plant

SOIL: violet mix

WATER: keep the soil moist but the leaves dry

LIGHT: bright indirect

African violets—or *Saintpaulia*, if you go by the Latin name— are sweet and kind and come in an inspiring range of both sizes and colors (some even have double blooms, too!). Compact and easy to find, these plants are perfect for small single arrangements that show off their tiny petals, furry leaves, and yellow stamens.

AFRICAN VIOLET
RECIPE 1:
ON ITS OWN

PLANTS

One 2-inch African violet
(*Saintpaulia*)

Two 4-inch African violets
(*Saintpaulia*)

CONTAINERS AND MATERIALS

3 log slices,
6 to 10 inches in diameter

3 copper vases,
3 to 5 inches in diameter

3 glass domes,
4 to 11 inches in diameter

1 cup of violet mix

½ cup or 6-inch square of sheet moss

1. Set the log slices on a table in a V shape with the tallest in the back. Match the appropriate-sized glass dome with each log slice.

2. Unpot the violets and massage the roots to remove excess soil. Plant the tiny 2-inch violet in the smallest copper vase. Follow suit with the other plants. Add violet mix if necessary to the bottom of the vases. The plant leaves should rest comfortably on the vase rim and their roots should touch the mix on the bottom. Don't leave the roots dangling in an empty space.

3. Place the glass domes on top, enclosing each violet. Give the plant room and make sure that the leaves do not touch the glass sides or top. Water about once a week, tipping to pour out any excess water. Pinch off any dead blooms to encourage reblooming.

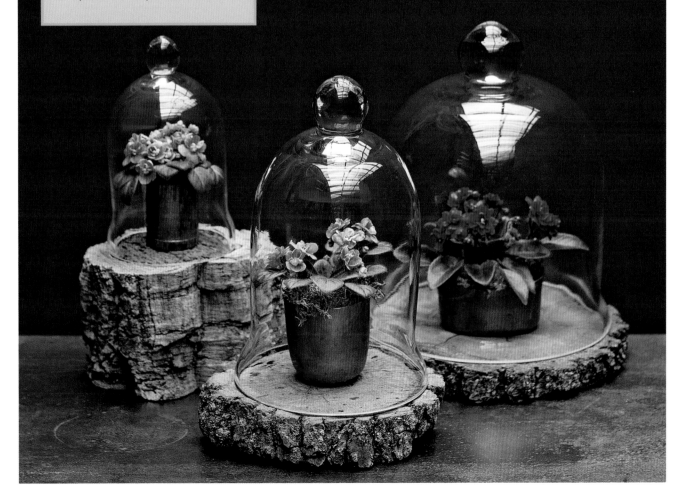

PLANTS
One 4-inch African violet (*Saintpaulia*)

One 4-inch spikemoss with a branching habit
(*Selaginella*)

CONTAINER AND MATERIALS
Block vase of California black walnut,
with a cavity 6 inches in diameter and
3 inches deep

Plastic liner or melted wax

1 cup of violet mix

Protect the bottom of the vase with a
plastic liner that fits snugly. For an added
layer of protection, melt a candle and
spread the wax over the exposed interior
to create a flexible yet waterproof
layer. Size up the violet with the pot. If
necessary, add violet mix to the liner.

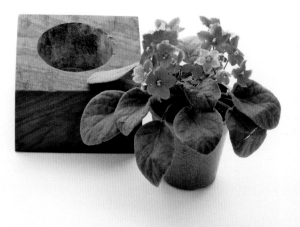

2 Unpot and gently loosen the soil. Plant
the violet in the plastic liner, leaving half
of the container open for the spikemoss.
Tilt the plant so that the leaves drape
over one flat edge of the vase.

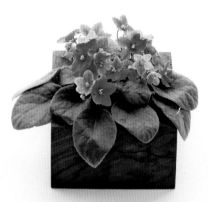

3 Repeat the planting process with the
spikemoss. Slightly pull the spikemoss up
so that it frames the violets. If necessary,
pull the violets down and forward a bit
to accentuate the contrast. Keep the
arrangement moist.

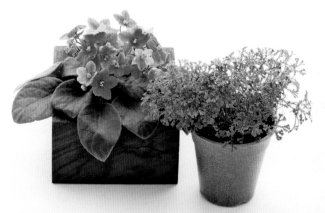

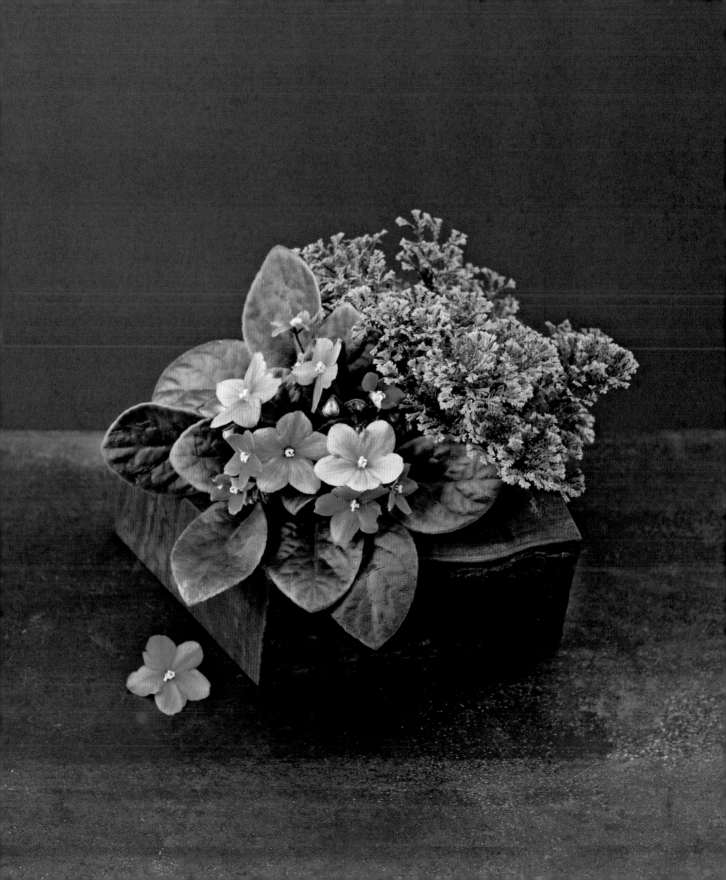

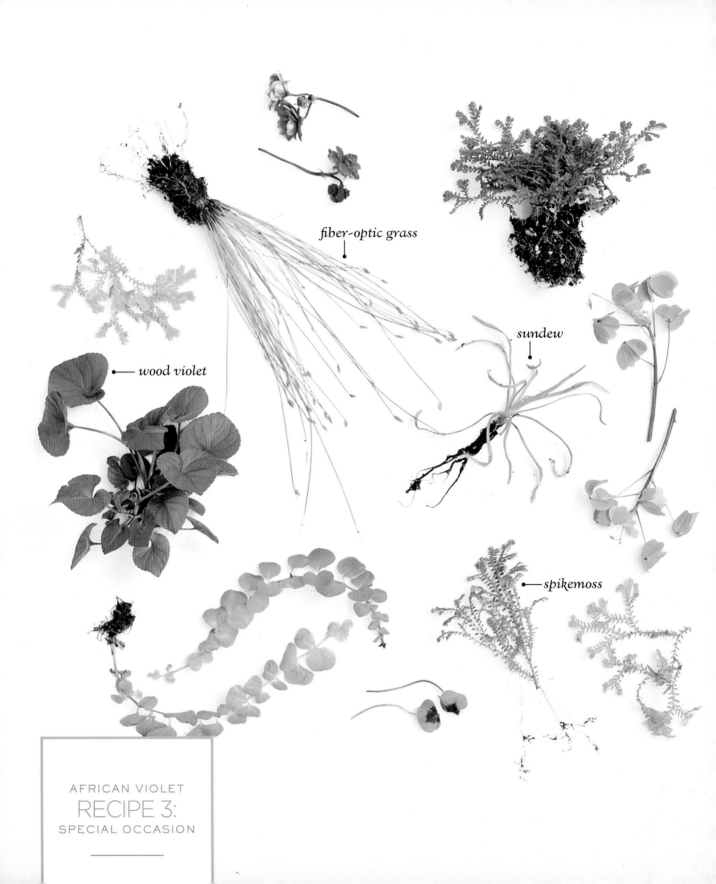

fiber-optic grass

sundew

wood violet

spikemoss

AFRICAN VIOLET
RECIPE 3:
SPECIAL OCCASION

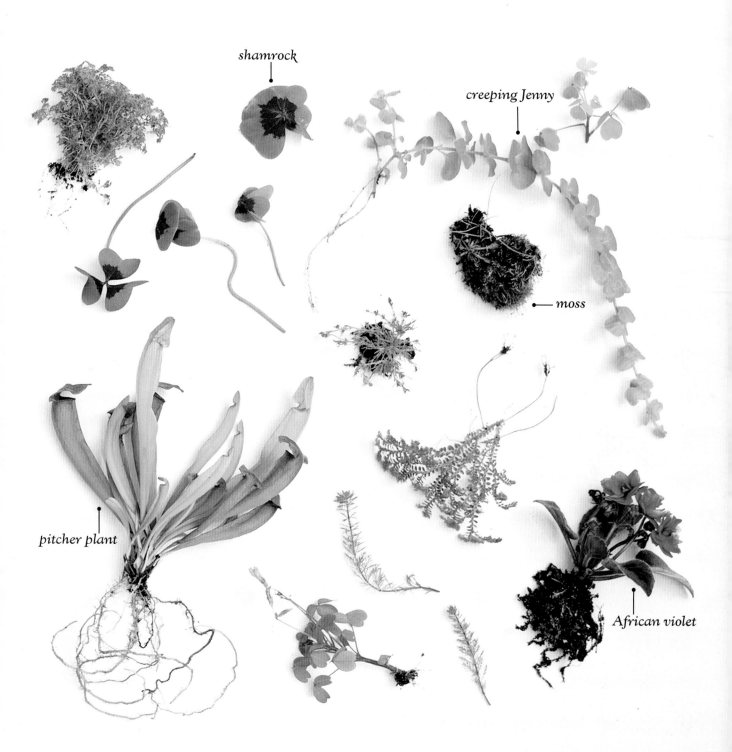

shamrock

creeping Jenny

moss

pitcher plant

African violet

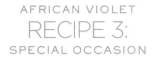

AFRICAN VIOLET
RECIPE 3:
SPECIAL OCCASION

PLANTS
Three 4-inch spikemosses, compact forms
(*Selaginella kraussian* and *S. apoda* are good choices)

Two 4-inch shamrocks
(*Oxalis siliquosa* 'Sunset Velvet' and *O. deppei* 'Iron Cross')

One 4-inch creeping Jenny (*Lysimachia* 'Goldilocks')

One 4-inch pitcher plant (*Sarracenia*)

Two 4-inch sundews (*Drosera capensis*)

One 4-inch wood violet (*Viola odorata*)

One 4-inch fiber-optic grass (*Isolepis cernua*)

Three 2-inch African violets (*Saintpaulia*)

CONTAINER AND MATERIALS
Glass terrarium 15¾ inches
at its widest point and 18 inches tall

½ cup of charcoal

5 cups of decorative gravel

5 handfuls of sphagnum moss

10 cups of potting, violet, and/or carnivorous mix

½ gallon of distilled water

2 clumps of cushion moss, to fill in any gaps

1 Spread the charcoal around the bottom of the terrarium. Add a 3-inch layer of decorative gravel on top. Soak the sphagnum moss for several minutes, squeeze out the excess water, and make a thin layer on top of the gravel.

2 Add enough potting mix to fill the vessel up to the bulge of the curve, or 3 to 5 inches. This design is viewed through the glass, but after a few months of growing time it might peek out of the top.

3 Begin unpotting and replanting the plants, gently indenting the soil mixture to set each one in place. For ease, work around the exterior edge first with the smaller, lower-growing plants, then fill in the center space with the larger ones such as the pitcher plant, fiber-optic grass, and shamrocks.

4 Fill up to the top of the soil level with distilled water. Cover any exposed topsoil with cushion moss. Use a long stick, if necessary, to fluff the shamrocks. Eventually they will sprawl tall and the pitcher plant will stretch toward the top of the container. Thoroughly soak the soil—but not the plants—to keep it wet, and this arrangement can live for years.

AIR PLANT *(Tillandsia)*

PLANT TYPE: bromeliad

SOIL: most need none

WATER: loves rain, fog, dew, and mist; soak once a week or mist every few days, but let dry between waterings

LIGHT: low to bright

This is a big category of plants. Air plants (*Tillandsia*) come in a range of colors and sizes, from light gray to greens, and from 1 inch tall to 3 feet wide. They often have leaves that arch from a center point, kind of like a star. Most of them don't need soil (there are exceptions, though, like the terrestrial *Tillandsia oerstediana* used in the Special Occasion recipe, page 44), and they love getting water from rain and fog and dew. Mimic that with a spritz of water every few days and a good soak about once a week. Do not, however, let the plant sit in water for more than a few hours—and make sure it is able to dry out completely within 4 hours (for example, don't soak it on a cold, damp evening).

PLANTS

One 6-inch air plant
(*Tillandsia floridiana*)

One 8-inch air plant
(*Tillandsia juncea*)

CONTAINER

Porcelain vase, 6 inches in diameter
and 5 inches tall

1. Choose an air plant whose personality will suit the vase, such as those shown here, which resemble the spines of a hedgehog. Match the plant size to the vase size.

2. Place the longer and straighter air plant directly in the vase leaning outward and then set the more curve-shaped one into the vase, angling the plant as needed.

3. About once a week, remove the air plants from the vase, soak, shake, and return.

RECIPE 2:

PLANTS

Two 4-inch miniature moth orchids
(*Phalaenopsis*)

Three 4-inch blooming succulents
(try *Echeveria*)

Three 6-inch air plants (*Tillandsia aeranthos*
'Purple Giant' or *T. stricta*)

Four to six 2-inch wispy air plants
(*Tillandsia fuchsii gracillis*)

Three to five 4-inch air plants with a red or
pink tint (I suggest *Tillandsia capita* 'Peach'
and *T. rubra*)

MATERIALS

Lichen twin wreath, 30 inches in diameter

Five 6- to 12-inch squares of sheet moss

Wire

Buy a premade wreath or make one of
your own. The wreath will host the plants
with its long branches, so make sure that
they're strong and long enough to tuck
plants into.

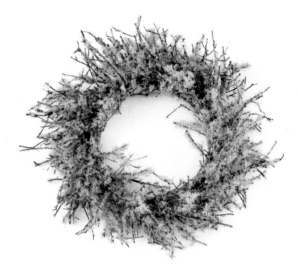

2 Unpot the orchids and echeverias, and
wrap their root balls with moss (see
page 17). Set the wreath on a worktable.
Starting with the moth orchids, tuck
the moss-covered root balls into the
branches, being careful of the delicate
blooms; wire them to the wreath securely.

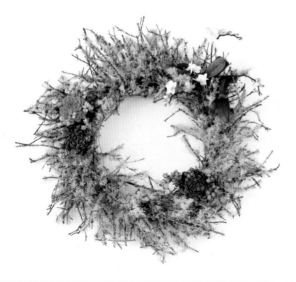

3 Wire in the blooming echeverias so
that the color and weight maintain the
balance of the wreath. Add in the air
plants, with wire if needed, maintaining
the balance between the sides. Add wire
at the top of the wreath and hang it on
the wall. Heartily spritz it weekly, and cut
back the blooms once they fade.

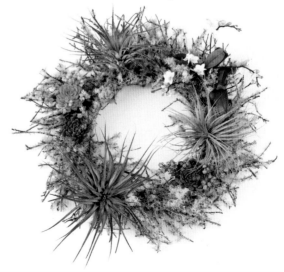

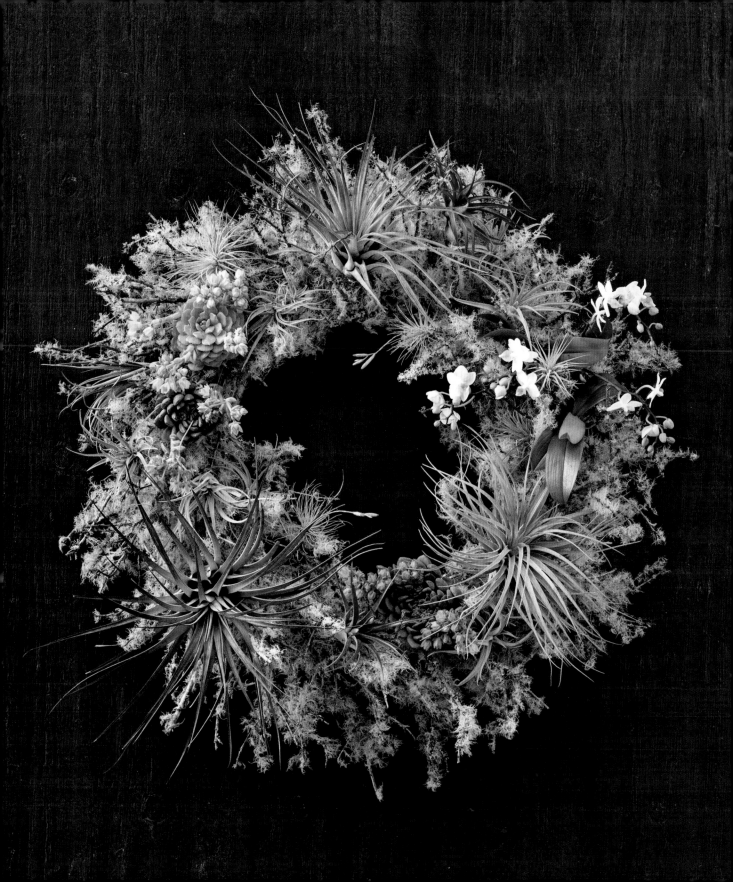

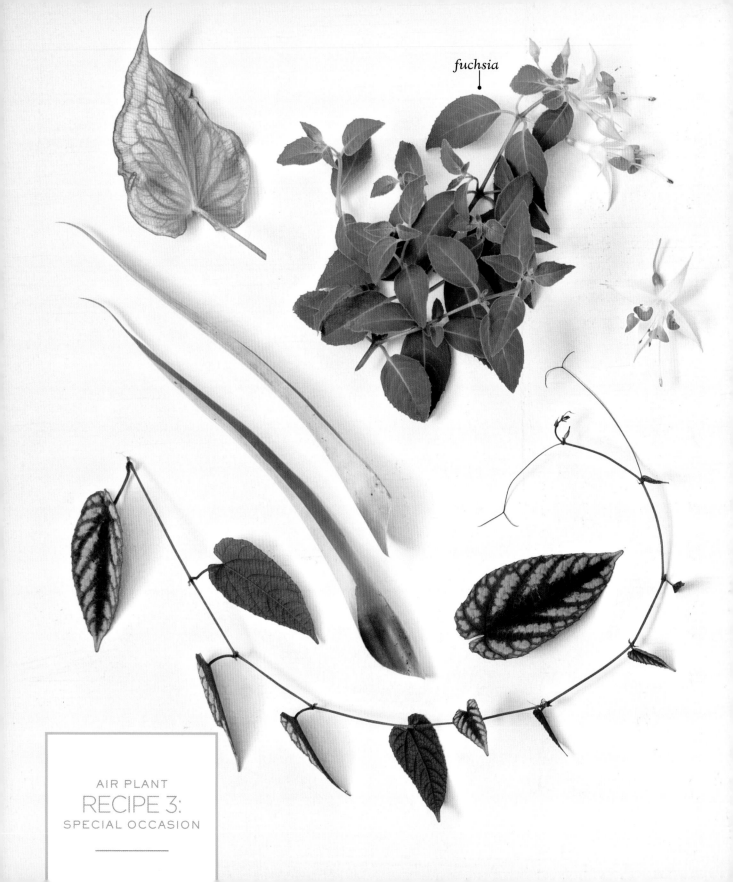

fuchsia

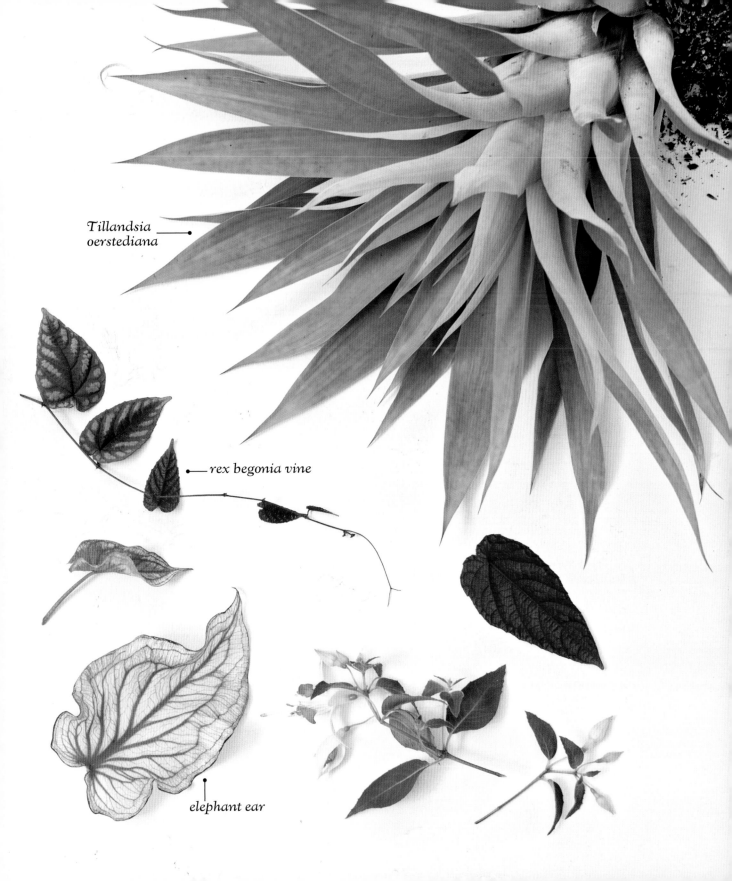

Tillandsia oerstediana

rex begonia vine

elephant ear

AIR PLANT
RECIPE 3:
SPECIAL OCCASION

PLANTS
One 8-inch *Tillandsia oerstediana*

One 6-inch fuchsia (*Fuchsia*)

One 6-inch elephant ear (*Caladium bicolor*)

One 6-inch rex begonia vine (*Cissus discolor*)

CONTAINER AND MATERIALS
Wood box with lid,
14 inches by 10 inches and 5½ inches tall

Plastic bag

5 cups of small lava rock

1. Line the box with the plastic bag and pour a thin layer of lava rock on the bottom. Keep the air plant in its original pot and set it on top of the gravel. This will keep its roots from sitting in water.

2. Keep the lid of the box open and use it as a backdrop for the plants. Slightly angle the air plant forward so that the inside center is visible and is not pointing straight up at the sky.

3. Plant the fuchsia next. Keep it in its container and weave its arching stems into the large leaves of the air plant.

4. Squeeze the pot of the elephant ear and slip it into the box on an opposite diagonal to the upright leaves of the air plant. Let the large, colorful, delicate leaves flop over the corner of the box.

5. As a final element, play off the color and the shape of the elephant ear leaves by planting the rex begonia vine. Eventually this will wind and twine its way through the arrangement.

6. Water each plant separately, giving more moisture to the elephant ear and fuchsia. If one element fades, pull it out and repot it. Make sure the arrangement receives bright but indirect light.

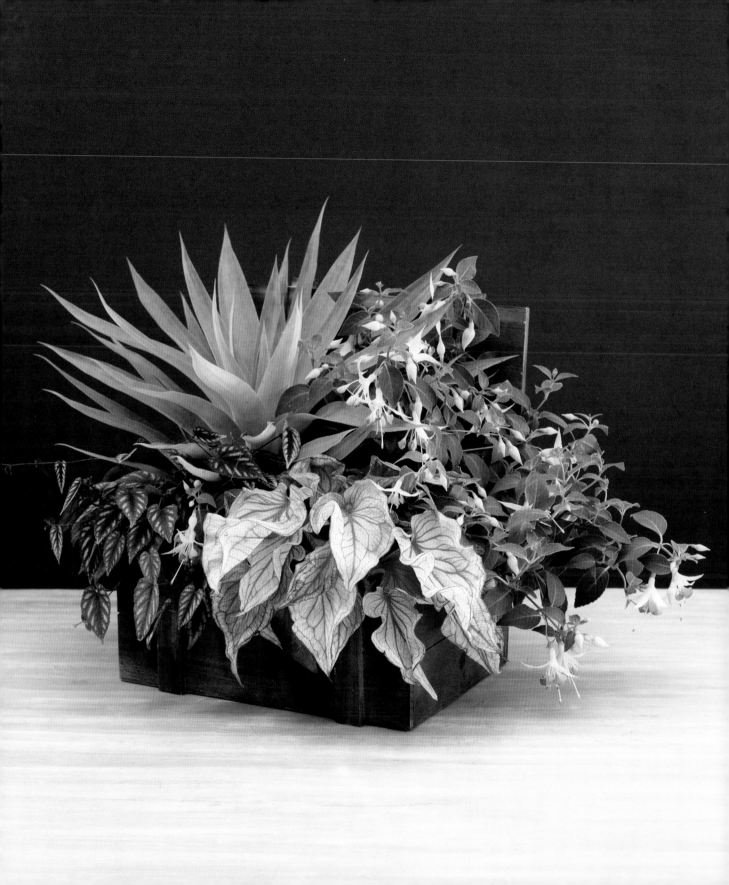

ALOE

PLANT TYPE: succulent
SOIL: cactus mix
WATER: let dry between waterings
LIGHT: bright direct

The most commonly recognized aloe is *Aloe vera* (shown here), whose gel is used to soothe burns. In these recipes, two other, lesser-known varieties are featured. One is more star-like in shape, and the other has fleshy, bumpy leaves. Aloes are easygoing and easy growing, with an intriguing shape to boot.

PLANT

One 4-inch lace aloe (*Aloe aristata*)

CONTAINER AND MATERIALS

Votive vase with open sides

A handful of lace lichen (*Ramalina menziesii*; Spanish moss—*Tillandsia usneoides*—is a good substitute and easier to find)

1. Choose a vessel that mimics the round and tooth-like shape of the aloe.

2. Soak the lichen to soften it. Unpot the aloe, remove the excess soil, and wrap its roots in the lace lichen.

3. Place the aloe inside the votive, lining up the plant with the "petals" of the vase to show off the repeat pattern.

4. Lightly water the arrangement once a week, making sure there is no standing water.

PLANTS

One 4-inch aloe hybrid (*Aloe* 'Pink Blush',
A. 'Peppermint', and *A.* 'Bright Star'
are good choices)

1 lichen-covered stick, about 20 inches long
and 1 to 2 inches in diameter

Two 4-inch burro's tails or sedum burritos
(*Sedum morganianum* or *S.* 'Burrito')

Two 4-inch cathedral windows
(*Haworthia cymbiformis*)

Four 4-inch zebra plants (*Haworthia fasciata*)

CONTAINER AND MATERIALS

Copper bowl, 24 inches in diameter

1 cup of small lava rock

10 to 12 cups of cactus mix

2 cups of decorative gravel

Pour a thin layer of lava rock into the
bowl, whose scalloped edges will play
off the sharp, pointy leaves of the aloe
and zebra plants. Add cactus mix to fill
the vase about two-thirds full, and create
a slight mound in the center. Unpot and
replant the aloe to one side of the bowl.

2 Divide the bowl in half with the lichen-
covered stick. Unpot and replant the
burro's tails so that they drape over
the stick. Then unpot and replant the
cathedral windows so that they sit snug
against the stick and at a slight angle, as
if they were growing from just under it.

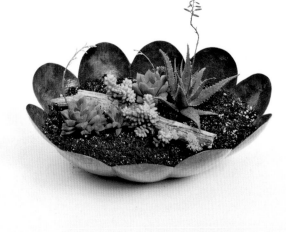

3 Unpot and replant the zebra plants so
that they also appear to be growing
from under the lichen-covered stick.
Then, using a spoon, cover the soil with a
layer of decorative gravel. Let the soil dry
out completely before watering about
once a week. This arrangement will last
about a year.

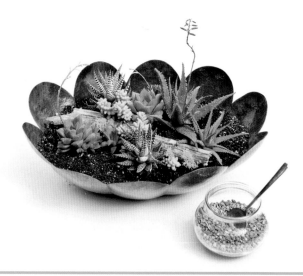

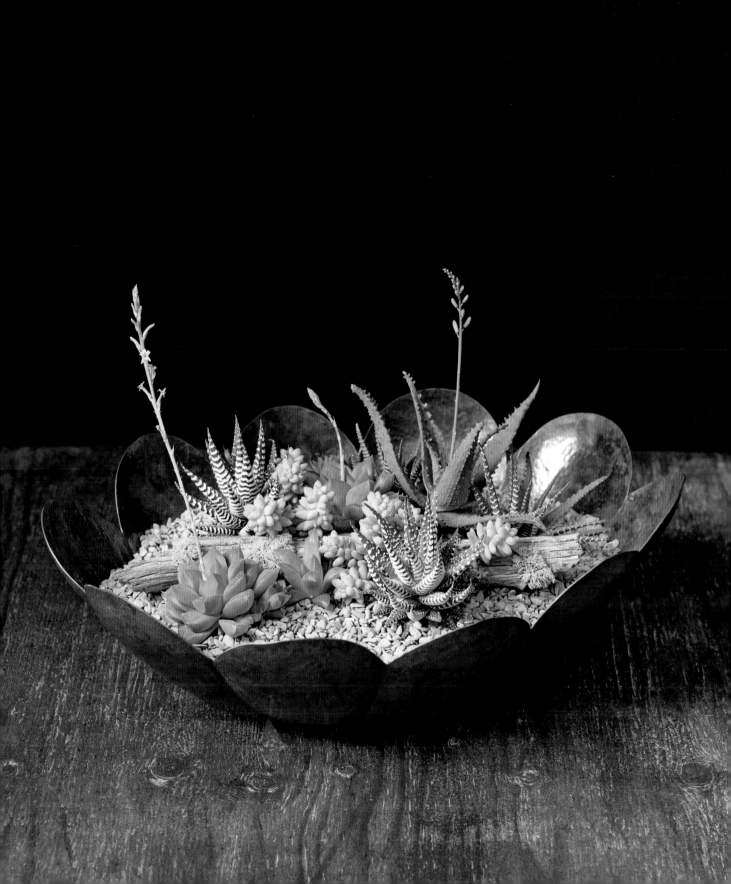

AMARYLLIS *(Hippeastrum)*

PLANT TYPE: bulb

SOIL: potting mix

WATER: keep just moist; let dry between waterings

LIGHT: bright

The huge, trumpet-shaped blooms of an amaryllis grow up to
6 inches in diameter. One thick, juicy stem may grow as tall
as 20 inches and host four blooms. Amaryllis are often found
in the winter months, but they can grow year-round in some
warmer climates. Plant bulbs in the fall or early winter or buy
them already blooming for a fabulous winter showcase.

PLANTS

3 amaryllis bulbs (*Hippeastrum*)
with at least one opened bloom

CONTAINERS AND MATERIALS

3 glazed French-style pots,
2 inches wider than each bulb

2 cups of potting mix

1 cup of decorative gravel

1. Fill each container with potting mix to an inch or more below the rim.

2. Plant each bulb so that it is secure and about half of the bulb is visible above the soil.

3. Using a spoon, cover the soil with the decorative gravel. Water the plants. As each plant grows and blooms, rotate it in order to keep it growing straight. Once the blooms have faded, compost the bulbs or save them for next year.

PLANTS

Two 6-inch amaryllis bulbs (*Hippeastrum*)
with unopened and open blooms

Three 4-inch ripple peperomias
(*Peperomia* 'Red Ripple' and 'Silver Dollar'
are good choices)

One 6-inch pink calla lily (*Zantedeschia*)

CONTAINER AND MATERIALS

Wood salad bowl, about 16 inches
in diameter and 4 inches tall

1 cork protector, 14 inches in diameter

Plastic bag (a small garbage bag works well)

4 to 6 clear plastic liners,
one for each grow pot

Set the cork on the bottom of the bowl, then line the bowl with a plastic bag; both will protect the wood from moisture. Place a plastic liner in the center back of the bowl. Gently remove the tallest amaryllis from its grow pot, keeping most of the soil on the bulb, and set it inside the liner.

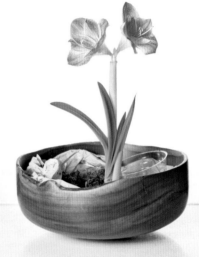

2 Fill the rest of the bowl with the liners. The liners are flexible, so squash them together if necessary to make them fit. Set the second amaryllis to the right of the first, then set the peperomia plants along the front of the bowl. If there is room, you may place more than one plant inside each liner.

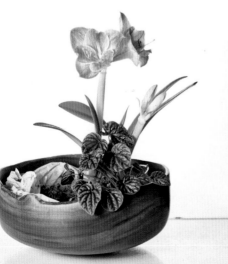

3 Add the calla lily to the left center of the bowl. Angle the pots toward the rim and tuck the plastic bag into the bowl so that it does not show over the rim. Fluff the peperomia leaves so that they float off the side of the bowl and conceal the liners. Water each plant about once a week, and cut the blooms when they fade. The peperomia will outlast the other plants.

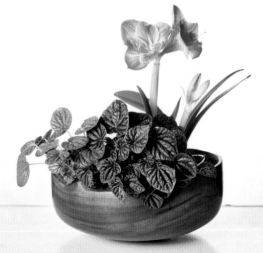

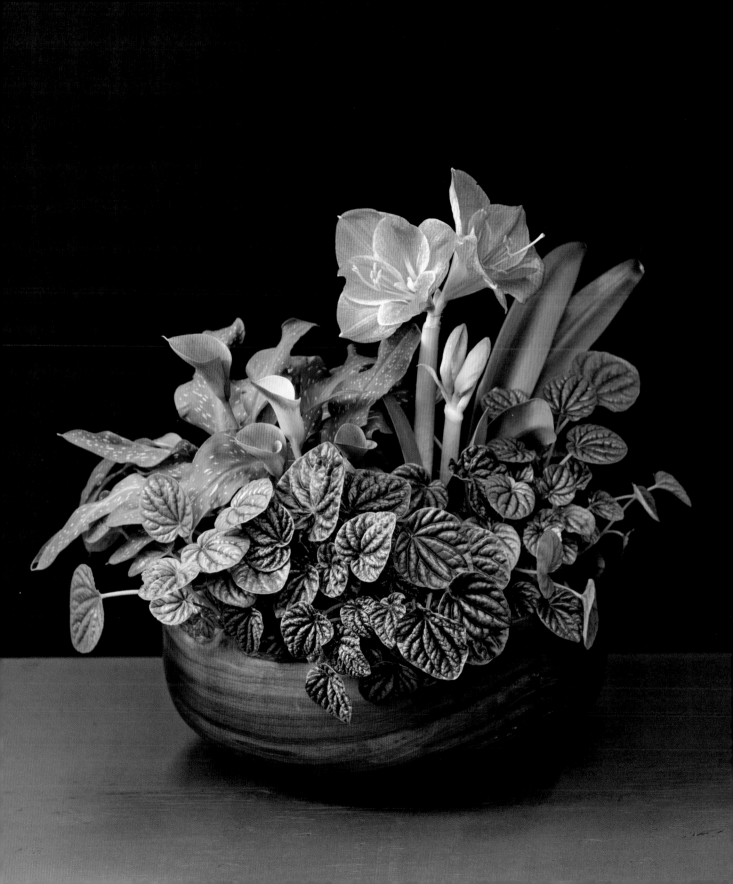

ASPARAGUS FERN
(*Asparagus plumosus*)

PLANT TYPE: perennial

SOIL: any

WATER: keep just moist to moist

LIGHT: low to bright

This plant is sometimes called emerald fern or plumosa fern—which is funny because it's not really a fern at all. It is, however, an asparagus, just not the kind you eat. It isn't alone—there are 150 other varieties of inedible asparagus. Some have red berries and most have sharp thorns, so be careful! The graceful wisps of this one float through the air. Their lovely, long length means they can easily be trained to grow up and around a window's frame.

RECIPE 1:
ON ITS OWN

PLANT
One 6-inch asparagus fern
(*Asparagus plumosus*)

CONTAINER AND MATERIALS
Hand-thrown pot, about 6 inches
in diameter and 10 inches tall

Water-tolerant stuffing,
such as Bubble Wrap

Plastic liner, 6 inches in diameter

One 6-inch square of sheet moss

1. Fill the pot with enough stuffing to bring the asparagus fern's grow pot rim flush with the pot's rim. Set the liner on top of the stuffing.

2. Set the plant (still in its pot) inside the liner and check that the liner is not visible above the rim of the decorative pot.

3. Gently rouse the feathery limbs of the plant up and down and out to add movement to the arrangement.

4. Lay the sheet moss on top of the soil to conceal the grow pot and liner and to create a clean-yet-woodsy look. Set the pot near a trellis or window frame and see how far up the fern will climb. Water it lightly.

RECIPE 2:
WITH COMPANY

PLANTS

One 6-inch asparagus fern
(*Asparagus plumosus*)

Two 4-inch begonias: 1 in bloom
(*Begonia* 'River Nile' is a good choice)
and 1 miniature eyelash begonia
(*Begonia bowerae* 'Leprechaun')

One 4-inch coral bells (*Heuchera*);
look for a variety with the name 'Lime'
in it for this fabulous color

One 4-inch asparagus fern
(*Asparagus sprengeri*)

CONTAINER AND MATERIALS

Decorative bowl 9 inches in diameter
and 6 inches tall

4 to 5 cups of potting mix

Add potting mix to the bowl until it is about two-thirds full. Unpot the 6-inch asparagus fern, gently loosen its roots, and replant it to the left of center at the back of the bowl.

2 Unpot and replant the larger-leafed, in-bloom begonia to the right of center in the bowl, angling it so that it drapes over the rim. Neatly tuck the 4-inch asparagus fern front and center in between the begonia leaves. Unpot and replant the coral bells to the left of center at the front of the bowl. It should sit below the asparagus fern. Allow the leaves to drape over the rim of the bowl.

3 Unpot and replant the miniature eyelash begonia to the right at the front, below the other begonia. Then fill the bowl with potting mix to about a half inch below the rim of the bowl. Let dry between waterings and make sure water doesn't sit on the bottom. Cut back the blooms when they fade, and separate and repot the plants after a few weeks.

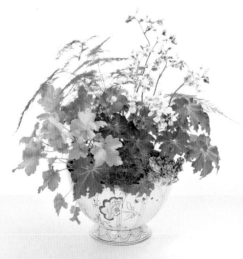

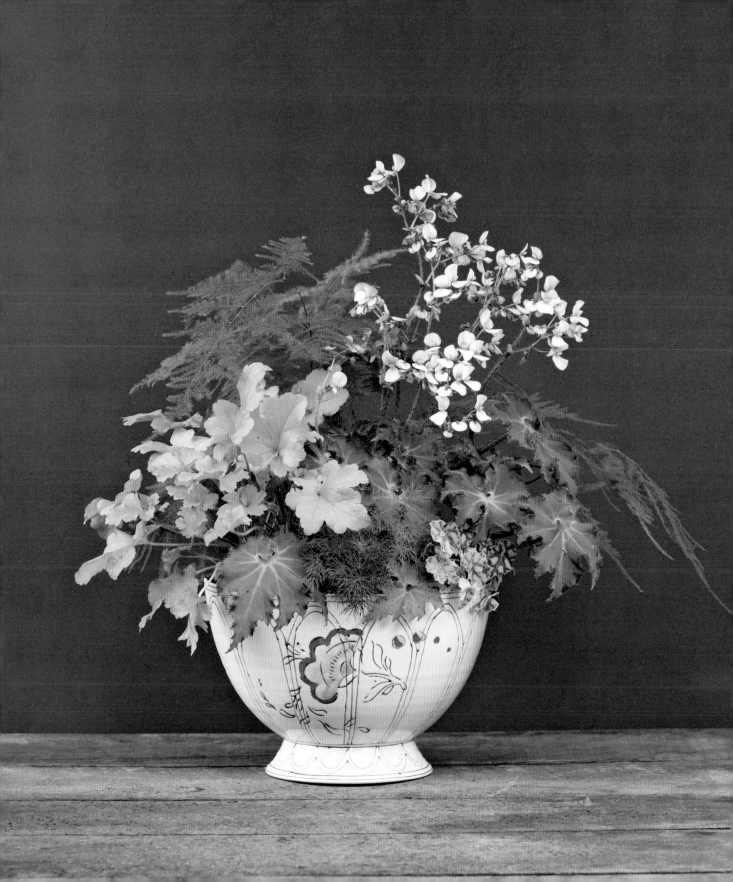

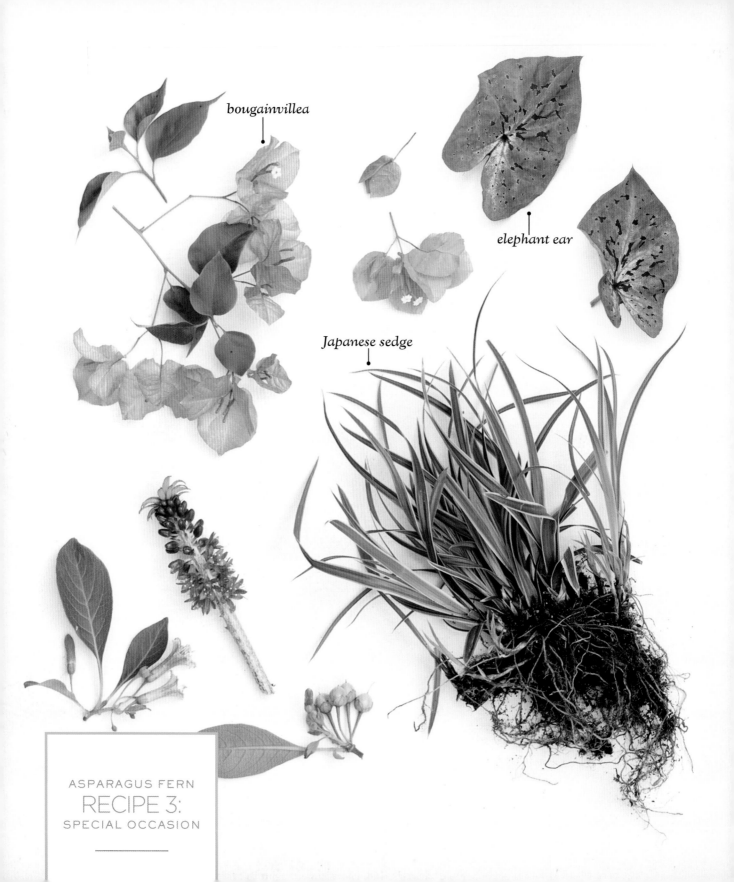

bougainvillea

elephant ear

Japanese sedge

ASPARAGUS FERN
RECIPE 3:
SPECIAL OCCASION

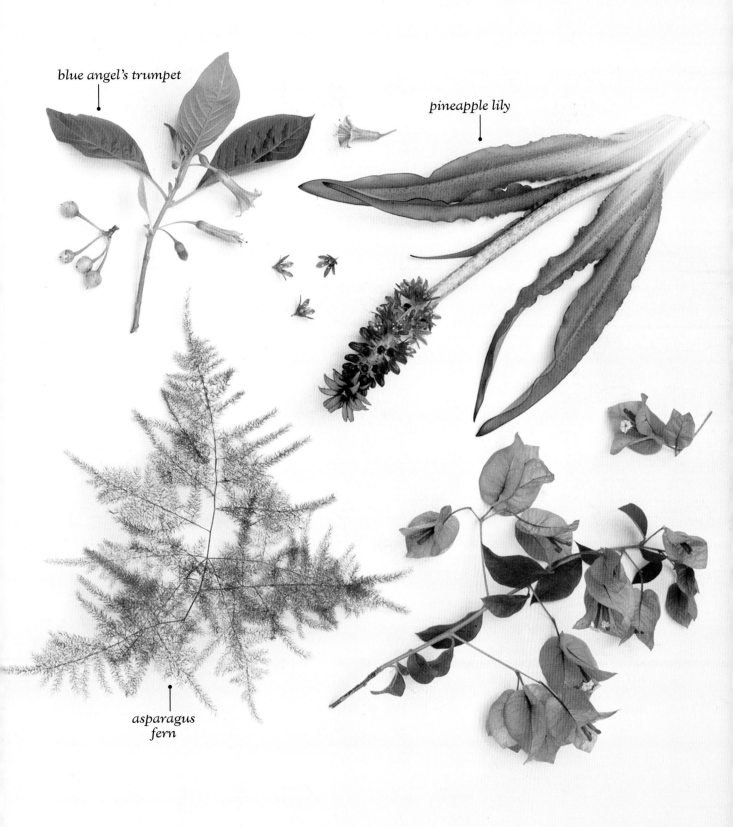

blue angel's trumpet

pineapple lily

asparagus
fern

RECIPE 3:
SPECIAL OCCASION

PLANTS
One 4-inch blue angel's trumpet (*Iochroma australis*)

One 6-inch asparagus fern (*Asparagus plumosus*)

One 6-inch elephant ear (*Caladium bicolor*)

One 4-inch bougainvillea (*Bougainvillea* 'Barbara Karst')

One 4-inch Japanese sedge (*Carex* 'Ice Dance')

One 6-inch pineapple lily (*Eucomis comosa*)

CONTAINER AND MATERIALS
Weathered copper cooking pot,
about 24 inches in diameter

Plastic liner, such as a small garbage bag

Water-tolerant stuffing, such as Bubble Wrap

1 Set the liner in the cooking pot and fill it with the waterproof stuffing.

2 Leave all the plants in their original pots. Begin with the tallest plant, the blue angel's trumpet, placing it in the center back of the cooking pot as the backdrop and architectural element. Place the asparagus fern slightly in front of the blue angel's trumpet and to its right, allowing the fern to drape over the side of the pot.

3 For a pop of color and fancy foliage, add the elephant ear and bougainvillea to the front center and left of the pot, angling them so that they drape over the edge.

4 Add the Japanese sedge and pineapple lily to the front right of the pot for a striking finish.

5 Water each plant separately, about twice a week, and be sure to keep the elephant ear moist. This arrangement will last about 3 months, and can easily be dismantled or rearranged as the plants die, bloom, or fade.

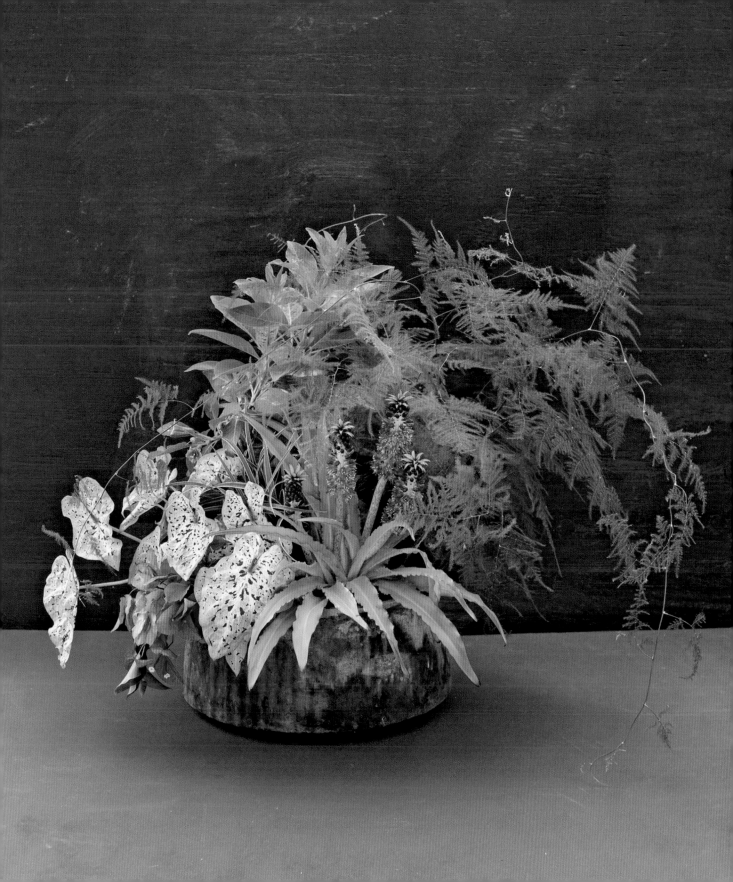

BEGONIA

PLANT TYPE: foliage and flower houseplant

SOIL: potting mix

WATER: keep just moist; allow the surface soil to dry between waterings

LIGHT: bright indirect

With such a diverse genus, begonias are chosen for their fabulous blowsy blooms or fantastically decorative foliage. Featured here are the fancy-leaf begonias. This bunch has references that include rex, eyelash, escargot, rhizomatous (and so many more). Don't get confused by all the names—just pick one you like and go for it. If their beautiful leaves with swirls of colors and patterns weren't enough to recommend them, fancy-leaf begonias bloom, too. Their airy blossoms are an accent floating above those gorgeous leaves.

PLANT
One 6-inch begonia with dappled leaves (look for easy-to-find *Begonia bowerae* var. *nigramarga* or *Begonia* 'Tiger Paws')

CONTAINER AND MATERIALS
Glazed blue flowerpot, sized to match the plant's grow pot

1-inch square of screen

Metal cachepot (decorative holder)

1. Cover the drainage hole in the glazed pot with the screen. Unpot the begonia and replant it in the new container.

2. Place it in the sink and water thoroughly. Let the water drain out the bottom.

3. Set the glazed pot inside the cachepot.

4. Gently tug the leaves so that they flow out and over the edges of the pot. To water, remove the flowerpot from the cachepot, place the pot in the sink, give the plant a thorough watering, let drain, and return. Let the surface soil dry between waterings.

BEGONIA
RECIPE 2:
WITH COMPANY

PLANTS

One 6-inch rex begonia
(*Begonia* 'China Curl')

One 4-inch hebe (*Hebe* 'Red Edge')

Two 2-inch miniature peacock orchids
(*Pleione*)

Two 2-inch flower dust plants
(*Kalanchoe pumila*)

CONTAINER AND MATERIALS

Low pedestal earthenware pot
(6 inches square)

¼ cup of small lava rock

1 cup of potting mix

¼ cup of sphagnum moss

Pour a 1-inch layer of lava rock into the pot. Fill the pot with potting mix until it is about two-thirds full. Place the begonia on the left side of the pot, planting it so that the crown of the plant (where the stem meets the soil) sits just below the rim of the pot.

2 Add in the hebe to the right of the begonia.

3 Create a mound with the orchids and flower dust plants at the front right and center of the arrangement. Fill in any gaps with potting mix. Gently press in the plants so that they stay put. Layer the top with sphagnum moss. Let dry between waterings roughly once a week. The blooms will fade—repot the hebe and the orchids; keep the flower dust and begonia as is.

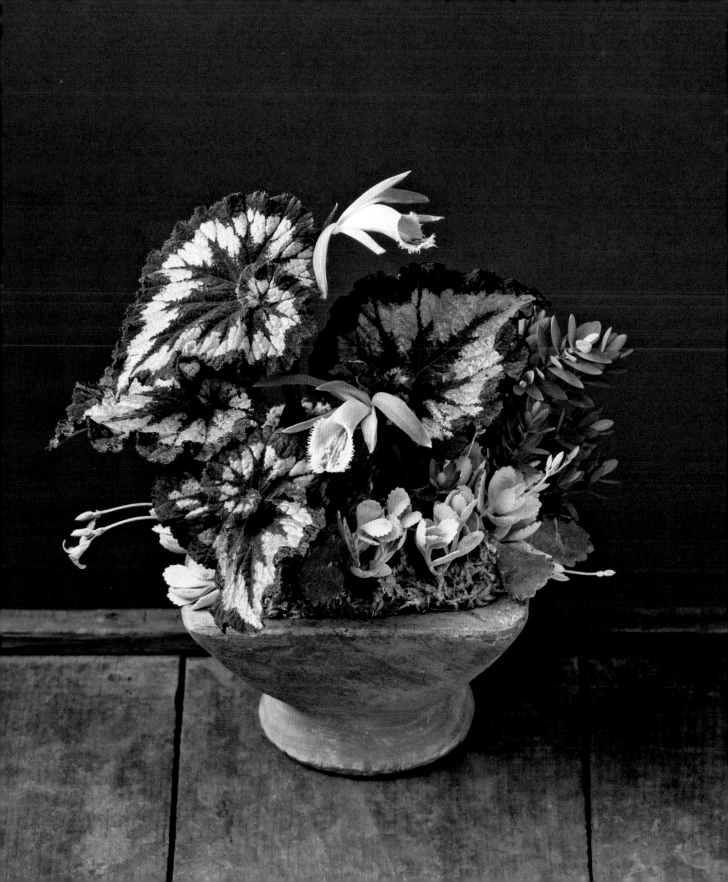

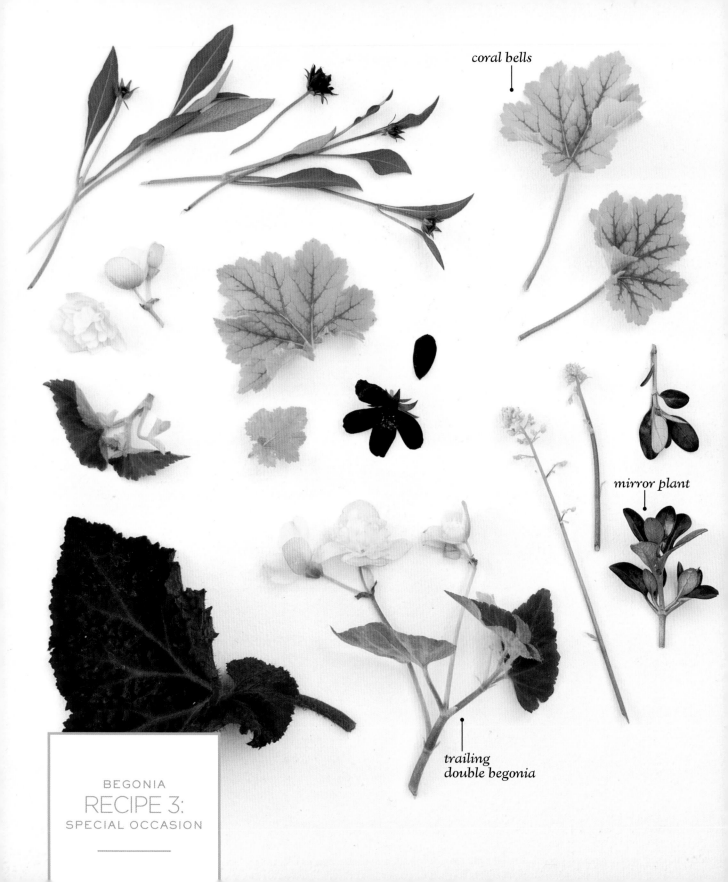

coral bells

mirror plant

trailing
double begonia

BEGONIA
RECIPE 3:
SPECIAL OCCASION

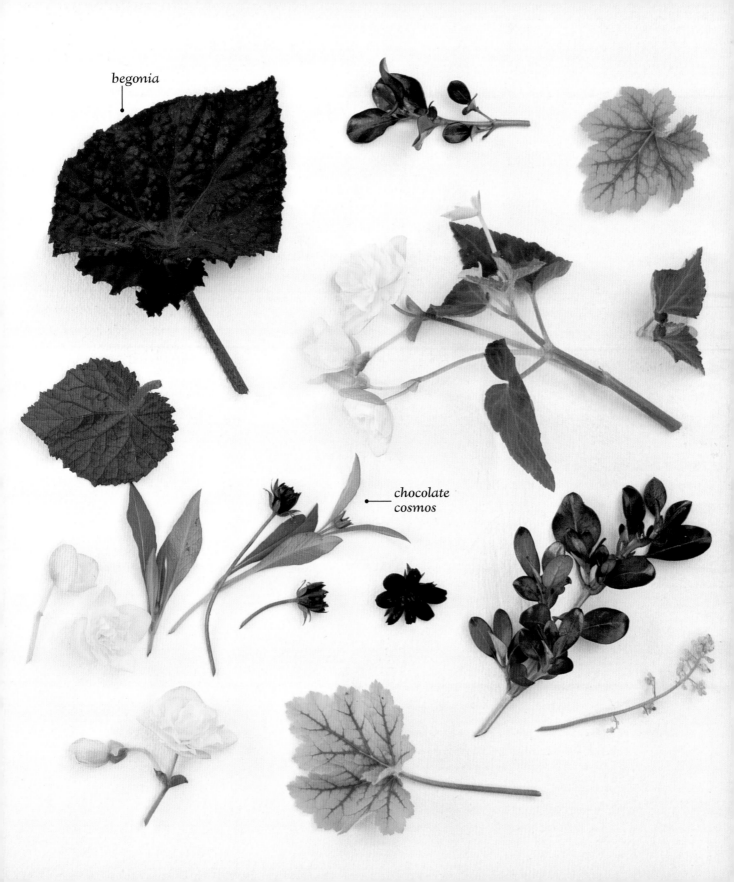

begonia

*chocolate
cosmos*

BEGONIA
RECIPE 3:
SPECIAL OCCASION

PLANTS

Two 4-inch chocolate cosmos
(*Cosmos atrosanguineus* 'Chocamocha')

One 4-inch coral bells (*Heuchera* 'Electra') in bright yellow

Three 6-inch trailing double begonias
(*Begonia* 'Sherbet Bon Bon') in pale yellow

One 4-inch begonia with chocolate foliage
(*Begonia* 'Black Taffeta' or 'Black Coffee'
makes a good choice)

Two 4-inch mirror plants (*Coprosma* 'Karo Red')

CONTAINER AND MATERIALS

Straw basket, 12 inches square and 10 inches deep

Plastic liner

Large round glass vase that fits snugly inside the basket

1 Line the basket with a plastic bag or other waterproof liner.

2 Set the plants, still in their pots, inside the glass vase to assess the arrangement. Start by placing the tallest plants, the cosmos and coral bells, in the middle. Then surround these with the other plants, working from tallest to shortest as you reach the edge of the vase. Move the plants around until you are satisfied with the arrangement. Then remove the pots and place them on your worktable in the same design.

3 Unpot and plant each plant, moving from the center to the edges of the glass bowl and following the design you created. Add a layer of potting mix to the bottom of the vase as needed to ensure that the crowns of all the plants are flush with the rim of the vase. Pack the plants in tightly, angling them slightly outward.

4 Carefully place the vase in the basket. Gently pull any leaves that are overflowing the rim of the glass vase so that they drape over the basket's edge. This recipe calls for a combination of traditionally indoor and outdoor plants. As the cosmos fade (they like sun), the trailing begonias will continue to flower. Once the trailing begonias have finished flowering, plant the chocolate leaf begonia in a small single pot for a long indoor life. In milder climates the coral bells and mirror plants can go outside, even in the winter.

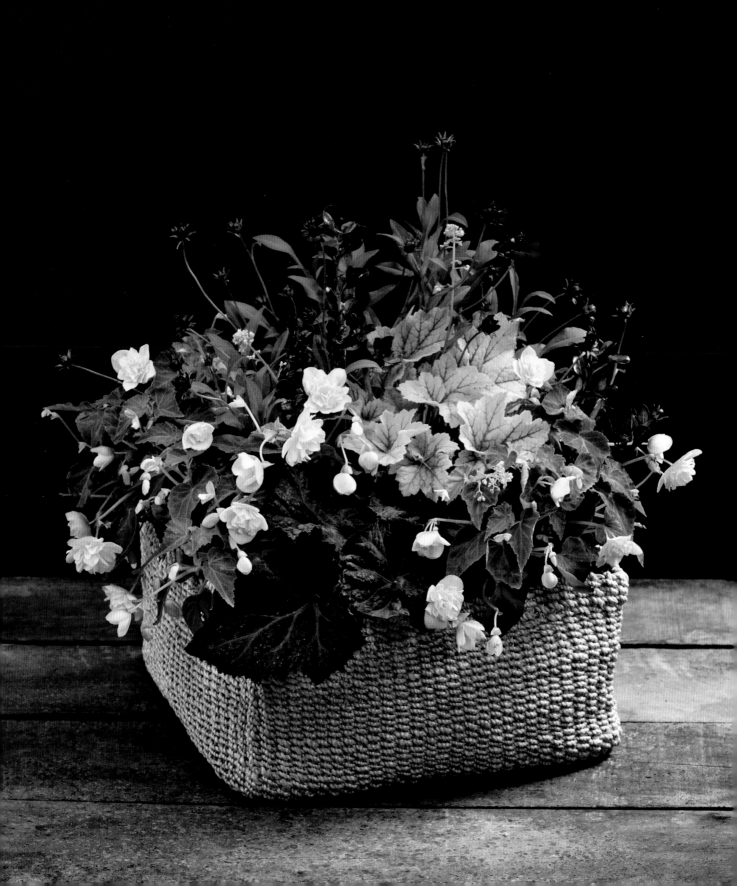

CLEMATIS

PLANT TYPE: vine

SOIL: potting mix amended with peat moss

WATER: keep just moist to moist

LIGHT: bright direct

The twisting tendrils and cascading delicate flowers make this vine irresistible when spring has not quite sprung outside. Though it is sometimes sold as a houseplant, it's not meant to live for years indoors. Clematis can be planted outside once the weather warms up in the late spring. Keep the roots cool to keep their gorgeous blooms happy.

RECIPE 1:
ON ITS OWN

PLANT
One 6-inch clematis
(*Clematis* 'Regal' is shown here)

CONTAINER AND MATERIALS
Stone pedestal planter 7 inches in
diameter and 8 inches tall

1-inch square of screen

1 to 4 cups of potting mix

1 cup of mulch

One 6-inch square of sheet moss

1. Cover the hole in the planter with the screen.

2. Fill the bottom of the planter with the potting mix. Leave enough room for the plant plus a few inches. Unpot the clematis and set it in the planter. Fill in around it with more potting mix, then add a 1-inch layer of mulch and a layer of sheet moss.

3. Gently untangle the plant from its trellis. (Clematises are usually sold with some sort of trellis to hold up the vine.) Tug lightly at the vines to arrange the flowers, tendrils, and vines with some asymmetrical movement.

4. Water the arrangement in a sink until the water runs out from the bottom of the planter. Let it finish dripping. Place it on a waterproof plate if the display surface might become water-damaged.

RECIPE 2:
WITH COMPANY

PLANTS
One 1-gallon dwarf Japanese skimmia
(*Skimmia japonica*)

One 6- to 8-inch wood hyacinth
(*Ledebouria socialis*)

One 6-inch clematis (*Clematis* 'Regal')

CONTAINER AND MATERIALS
Faux cement planter, 9 inches by 11 inches

1-inch square of screen

1 cup of small lava rock

1 to 3 cups of potting mix

Cover the hole in the planter with the screen, then pour in a 1-inch layer of lava rock. Add a few inches of potting mix and place the unpotted skimmia in the planter. If its crown sits more than 2 inches below the rim, remove the plant and add more potting mix.

2 Repeat the measuring and placing procedure with the wood hyacinth.

3 After the clematis is planted, tenderly untangle the vine and wrap it around the base of the plants for a compact shape and contemporary look. Water once or twice a week, making sure to let the water run out the bottom.

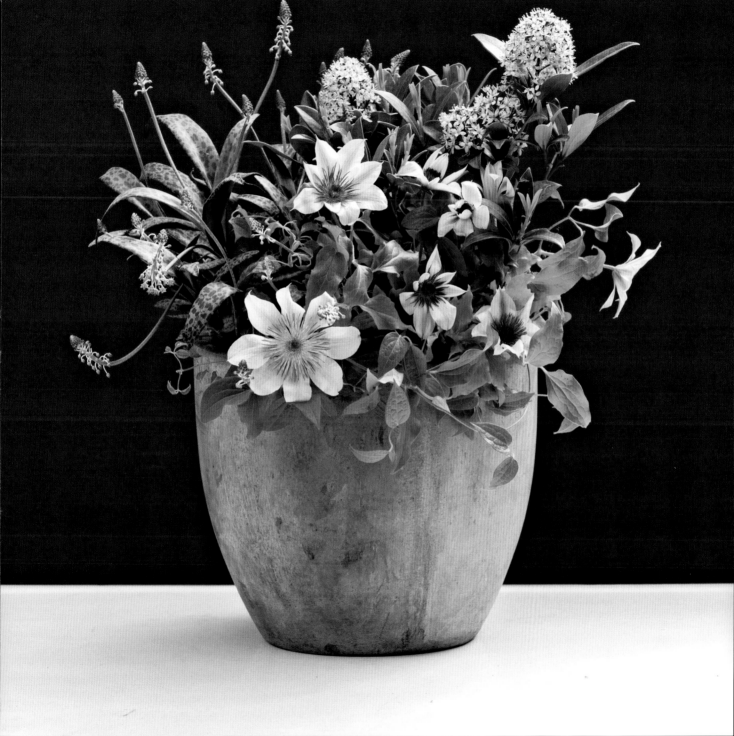

EARTH STAR

(Cryptanthus)

PLANT TYPE: bromeliad

SOIL: potting mix amended with peat moss, or orchid or violet mix

WATER: keep just moist; it wants high humidity

LIGHT: low to bright

Wavy leaves with distinctive stripes make this terrarium-loving plant look like a starry sea creature—hence its common names starfish plant or earth star. It's easy to keep alive, too. Out in the wild these grow on the forest floor, so keep them on the moister side. The tiny pups are perfect for teeny-tiny arrangements. Just pluck them off and replant.

RECIPE 1:
ON ITS OWN

PLANTS
Two 2- to 4-inch earth stars
(*Cryptanthus* 'Pink Starlight'
is a good choice)

CONTAINERS AND MATERIALS
2 wood block vases

Wax (a candle will do)

1. Look for vases that are about the same size as the plants' grow pots.

2. Melt a candle over the interior of the vases to protect them from moisture.

3. Unpot and plant the earth stars so that the leaves rest on the surface of the vases.

4. Let the plants take root before standing the block vertically; or glue three small wires under the leaves and across the surface of the soil to secure the plants. Keep the plants moist.

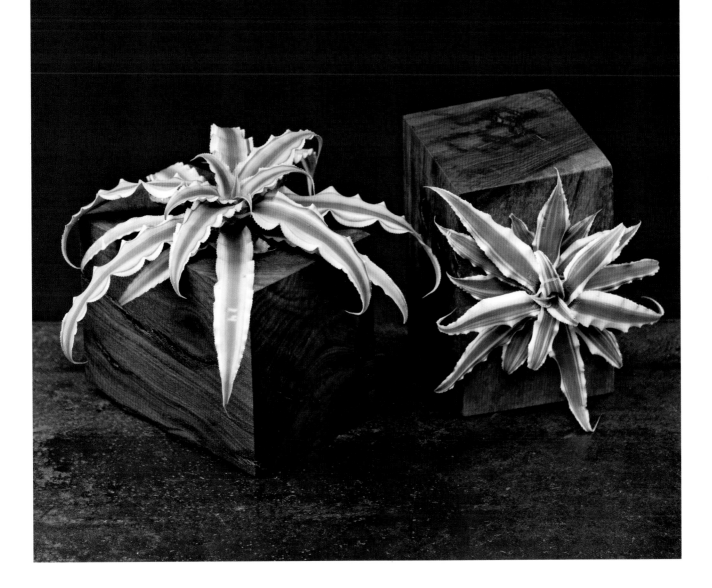

PLANTS
One 6-inch bromeliad
(*Vriesea gigantean* 'Nova' or *V. Ospinae*
var. *gruberi* is a nice choice)

One 4-inch bromeliad (*Neoregelia* 'Donger')

One 4-inch and two 2-inch earth stars
(*Cryptanthus* 'Pink Starlight', *C.* 'Elaine',
and *C.* 'Ruby' are good choices)

MATERIALS
Branch of Harry Lauder's Walking Stick
(*Corylus avenlana* 'Contorta'), about
4 feet long; a curly willow branch
will work, too

Two 12-inch squares of sheet moss

6 feet of fishing line

Lay the branch in a stable position.
Note: Because of the delicate balance
of the design, this arrangement must be
built where it will be displayed.

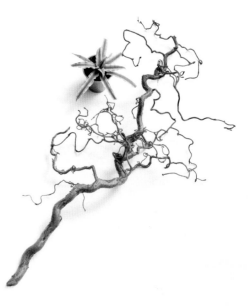

2 Unpot all the plants, removing the pups
from the larger earth stars. Wrap the
roots of all the plants and pups in moss
balls (see page 17). Place the largest
plant (the *Vriesea* 'Nova') first, resting it
near the thickest part of the branch.

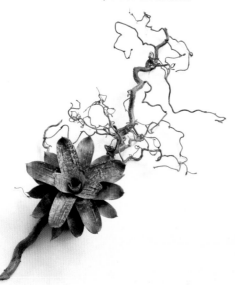

3 Continue with the smaller bromeliad and
the large earth star. Rest the small earth
stars and pups on the smallest branches.
Mist the arrangement once a day, and
remove and soak the plants about twice
a week. The arrangement will last several
months.

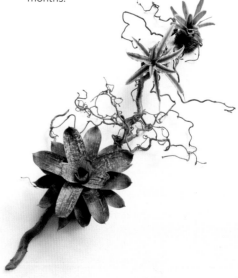

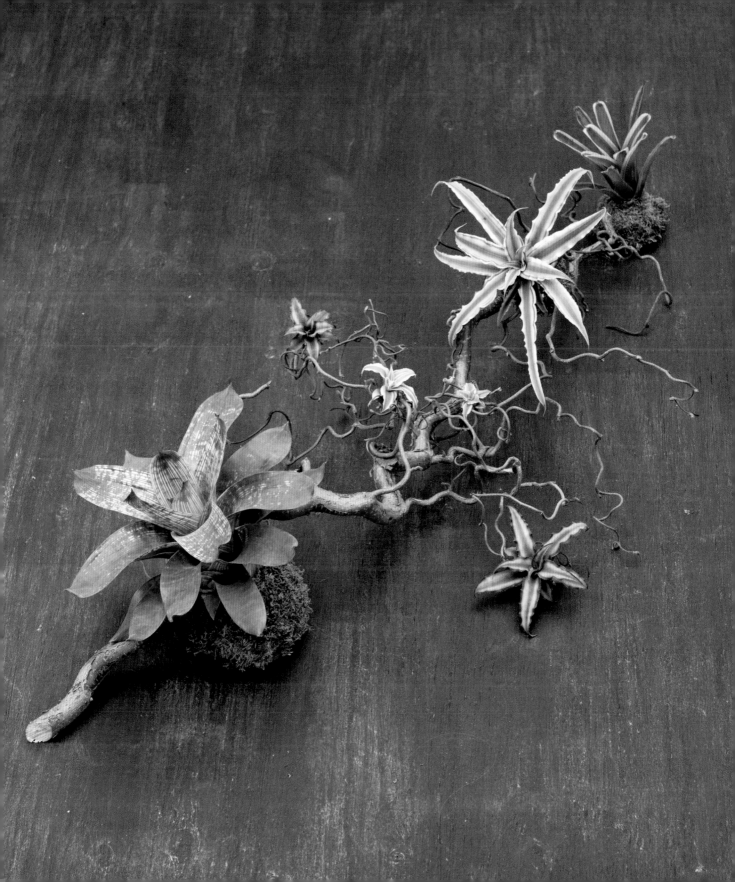

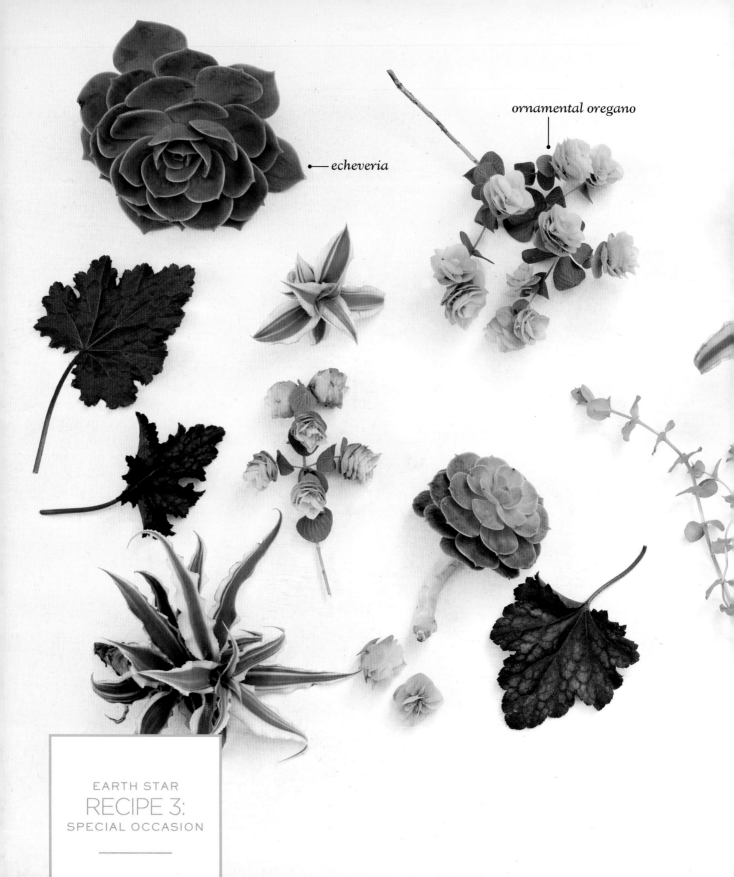

echeveria

ornamental oregano

EARTH STAR
RECIPE 3:
SPECIAL OCCASION

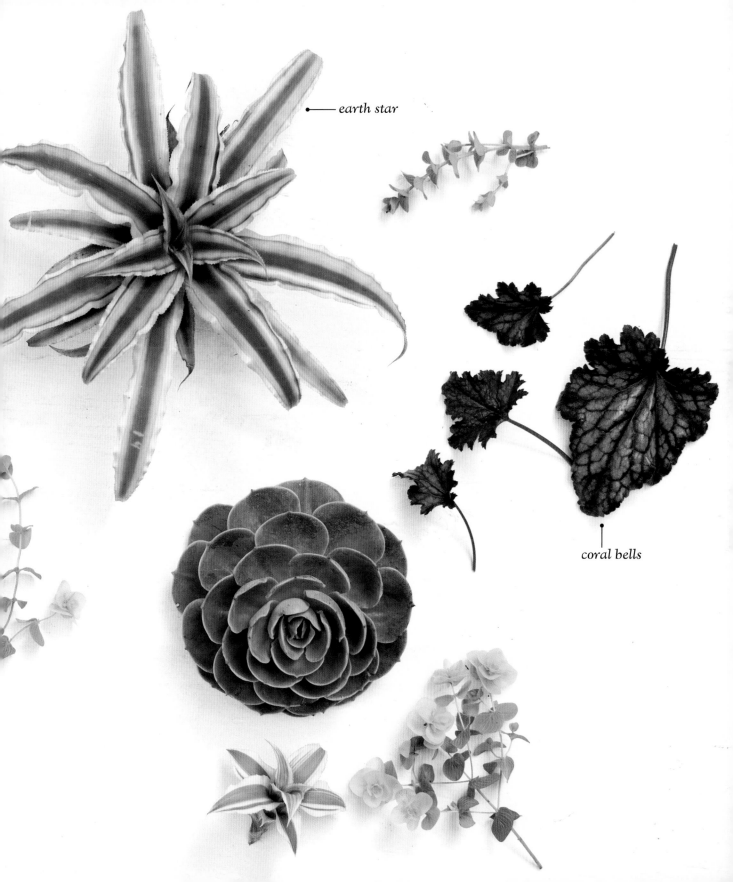

earth star

coral bells

EARTH STAR
RECIPE 3:
SPECIAL OCCASION

PLANTS
Four 4-inch echeverias (*Echeveria* 'Imbricata' or
any other gray one)

One 4-inch earth star (*Cryptanthus* 'Pink Starlight')

Two 4-inch coral bells with purple leaves (*Heuchera*
'Purple Palace' or 'Plum Pudding' is a nice choice)

Two 4-inch ornamental oreganos (*Origanum* 'Kent Beauty')

CONTAINER AND MATERIALS
Vintage silver pedestal vase, at least 12 inches in diameter

2 to 4 cups of potting mix

1 — Choose a vase with a slight pedestal so that the plant design is roughly one and a half times the height of the vase, allowing the plants to drape over the edge.

2 — Add the potting mix, creating a mound in the center and leaving several inches from the top of the soil to the rim of the vase.

3 — Unpot and replant the echeveria first, mounding them in the center and left of the vase. Tilt the plants forward so that the centers are visible from the front. Allow plants at the front to rest on or drape over the rim of the vase.

4 — Tilting it forward, place the earth star facing front and center as the focal piece. Gently pull the leaves so that they drape over the front rim of the vase.

5 — Place the coral bells on either side of the echeveria asymmetrically. A view from both sides of the vase will show off their purple leaves.

6 — For fluff and fragrance, plant the oregano so that it drapes off one side of the vase and in the center back of the opposite side to create a diagonal line.

7 — Mist the earth star three times a week, and keep the oregano moist. When the arrangement begins to droop, disassemble it and repot it.

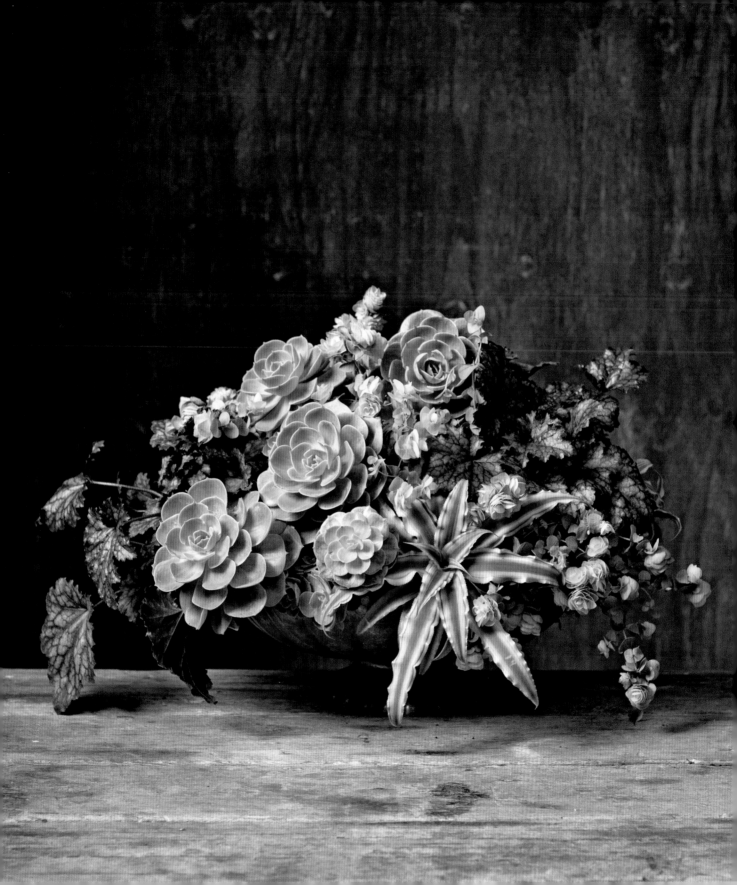

ECHEVERIA

PLANT TYPE: succulent

SOIL: cactus mix

WATER: keep just moist; allow the surface soil to dry between waterings

LIGHT: bright direct

This succulent, sometimes known as hen and chicks, offers up juicy rosettes in a variety of colors. If you're lucky enough to find one in bloom, the nodding flowers in sweet bell shapes add height and temporarily change up this reliable, low-growing succulent. Pluck off its offshoots—this one keeps growing and all you have to do is replant its plentiful pups for more succulents.

ECHEVERIA
RECIPE 1:
ON ITS OWN

PLANTS

Five 4-inch echeverias:
2 painted echeveria (*Echeveria nodulosa*), 2 shattering echeveria (*E. difractens*), and 1 *E. tomentosa*

Nineteen 2-inch echeverias or cuttings: 3 *Echeveria* 'Lola', 6 pink-edged or pink-tipped (*E. pulidonis, E. pulindonis* x *derenbergii, E. chihuahuaensis,* or *E.* 'Captain Hay'), 4 hens and chicks (*E. secunda*), 4 *E.* 'Dondo', and 2 *E.* 'Ramillete'

CONTAINER AND MATERIALS

Painted wood living picture frame box, 12 inches by 7 inches and 2½ inches tall, with wire mesh to hold in the soil

4 cups of cactus mix soil

1. Choose plants and a frame color that complement one another. The pink frame shown here makes the contemporary succulents more playful.

2. Fill the frame with the cactus mix. Shake the box to even out the soil and allow for it to fall through the mesh.

3. Unpot the echeverias and massage the roots to remove excess soil, which will allow easier placement into the metal mesh. Place the plants and cuttings in the frame so that the stem penetrates the soil by at least ⅛ inch. A skewer is helpful with tucking in any roots.

4. Group the larger rosettes together and arrange swaths of like succulents to create a pattern. Let the rosettes rest against the edges so that they spill out of the frame.

5. Enjoy on a tabletop for about a month, until the cuttings and plants have rooted; then you can hang the arrangement on a wall (a regular nail will hold the weight). A felt pad mounted on the wall will help protect it from damage.

6. Let the arrangement dry thoroughly between waterings, and make sure it gets lots of sun.

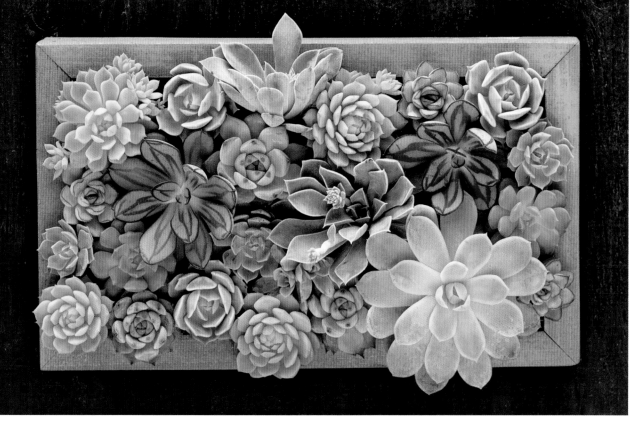

PLANTS

One 2-inch blue chalkstick (*Senecio serpens*)

Two 2-inch jeweled crowns
(*Pachyveria* 'Scheideckeri')

One 2-inch Desert Gem stonecrop
(*Sedum* 'Desert Gem')

One 2-inch gray echeveria
(*Echeveria secunda* is a nice choice)

1 lichen-covered twig, 3 inches long

CONTAINER AND MATERIALS

Teardrop glass, 9 inches in diameter

1 cup of decorative gravel

½ cup of cactus mix

5 feet of twine

Scoop three-quarters of the decorative gravel into the teardrop glass. Tip the teardrop so that the rocks slope from low to high and from front to back. The angle will make for a pretty view from the back.

2 Spoon in the cactus mix, following the same gentle slope. Unpot the plants. Begin planting from large to small and back to front, starting with the blue chalkstick, then the jeweled crowns, the stonecrop, and the echeveria. The chalkstick makes an interesting backdrop for the other rosette plants.

3 Place in the twig for a nice accent. Use a small funnel to cover the cactus mix with the decorative gravel. Attach a length of twine to the teardrop and hang it in a window. Water with a spoon or a dropper, making sure to spread the water out evenly and that none sits at the bottom of the glass.

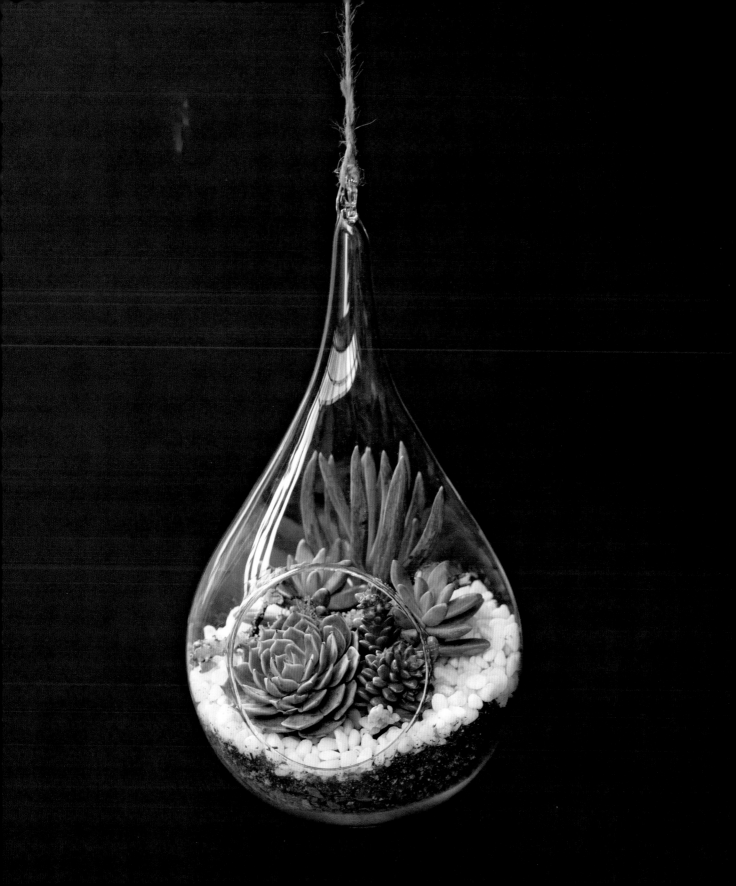

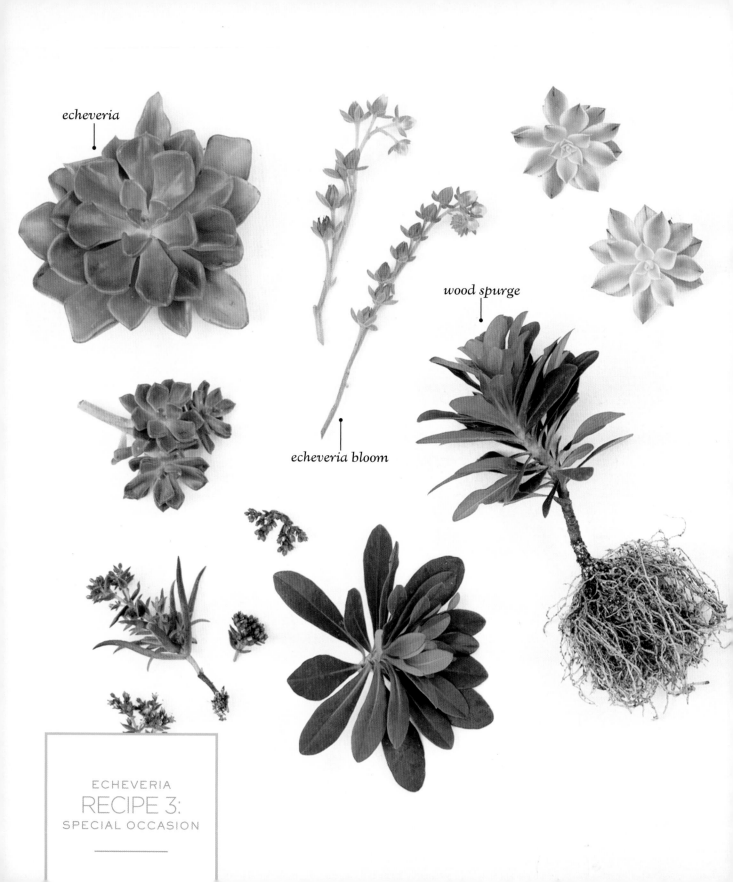

echeveria

wood spurge

echeveria bloom

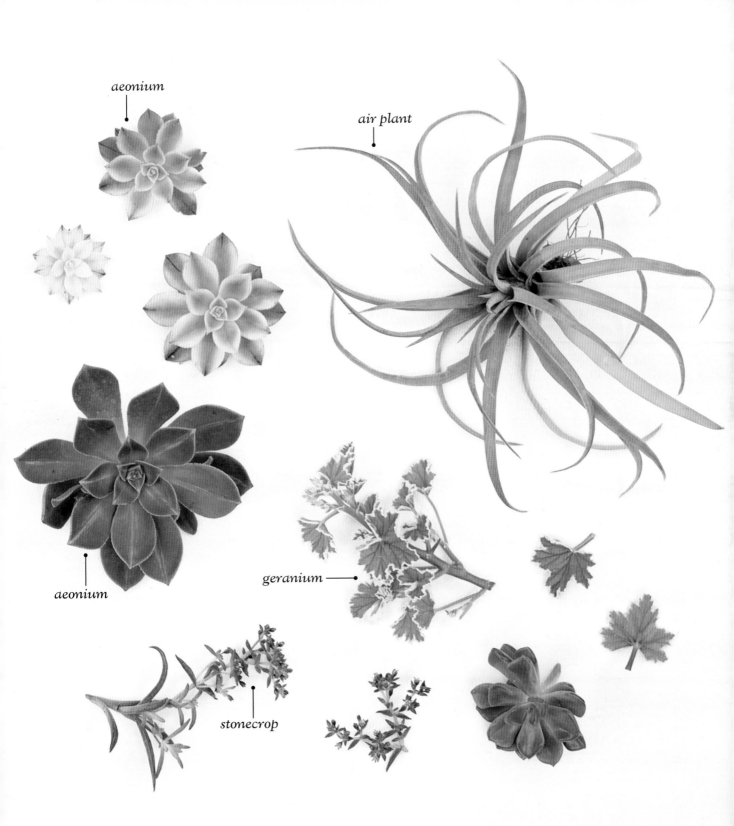

aeonium

air plant

aeonium

geranium

stonecrop

RECIPE 3:
SPECIAL OCCASION

PLANTS

Two 1-gallon echeverias (*Echeveria* 'Goochie')

One 4-inch geranium (*Pelargonium* 'Oldbury Duet')

Two 4-inch wood spurges (*Euphorbia amygdaloides* var. *robbiae*)

Two 4-inch aeoniums (*Aeonium* 'Kiwi')

Two 4-inch stonecrops (*Sedum* 'Cranberry Harvest')

One 6-inch air plant (*Tillandsia velutina*)

CONTAINER

Vintage pedestal bowl about 12 inches in diameter and 4 inches tall

1. Choose a bowl with a pedestal for a formal centerpiece look. Unpot all the plants and remove any extra soil from the roots, breaking up the aeonium rosettes and the stonecrops.

2. Begin by placing the echeverias, one left of center and the other just behind it and in the center, as focal points. Tip the plants toward the front of the bowl.

3. Place the geranium on the right edge of the bowl behind the echeverias, and work across the back of the vase with the wood spurges.

4. Plant the aeonium rosettes and the stonecrops in clusters, leaving a space to the left of the echeveria at the front. Finally, gently place the air plant in that space, resting it on the leaves of the surrounding plants. Drape and fluff all the plants, making sure that the echeverias and stonecrop blooms peek out of the arrangement.

5. This is a temporary arrangement; disassemble after a couple of weeks and replant—the plants will thrive on their own.

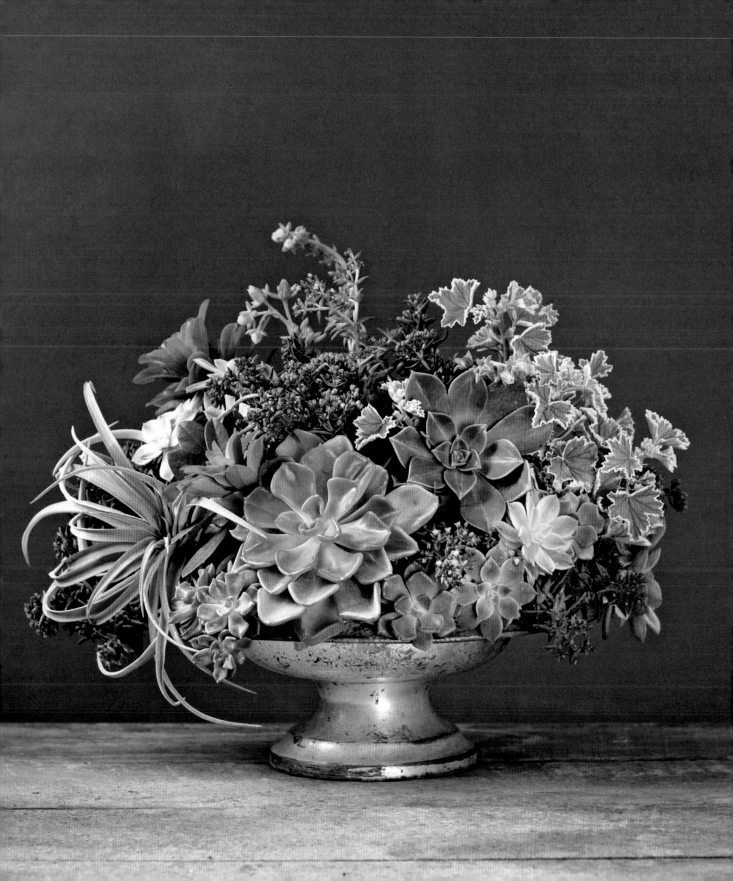

EUONYMUS

PLANT TYPE: shrub

SOIL: potting mix

WATER: keep just moist; let dry between waterings

LIGHT: low to bright

This is an easy-breezy simple plant. Euonymus may not have much flair about it, but it's steady as she goes and reliable. Add splashes of temporary color or topiary for some interest.

PLANTS

One 6-inch and one 4-inch variegated dwarf euonymus (*Euonymus japonicus* 'Microphyllus Albovariegatus')

One 6-inch miniature rose (*Rosa*)

One 4-inch fernleaf lavender (*Lavandula multifida*)

CONTAINER AND MATERIALS

Carved stone pot 10 inches by 7 inches and 5 inches tall

1-inch square of screen

3 cups of potting mix

1. Choose a classic formal garden pot for this arrangement. Place the screen over the drainage hole and add potting mix until the pot is two-thirds full.

2. Create a small mound of potting mix in the center. Unpot the larger euonymus and place it on top of the mound. This will create more height.

3. Unpot the garden rose and plant it in the front and to the left, tilting it slightly so that the blooms drape over the edge of the container.

4. Unpot and plant the smaller euonymus in the front and to the right of the mounded area, and slightly angle it to the right. Finally, unpot and snugly plant the lavender in the small opening in the front center of the arrangement. As the roses fade, the euonymus foliage will live on. Let the water drain thoroughly after watering.

EUONYMUS
RECIPE 2:
ON ITS OWN

PLANTS
One 4-inch and one 6-inch dwarf evergreen euonymus topiaries (*Euonymus japonica* 'Microphyllus')

CONTAINERS AND MATERIALS
2 vintage wood vessels with openings 3 to 6 inches in diameter

Aluminum foil

3 clumps of cushion moss

Find elongated wood vessels that mimic the height of the plants. Line them with foil to protect the wood from the moisture. As an extra protective measure, unpot the plants and wrap their roots in foil.

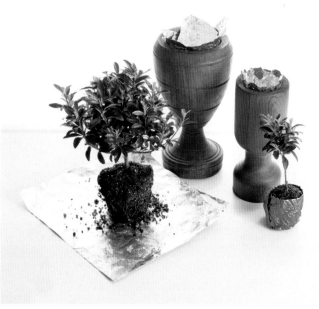

2 Place the plants in the vessels and cover the soil with cushion moss.

3 Prune the straggly branches into the shape of a ball. Water the arrangement about once a week, letting it dry thoroughly in between. It will last about 6 months.

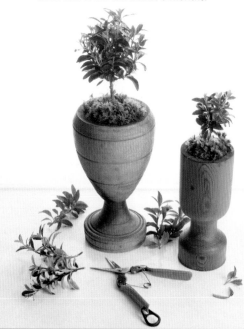

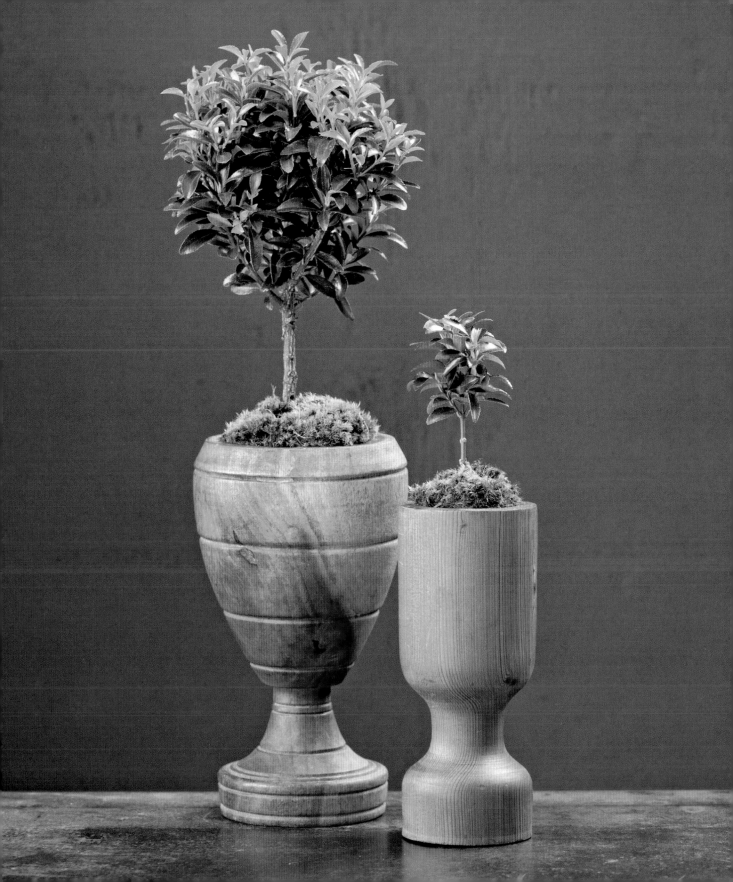

EUPHORBIA

PLANT TYPE: succulent

SOIL: cactus mix (for the varieties listed here)

WATER: allow the surface soil to dry between waterings; keep dry/light in winter

LIGHT: bright direct

Euphorbia is one of the largest and most diverse genera around; it includes poinsettias as well as the red pencil tree, a cultivar called 'Sticks on Fire', used here. Their sap can sometimes irritate skin, so be careful if the milky white goo squeezes out when you cut the stem. Crown of thorns has tiny leaves and sharp thorns but will bloom for months with little care.

PLANT
One 4-inch red pencil tree
(*Euphorbia tirucalli* 'Sticks on Fire')

CONTAINER AND MATERIALS
Ceramic vase, 3½ inches in diameter
and 9 inches tall

¼ cup of small lava rock

⅛ cup of decorative gravel

1. Pour the small lava rock into the vase.

2. Unpot the red pencil tree and loosen the roots gently to remove extra soil so that it will fit into the vase.

3. Plant so that it is stable and upright with the crown of the plant level with the rim of the vase. Add the decorative gravel.

4. Keep the plant dry and give it all the light you can. The more sun the sticks get, the more red they become. In the shade, they turn green.

PLANTS
One 2-inch crown of thorns (*Euphorbia milii*)

One 2-inch succulent
(*Crassula* 'Spring Time')

One 2-inch rat's tail cactus (*Aporocactus*)

CONTAINER AND MATERIALS
Ceramic pot, 4 inches in diameter
and 3 inches tall

¼ cup of small lava rock

½ cup of cactus mix

⅛ cup of decorative gravel

Pour in the lava rock to make the first layer. Fill the container two-thirds full with cactus mix.

2 Unpot the crown of thorns and carefully place it in the center back of the pot. Use paper to protect your fingers from the thorns if needed. Then unpot and plant the succulent at the center front.

3 Add the rat's tail cactus in the back to the left of the crown of thorns. Play with its long, prickly legs so that they "dance" and visually balance the crown of thorns. Cover the soil with the decorative gravel for a polished look. Water the arrangement about once a week, tipping the pot gently to make sure no water stands at the bottom. Enjoy for months on end.

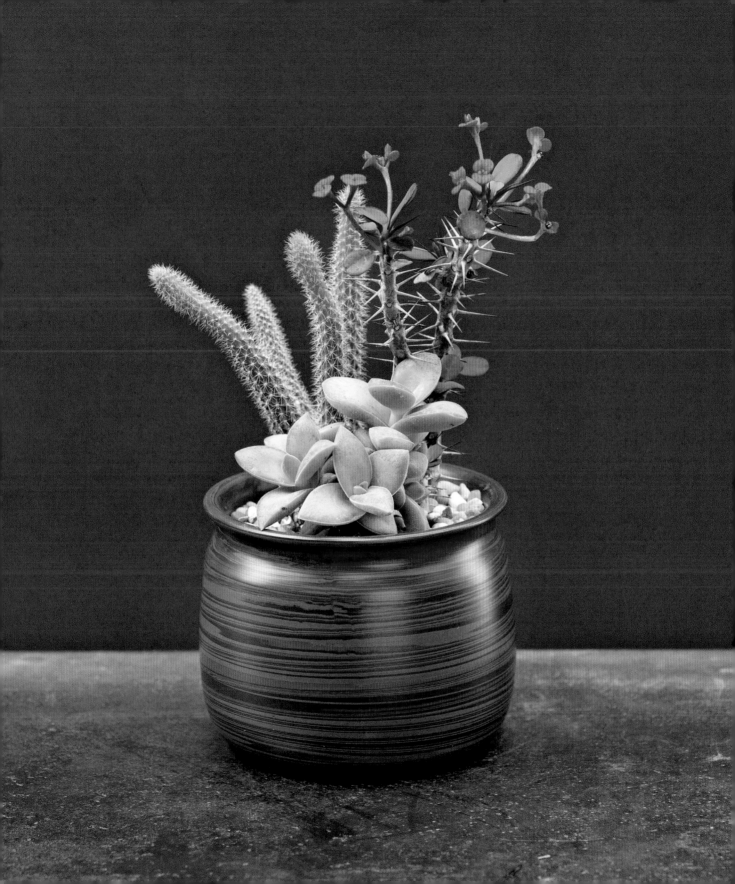

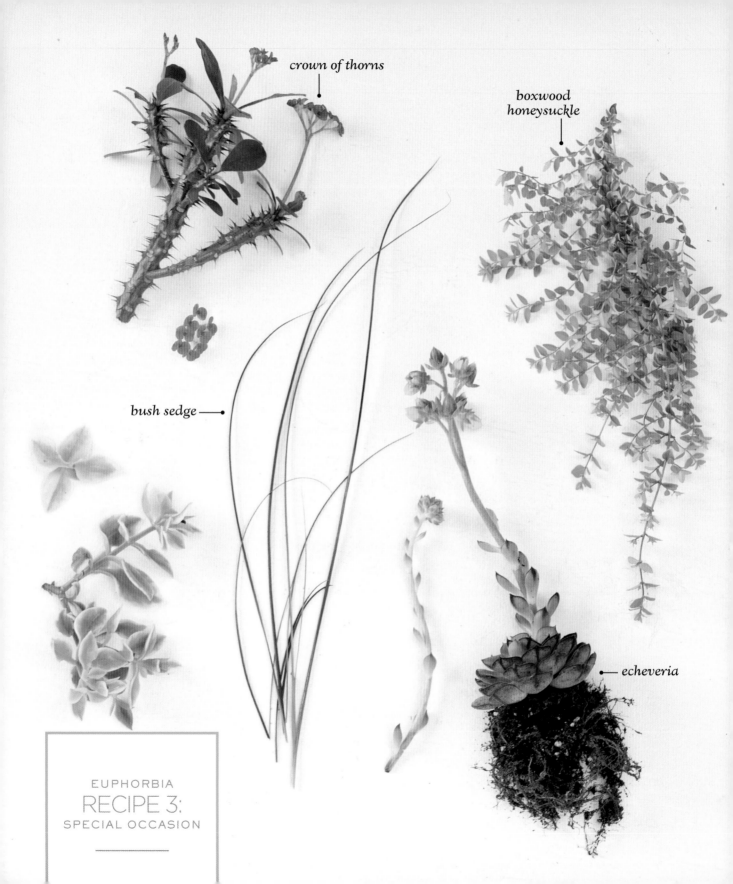

crown of thorns

boxwood
honeysuckle

bush sedge

echeveria

EUPHORBIA
RECIPE 3:
SPECIAL OCCASION

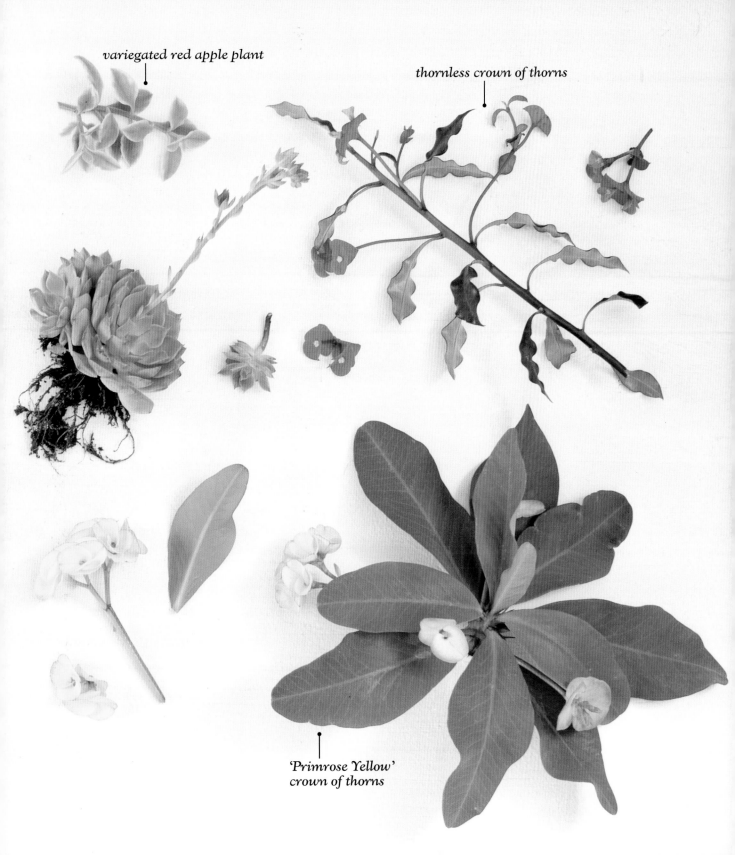

variegated red apple plant

thornless crown of thorns

'Primrose Yellow'
crown of thorns

EUPHORBIA
RECIPE 3:
SPECIAL OCCASION

PLANTS

One 6-inch thornless crown of thorns (*Euphorbia geroldii*)

Two 6-inch crowns of thorns (*Euphorbia* 'Primrose Yellow')
with yellow blooms

One 4-inch crown of thorns (*Euphorbia milii*)

One 4-inch bush sedge (*Carex solandri*)

Two 4-inch boxwood honeysuckles
(*Lonicera* 'Baggesen's Gold')

One 4-inch variegated red apple plant
(*Aptenia cordifolia* var.)

Two 4-inch echeverias, green varieties with blooms
(try *Echeveria* 'Ramillete')

CONTAINER AND MATERIALS

Tin bowl, 10 inches in diameter and 5 inches tall

1 to 3 cups of cactus mix

1 Select various euphorbia plants of different heights and sizes for this jungle-like arrangement. Fill the bowl with a thin layer of cactus mix.

2 Start in the center and add the taller plants, the crowns of thorns. Place the large-leafed focal euphorbia in the front. Move to the front and plant the third and smallest euphorbia.

3 Taking care to avoid the two thorny euphorbia, plant the softer plants. Start tall again with the sedge and boxwood. Plant them at an angle so that they balance each other out and create flow in the arrangement.

4 Weave the chartreuse boxwood stems into the euphorbia stems.

5 Fill in the bottom layer with the softer variegated red apple plant and echeverias.

6 Keep the arrangement in bright light and water once a week, making sure there is no standing water in the bottom of the bowl. This arrangement will grow and change— trim and/or prune as needed.

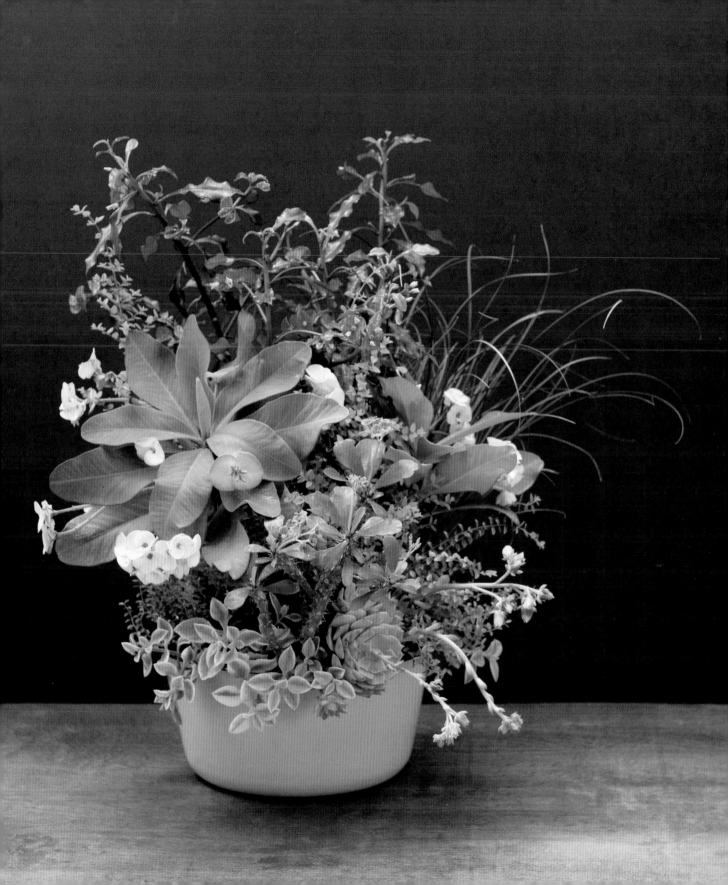

FICUS

PLANT TYPE: tree/shrub and vine

SOIL: varies

WATER: keep moist; allow the surface soil to dry between waterings

LIGHT: low to bright, but only indirect

Ficus is also referred to as fig, but the two varieties shown here aren't edible. Mistletoe fig has itty-bitty fruits, but these precious treasures are not guaranteed to be edible either. Just enjoy them as they turn from green to yellow before they drop. The creeping fig will dance along with little care, crawling and stretching horizontally across the table on which it sits.

PLANT
One 4-inch mistletoe fig
(*Ficus deltoidea*)

CONTAINER AND MATERIALS
Rustic round stone planter,
4 inches in diameter

A clump of cushion moss

1. Look for a container with a bit of texture and a round shape that mimics the shape of the ficus leaves.

2. Choose a plant with several limbs and a few berries. Even though they're not edible, they change colors and look like tiny figs.

3. Set the grow pot inside the stone planter, keeping the crown flush with the rim.

4. For a polished look, cover the soil with a bit of moss. Water this arrangement lightly; it will last a long time with little care.

PLANTS

One 4-inch creeping fig (*Ficus repens*)

Two 4-inch sansevierias
(*Sansevieria hahnii* 'Golden' and
S. 'Black Star' are nice choices)

One 2-inch Christmas cactus
(*Schlumbergera* 'Christmas Fantasy'
has peachy orange blooms)

One 2-inch flaming Katy
(*Kalanchoe blossfeldiana*)

CONTAINER AND MATERIALS

Straw basket, 6 inches in diameter

Cellophane

Plastic liner, 6 inches in diameter

1 cup of cactus mix

Line the basket with cellophane and insert the plastic liner. Adding cactus mix as needed, unpot the creeping fig and plant it in the front of the basket, letting the vines drape over the edge.

2 Add the first architectural element, planting one of the sansevierias in the back, tilting it a bit to the right. Add the second sansevieria in the back of the arrangement. Tip it to the right also so that the two plants fit together as if they were one.

3 Tuck both the Christmas cactus and the flaming Katy into the center and left of center to add a pop of color. This is a long-lasting arrangement; water sparingly.

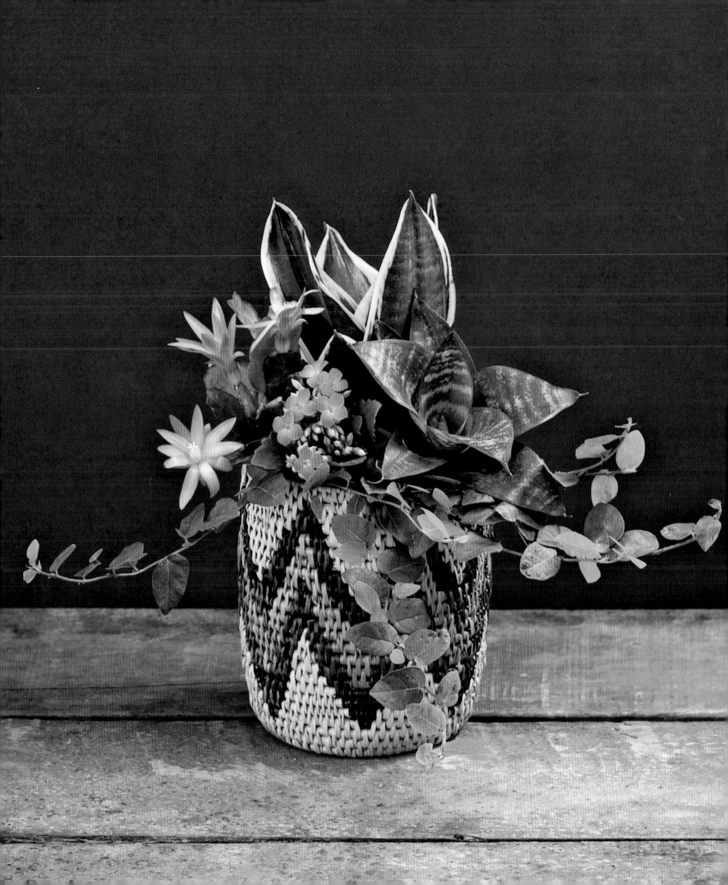

HELLEBORE

(*Helleborus*)

PLANT TYPE: perennial

SOIL: potting mix

WATER: keep just moist

LIGHT: low to bright indirect

This early bloomer is also called Lenten rose or Christmas rose. Soft, bobbing flower rosettes dangle above its tough, serrated leaves. There are so many species and hybrids of this plant, but one thing for sure is that they are all lovely! The colors of the blooms range from gorgeous mauve colors to a brighter green. Some have spots and some a double bloom to boot.

HELLEBORE
RECIPE 1:
ON ITS OWN

PLANT
One 6-inch hellebore (*Helleborus*)

CONTAINER AND MATERIALS
Log vase, 7 inches in diameter

Plastic liner that fits snugly
in the vase

Two 2- to 3-inch rounds
of cushion moss

1. Insert the liner into the log vase, and set the plant (still in its pot) into the vessel. If needed, stage the pot (see page 16) to align the crown with the top of the vase.

2. Cover the soil around the exposed pot with the moss. Water once a week or when dry—keep just moist. When the hellebore is done blooming, plant it outside in the garden. The serrated leaves amaze me, especially when the blooms are long gone.

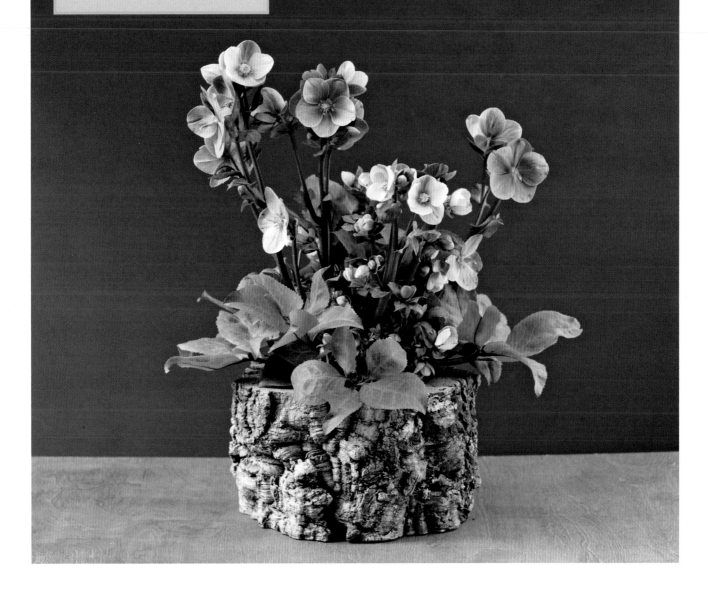

PLANTS

Two 3-gallon aeoniums
(*Aeonium* 'Cyclops' is a nice choice)

One 1-gallon aeonium
(*Aeonium* 'Atropurpureum' and
A. 'Blackbeard' make nice choices)

One 2-gallon Astelia 'Silver Spear'

One 1-gallon hellebore (*Helleborus*)

CONTAINER AND MATERIALS

Aluminum bucket,
17 inches in diameter and 18 inches tall

2 bricks or other sturdy objects for staging

Plastic liner that fits snugly into the bucket

10-gallon plastic pot with drainage holes
(16 inches by 16 inches)

12-quart bag of potting mix

Determine the height of the bucket in relation to the plants. Pick appropriate materials to stage the plants (see page 16), such as bricks, and place them in the bucket. Set the liner on top, and set the bucket aside.

2 Start with the most dramatic of the plants, the aeoniums. Unpot and plant them in the plastic pot, adding potting mix as needed so that the plants are sitting at the correct height. Then add in the draping silver spear.

3 Place the pot in the decorative container, then unpot and plant the hellebore into it for fluff and detail. All these plants can handle shade, and because of the large scale, the arrangement might like it best on a shady deck after spending a few weeks inside. Water when dry.

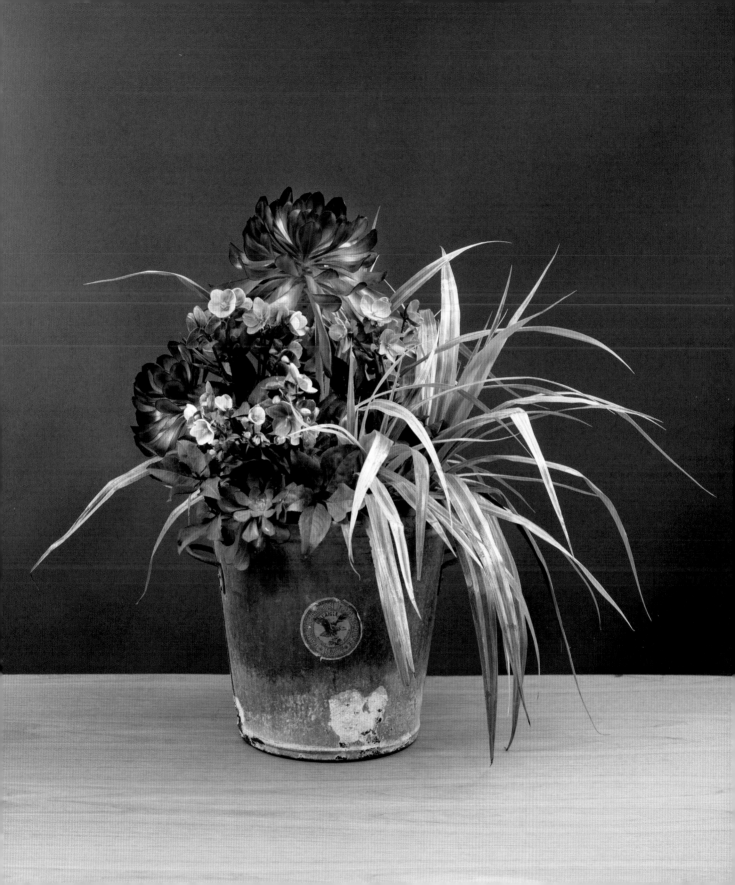

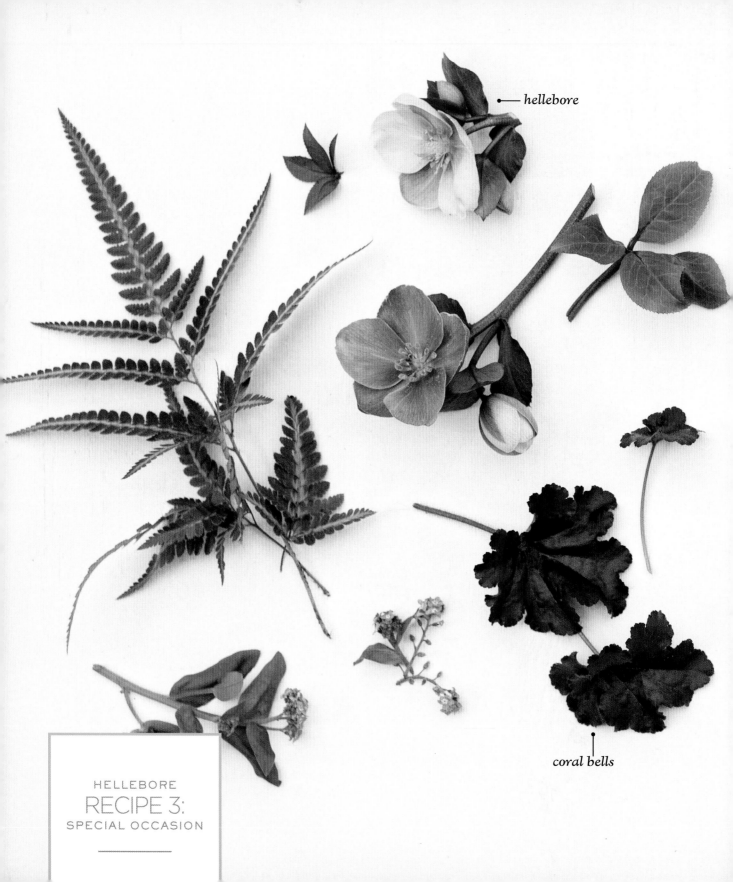

hellebore

coral bells

HELLEBORE
RECIPE 3:
SPECIAL OCCASION

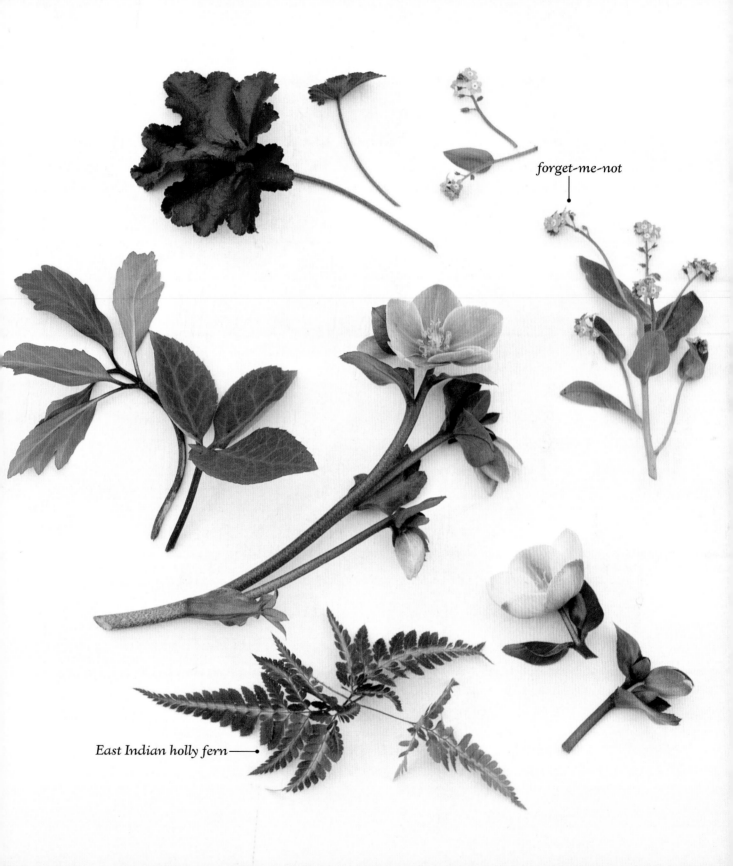

forget-me-not

East Indian holly fern

RECIPE 3:
SPECIAL OCCASION

PLANTS

One 6-inch hellebore (*Helleborus*)

One 4-inch coral bells with purple leaves
(*Heuchera* 'Purple Palace' or similar variety is fine)

One 6-inch East Indian holly fern
(*Arachniodes simplicior* 'Variegata')

One 4-inch forget-me-not (*Myosotis palustris*)

CONTAINER AND MATERIALS

Lime-green bowl, 10 inches in diameter

5 to 10 cups of potting mix

1. Choose a vibrant color bowl to offset the yellow in the fern, the dark purples of the coral bell leaves, and the mauve accents in the hellebore.

2. Unpot all the plants and set them aside.

3. Plant the hellebore first, since it may take up a big portion of the bowl. Hellebores sometimes have solid root and soil clumps that keep the shape of the container they were planted in. Shape with a knife (yes, cut it like a loaf of bread) if needed, just around the bottom and edges of the root structure to make room for the other plants.

4. Plant the coral bells at the front and left of center, tilting it at a slight outward angle so that the large, dark leaves drape over the edge of the bowl.

5. Repeat the planting method with the fern, placing it at the front and right of center. Tuck the tiny forget-me-nots into the front center of the bowl.

6. Fluff the ferns up and out and stake any hellebore flower stems that need to be firmly rearranged to face forward. Keep the arrangement moist by watering it once or twice a week. The forget-me-nots will fade first—after the hellebore blooms fade, disassemble the arrangement and repot the plants separately, indoors or out.

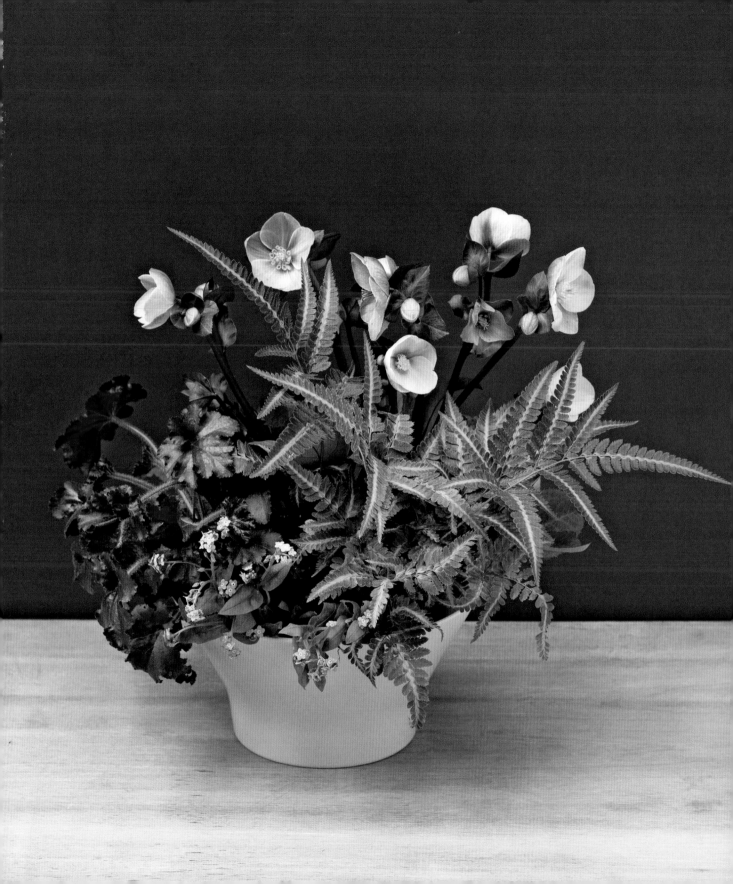

HOYA

PLANT TYPE: creeper or vine

SOIL: potting mix, perhaps with a bit of perlite to make it better-draining

WATER: keep just moist; allow the surface soil to dry between waterings, especially in winter

LIGHT: bright

Known also as wax plant and Hindu rope plant, hoya have draping, trailing, fun-shaped leaves. If you're lucky enough to get one in bloom (root-bound plants are said to bloom better), the flowers are amazingly fragrant, too. It's even possible to train it up a trellis.

RECIPE 1:
ON ITS OWN

PLANTS
Two 4-inch Hindu rope plants
(*Hoya carnosa* 'Crispa Variegata'
and *H. c.* 'Compacta')

CONTAINER AND MATERIALS
Miniature pitcher, with a 3-inch
opening and 5 inches tall

½ cup of potting mix

1. Look for a small vessel with a variety of colors and stripes to mimic the plants' curly and slightly tinted leaves. Fill the pitcher one-half to two-thirds full of potting mix.

2. Thoroughly water then unpot both plants. The roots will likely easily separate. Use only two or three stems of each variety and replant them. Plant the longest stem above the spout for a bit of whimsy.

3. Place the extra stems back in their original containers.

4. Pull the cool, curly leaves down over the rim of the vase so everyone can admire their curlicues. Water so it's just moist.

PLANTS

One 4-inch crown of thorns (*Euphorbia milii*)

One 4-inch Hindu rope plant
(*Hoya carnosa* 'Compacta')

One 4-inch stonecrop (*Sedum* 'Cape Blanco')

CONTAINER AND MATERIALS

Handmade clay pot 5 inches in diameter
and 2 inches tall

1-inch square of screen

Potting mix

Choose a low pot with vertical lines and natural colors to mimic the upright crown of thorns and the rolling shape of the Hindu rope plant. Add the screen to cover the drainage hole. Add a shallow layer of soil, if necessary. Unpot the crown of thorns and place it in the back along the tallest wall of the pot.

2 Unpot the Hindu rope plant and place it in front and to the left, opposite the crown of thorns, keeping its leaves upright to balance those of the other plant.

3 Unpot the stonecrop and slip it into the front and to the right, filling the space between the other two plants. Let it drape over the lowest rim of the pot. Water lightly and drain in the sink, letting the arrangement dry thoroughly between waterings.

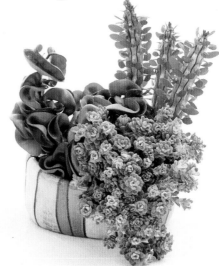

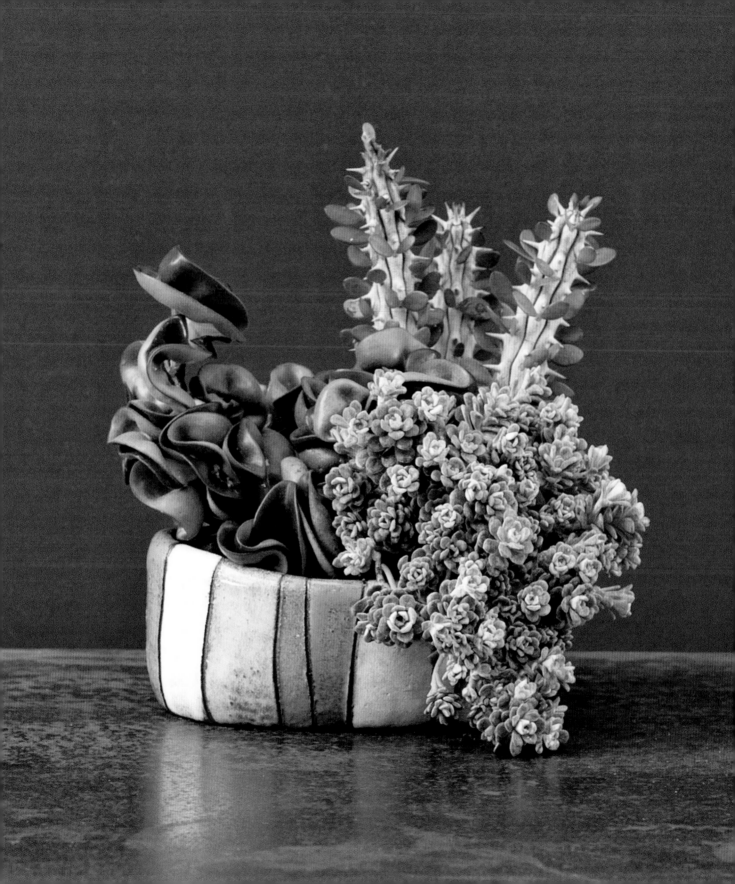

HYACINTH
(*Hyacinthus orientalis*)

PLANT TYPE: bulb

SOIL: rocks, water, or well-draining soil

WATER: keep just moist

LIGHT: bright

Fragrance and a pop of color—wow! Hyacinths will even grow in plain water. Its flowers will last about two weeks. Whether you get them as bulbs and watch them grow or buy them when already full of small, tight blooms, keep them cool so they will last as long as possible.

RECIPE 1:
WITH COMPANY

PLANTS

Seven 4-inch hyacinths:
3 *Hyacinthus orientalis* and
4 grape hyacinths (*Muscari*)

Two 4-inch tulips (*Tulipa*)

Two 4-inch rosy maidenhair ferns
(*Adiantum hispidulum*)

One 6-inch fern
(*Polystichum* is easy to find)

CONTAINER AND MATERIALS

Ceramic serving bowl,
8 inches in diameter

5 cups of potting mix

One 6-inch square of sheet moss

1. Add enough potting mix to the bowl to allow for the plants' crowns to sit level with the rim of the bowl.

2. Unpot all the plants.

3. Begin with the hyacinths in the center. Mound the potting mix below them, if necessary, to give them a bit more height. Plant the tulips to the right of the hyacinths so that they lean slightly over the edge of the bowl, creating a sense of movement.

4. Plant the ferns and grape hyacinth in the front and left of the bowl, filling in the spaces. This will add fluff and texture. Water evenly until moist. After the blooms fade, repot and keep the ferns.

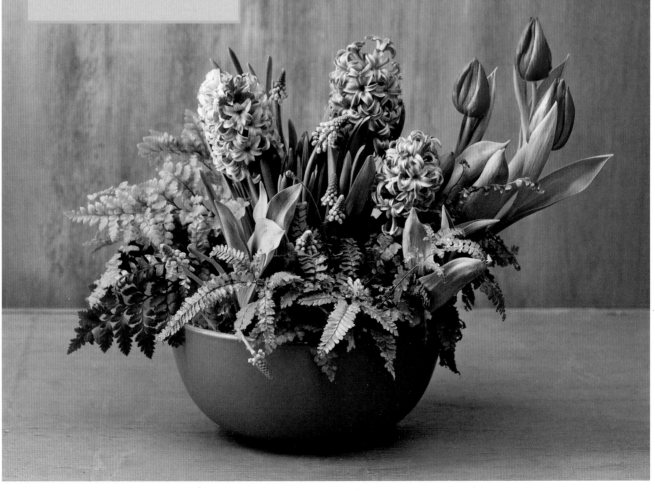

PLANTS

10 hyacinth (*Hyacinthus orientalis*) bulbs with stems and bloom starts or blooms

CONTAINERS AND MATERIALS

4 colorful shallow bowls in various sizes

One 12-inch square of sheet moss

1 Arrange the bowls and bulbs from small to large. Unpot and plant the smallest bulbs in the smallest bowls; or, for more pizzazz, choose the lightest-colored flowers to go in the smallest bowls to create the effect of a gradient.

2 Continue with the rest of the bowls, planting the largest (or darkest) bulbs into the largest bowl. Cover the soil with the sheet moss.

3 Arrange the bowls in a pleasing manner. Add water to keep the hyacinths moist, and keep cool for a long-lasting arrangement.

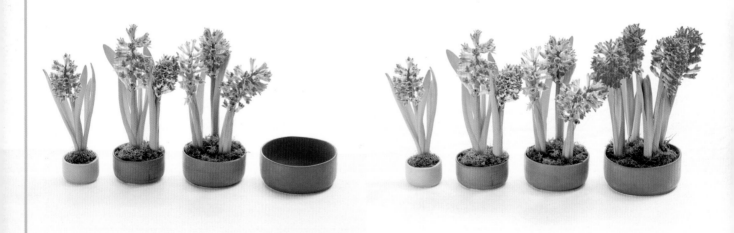

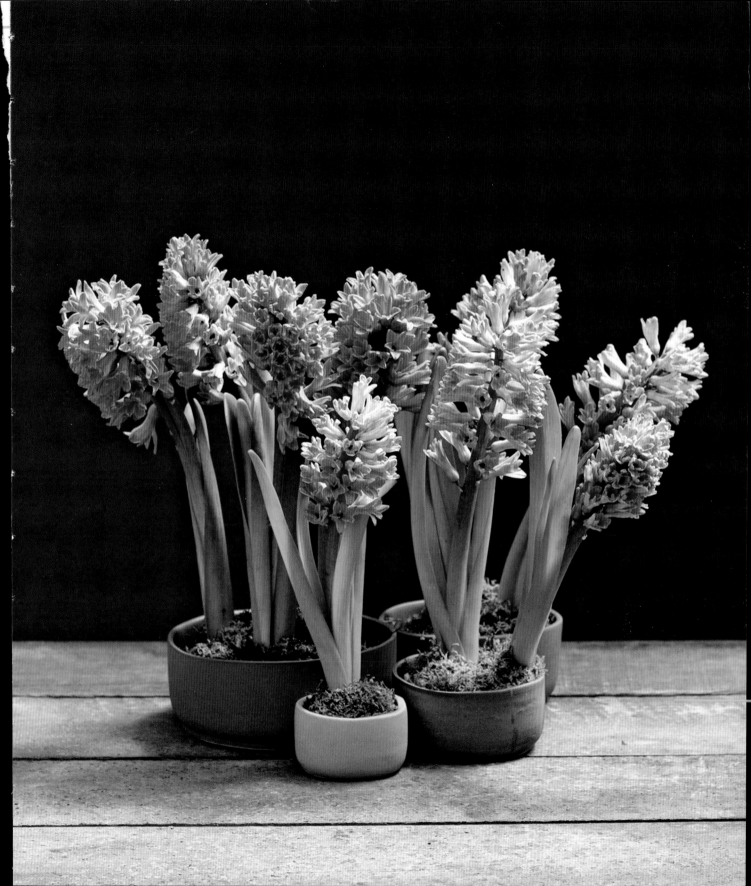

HYDRANGEA

PLANT TYPE: flowering shrub
SOIL: potting mix
WATER: keep moist
LIGHT: bright indirect

The lace cap flowers of a hydrangea are perfect for a blast of color. After the blooms fade, plant it in the ground outside, and it will likely flower again for you. These plants love water and will droop if they get too thirsty. If that happens, dunk the whole plant in water, let it soak, then drain, and cross your fingers for revival.

PLANTS
Three 6-inch hydrangeas
(*Hydrangea macrophylla*)

CONTAINER AND MATERIALS
Patterned fabric tote, 12 inches
in diameter

Cellophane or a plastic bag

Plastic liner, 12 inches in diameter

1. Line the bottom of the bag with the cellophane. Then, as added protection, set a plastic liner into the tote bag.

2. Keep the plants in their grow pots. Remove any supports, sticks, or strings that are holding up the stems.

3. Place each plant inside the bag, slightly angling them to form a round shape.

4. Because this container is staged and this plant loves water, take care to water each plant separately and thoroughly.

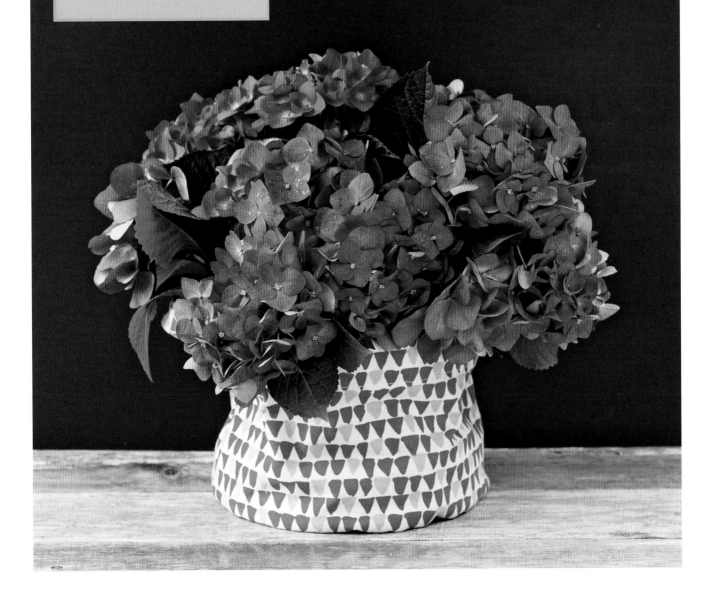

HYDRANGEA
RECIPE 2:
WITH COMPANY

PLANTS

One 6-inch hydrangea
(*Hydrangea macrophylla*)

One 6-inch star-of-Bethlehem
(*Ornithogalum* 'Bethlehem')

One 6-inch clematis (*Clematis*)

CONTAINER AND MATERIALS

Wood vase, 11 inches in diameter
and 13 inches tall

Cellophane

Water-tolerant stuffing, such as Bubble Wrap

Set the hydrangea next to the vase to determine how much support will be needed to make the plant's crown level with the rim of the vase. Line the vase with cellophane and add the Bubble Wrap. Unwrap any decorative foil from the grow pots and remove any strings or plant supports, but keep the plants in their original containers.

2 Set the hydrangea in front and slightly to the right of center. Tilt it toward the front of the vase so that the leaves and blooms drape over the rim.

3 Add the star-of-Bethlehem in the back. Finally, place the clematis on the front left rim and gently drape its vines down the side of the vase. Keep each plant moist, and plant outside once the blooms have faded.

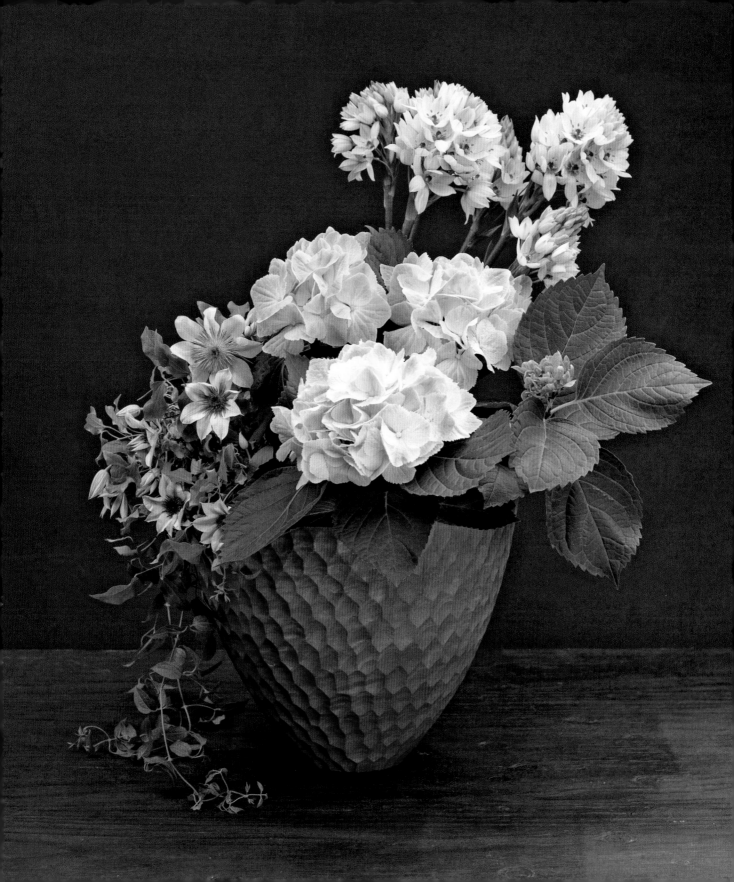

IVY *(Hedera)*

PLANT TYPE: vine

SOIL: any

WATER: keep just moist; allow the surface soil to dry between waterings

LIGHT: low to bright indirect

Ivy, with its dripping, crawling, reaching leaves, is a great plant for arrangements. You see it everywhere. It adds movement, and it sticks around long after many plants fade away. Try an ivy with a red stem or variegated yellow leaves, or even a miniature-leafed form (as seen in Recipe 1), for something new.

RECIPE 1:
ON ITS OWN

PLANT
One 4-inch bonsai ivy
(*Hedera helix* 'Duck Foot')

CONTAINER AND MATERIALS
Small white porcelain bowl about
3½ inches wide

⅛ cup of potting mix, if needed

Small bit of cushion moss or
sheet moss (a 1-inch piece will do)

¼ cup of white sand

1. Choose a shallow bowl that is a tiny bit bigger than the bonsai.

2. Unpot the ivy and place it in the bowl. Fill in with any extra potting mix if needed.

3. Wrap a small amount of moss around the base, then pour the sand around the edge of the plant to create a sense of serenity.

4. Prune the ivy into a shape that looks like it's blowing to one side. Water lightly with a tablespoon, taking care not to allow water to pool at the bottom of the bowl. Prune to maintain its shape.

RECIPE 2:
WITH COMPANY

PLANTS

Two 4-inch English ivies (*Hedera helix*)

One 2-inch New Zealand hair sedge
(*Carex* 'Frosted Curls')

One 4-inch thyme-leafed fuchsia
(*Fuchsia thymifolia*)

One 4-inch lewisia (*Lewisia cotyledon*)

Three 4-inch red stars
(*Rhodohypoxis* 'Pintado')

CONTAINER AND MATERIALS

Refurbished vintage wood gutter

1 cup of potting mix

Pour a small amount of potting mix into the container. Unpot and split the ivy plants into sections and plant them along the length of the container to create a repetitive linear design. Unpot and plant the upright New Zealand hair sedge toward the right of the container, between two sections of ivy.

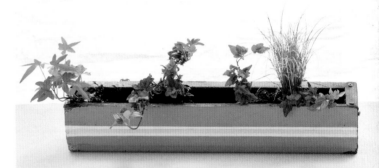

2 Unpot and plant the fuchsia to the left of center, between two sections of ivy, allowing its leaves to drape over the front edge.

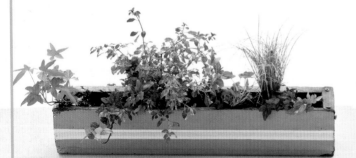

3 Fill in the remaining spaces with the blooming lewisia and red stars. Water until moist, about once or twice a week, and keep in bright light.

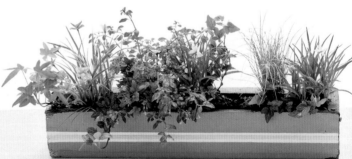

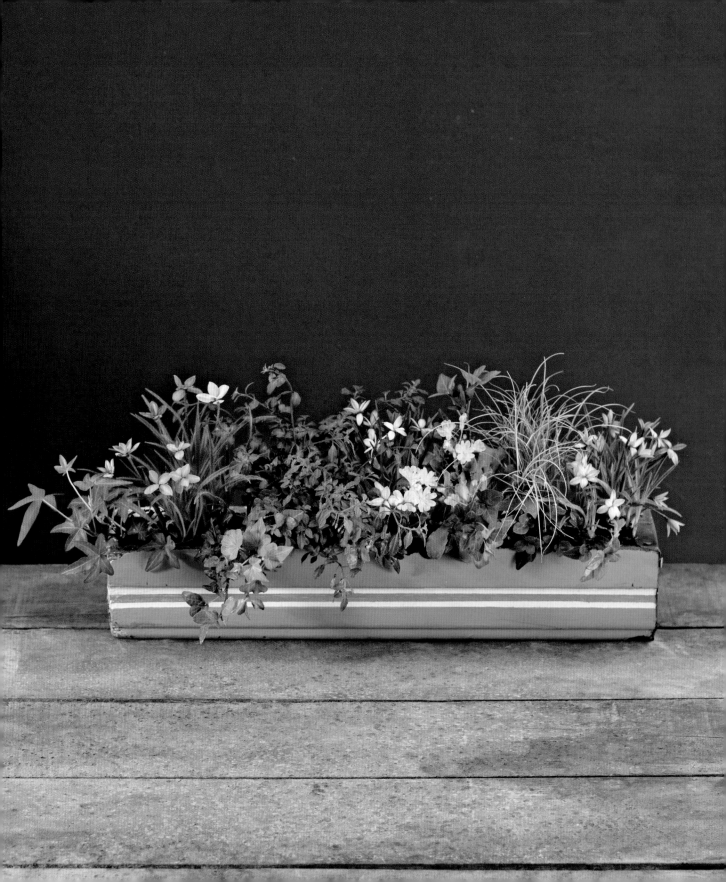

KALANCHOE

PLANT TYPE: succulent

SOIL: cactus mix

WATER: allow the surface soil to dry between waterings

LIGHT: bright direct or low, depending on the plant

The kalanchoe variety known as the panda plant—shown here—does just fine inside. And how can anyone resist those fuzzy leaves? It doesn't just look cool, it holds moisture so well that you won't need to water it very often. Then there's the dramatic velvet elephant ear, so called for its large, undulating leaves. Even the more typical *Kalanchoe blossfeldiana*, known as flaming Katy (see Ficus Recipe 2 and Nerve Plant Recipe 2), has bright, bold flowers and glossy leaves.

PLANTS

One 6-inch panda plant
(*Kalanchoe tomentosa*)

One 4-inch eyelash begonia
(*Begonia bowerea* var. *nigramarga*
is easy to find)

Two 3-inch air plants (*Tillandsia
velutina* is a good choice)

CONTAINER AND MATERIALS

Vintage pedestal bowl, about
12 inches in diameter and 4 inches tall

One 6-inch square of sheet moss

1. Select a container that complements the golden hue of the plants.

2. Unpot the panda plant and the begonia. Begin planting with the tallest plant, the panda plant, placing it in the back and to the left of center.

3. Gently place the begonia in the back and right of center so that its leaves drape over the edge of the bowl. Fill in around both plants with the moss.

4. Place both air plants in the front and center.

5. Each week, remove the air plants, soak, shake, and place back in the arrangement. Once a week, lightly water the entire arrangement, letting it dry thoroughly between waterings and making sure water doesn't pool at the bottom. Enjoy for many, many months.

PLANTS

One 2-inch panda plant
(*Kalanchoe* 'Chocolate')

Two 4-inch kalanchoes: 1 panda plant
(*Kalanchoe tomentosa*) and
1 *K. beharensis* 'Fang'

CONTAINERS AND MATERIALS

3 vases made from copper pipe, 1 to 3 inches
in diameter and 2 to 3½ inches tall

1 cup of small lava rock

3 cups of cactus mix

1 cup of decorative gravel

Spread a half-inch layer of lava rock into
each vase. Add the cactus mix until the
vases are about two-thirds full.

2 Match the sizes of the plants to the sizes
of the vases, then unpot and plant the
kalanchoes.

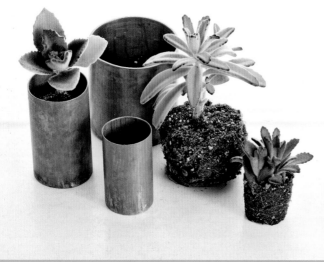

3 Using a funnel or a spoon, cover the soil
with decorative gravel. Water lightly,
letting the arrangement dry thoroughly
between waterings and making sure no
water stands at the bottom. Enjoy for
many months.

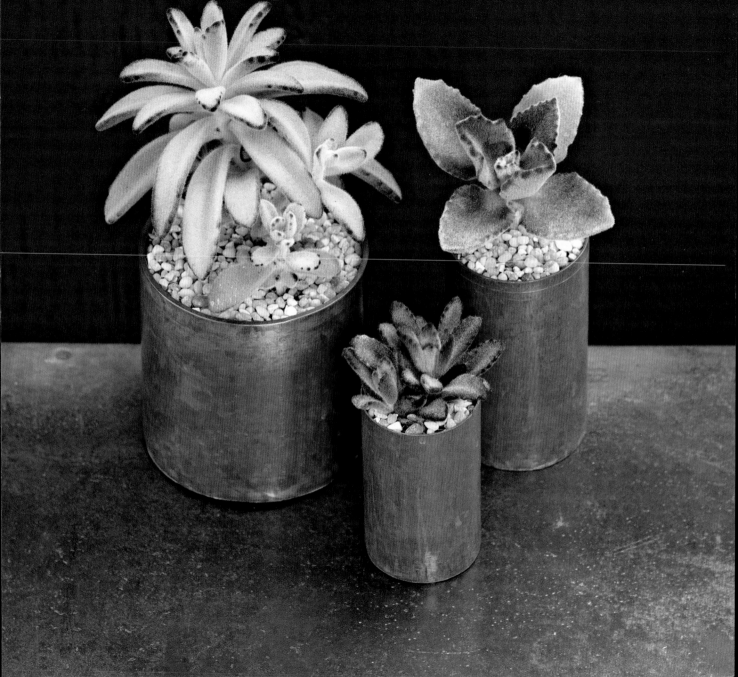

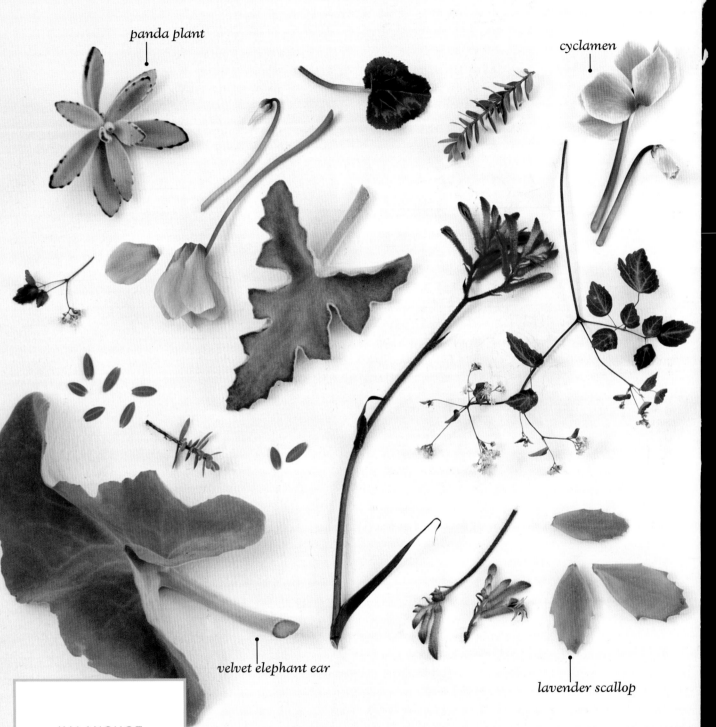

panda plant

cyclamen

velvet elephant ear

lavender scallop

KALANCHOE
RECIPE 3:
SPECIAL OCCASION

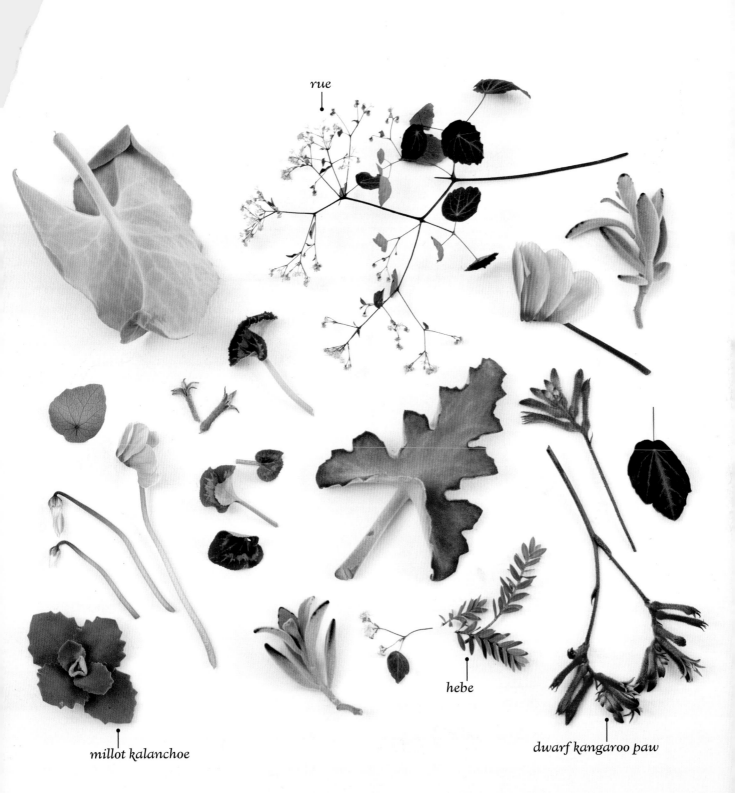

rue

millot kalanchoe

hebe

dwarf kangaroo paw

KALANCHOE
RECIPE 3:
SPECIAL OCCASION

PLANTS

One 6-inch velvet elephant ear (*Kalanchoe beharensis*)

Five 6-inch cyclamens (*Cyclamen persicum*)

Two 6-inch dwarf kangaroo paws (*Anigozanthos*)

One 1-gallon rue (*Thalictrum* 'Evening Star')

Two 4-inch panda plants (*Kalanchoe tomentosa*)

Three 2-inch millot kalanchoes
(*Kalanchoe millotii*)

One 4-inch hebe (*Hebe* 'Red Edge')

Two 2-inch lavender scallops (*Kalanchoe fedtschenkoi*)

CONTAINER AND MATERIALS

Bronze light fixture flipped over, 14 inches square and
7 inches tall

5 cups of lava rock, small or large—this is a very
large arrangement

8-quart bag of cactus mix

1 Spread a layer of lava rock in the container.

2 Add the cactus mix until the container is about
two-thirds full, then add more to the center to
create a mound.

3 Unpot all the plants. Plant the 6-inch velvet
elephant ear in the back, to the right of
center. Make sure it rests at a high point of the
arrangement.

4 Plant the cyclamens next, placing them around
the sides and in front of the elephant ear.

5 Plant the kangaroo paws and rue next, with
the kangaroo paws to the left and the rue
to the right of the elephant ear, and tucked
behind the cyclamens.

6 Fill the front of the container with the panda
plants, the other kalanchoes, and the hebe. Add
in the lavender scallops. Fluff the cyclamens and
the rue blooms to highlight the plants' pinks and
browns. Let dry between waterings about once
a week.

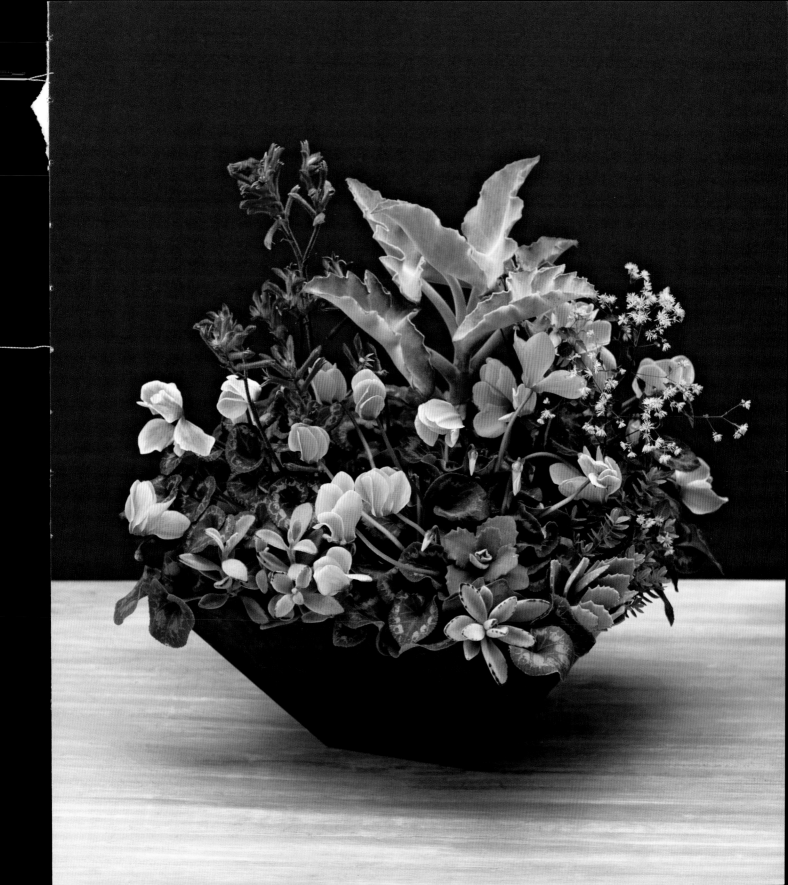

LADY'S SLIPPER

(Paphiopedilum)

PLANT TYPE: orchid

SOIL: orchid mix

WATER: once a week

LIGHT: bright

Some plants have sweet faces, and this is one of them. Some are short and squat while others are long and lean with twisting, dripping ears, but they always have a long jowl that makes me smile. This long-blooming plant is fairly easy to find and easy to grow.

LADY'S SLIPPER
RECIPE 1:
ON ITS OWN

PLANTS

Two 4-inch lady's slippers
(*Paphiopedilum*)

One 4-inch bulldog lady's slipper
(*Paphiopedilum*)

CONTAINER AND MATERIALS

Glass vase with lid, 8 inches
in diameter and 18 inches tall

2 cups of orchid mix

1 cup of potting mix

⅛ cup of charcoal

A handful of sphagnum moss

1. Add the orchid mix, potting mix, and a dash of charcoal to the vase.

2. Unpot all three plants and set them inside the vase, placing the shortest one in the front and the tallest at the back.

3. Cover the soil with a bit of moss. Lady's slippers love terrariums, so feel free to keep the lid on. Water so the arrangement is just moist, making sure water doesn't pool at the bottom of the vase. Snip the blossoms as they fade, and enjoy the arrangement for a couple of months.

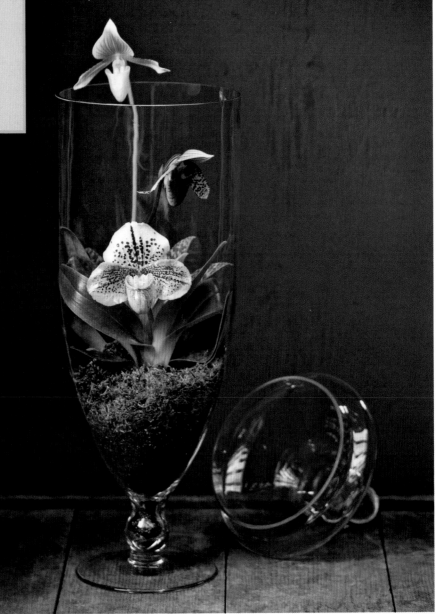

PLANTS
One 6-inch multifloral lady's slipper
(*Paphiopedilum robinianum*)

One 6-inch rex begonia with dark leaves
(*Begonia* 'Helen Teupel' is a nice choice)

CONTAINER AND MATERIALS
Glass box

Block of wood

2 plastic liners

1 cup of decorative gravel

Two 12-inch squares of sheet moss

Choose a box that fits the width of both plants perfectly. Place the wood block in the vase to prop up the plants so that the tops of their grow pots sit 2 inches below the rim. Place gravel in the bottom of the plastic liners and set them on top of the block.

2 Unpot the lady's slipper and plant it in one of the liners.

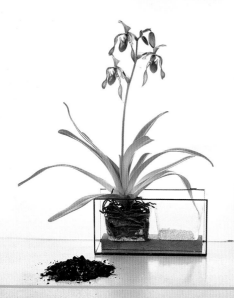

3 Leave the begonia in its pot and place it in the other liner. Then tuck the sheet moss in between the walls of the box and the plants to hide the liners. Thoroughly water the orchid once a week, but do not let the roots sit in water. Water the begonia about twice a week: remove it from the liner, put it in the sink, let water run through it, then return it to the arrangement.

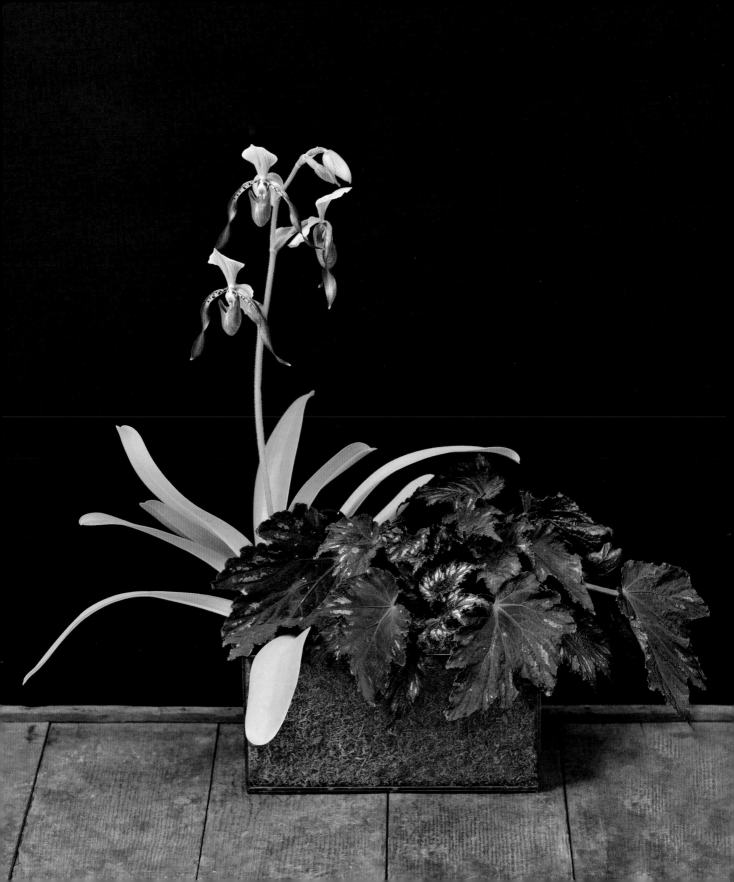

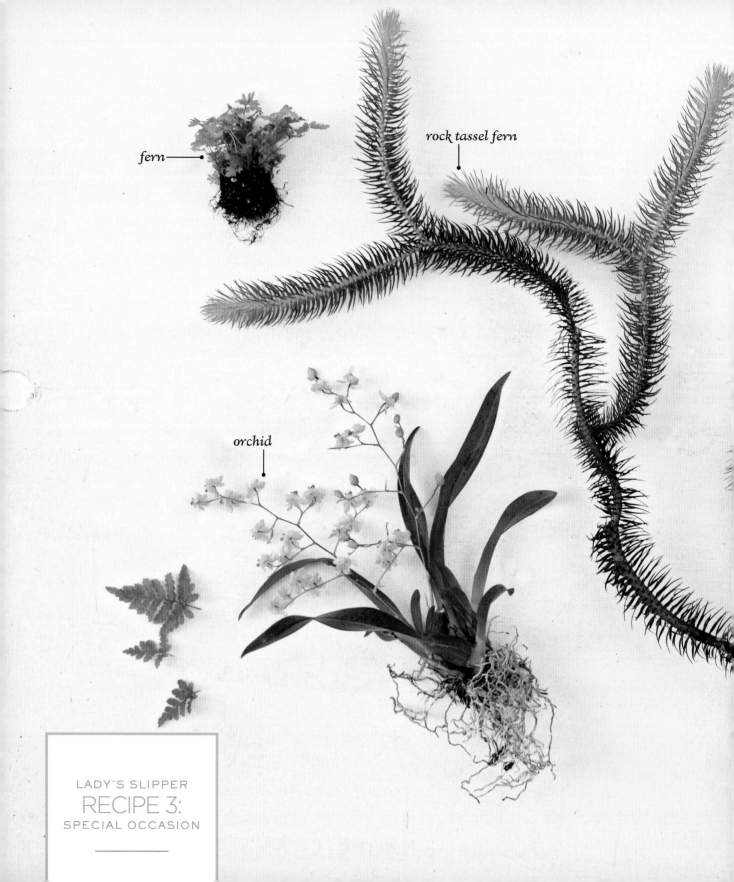

fern

rock tassel fern

orchid

LADY'S SLIPPER
RECIPE 3:
SPECIAL OCCASION

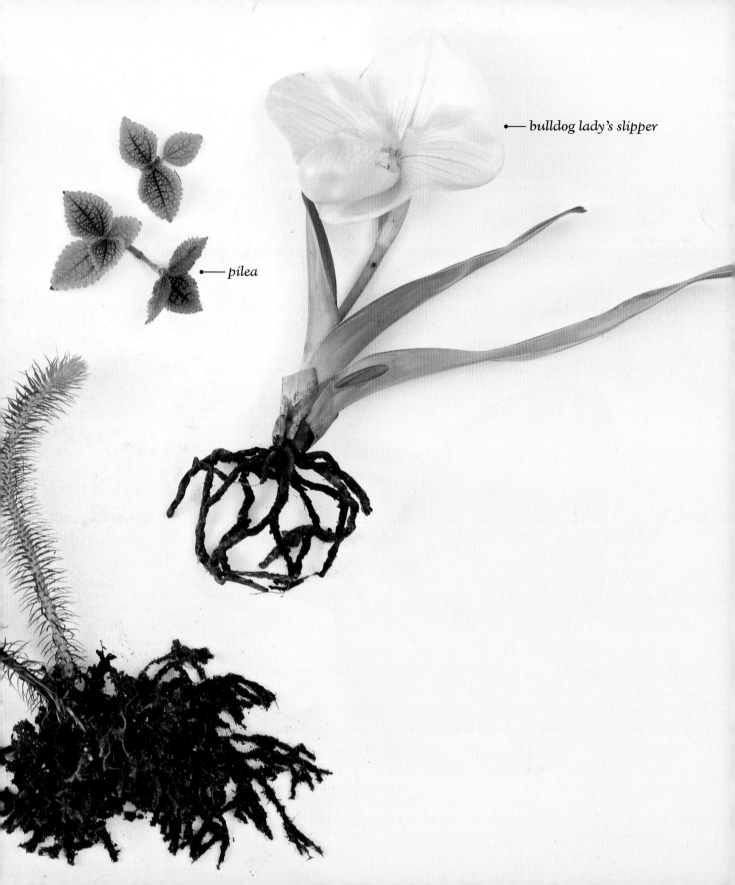

bulldog lady's slipper

pilea

RECIPE 3:

SPECIAL OCCASION

PLANTS

One 4-inch bulldog lady's slipper (*Paphiopedilum*)

One 4-inch rock tassel fern (*Huperzia squarrosa*)

One 4-inch orchid (*Oncidium* 'Twinkle')

Two 4-inch pileas (*Pilea* 'Moon Valley')

Three 2-inch ferns (*Polystichum* is easy to find)

CONTAINER AND MATERIALS

Glass vase, 10 inches in diameter at its widest point
and 24 inches tall

½ cup of charcoal

5 cups of potting mix

1. Add a layer of charcoal and the potting mix to the vase. Allow enough room for all the plants to reside inside the vase. The view will be through the glass.

2. Unpot and set the lady's slipper in the center back, making sure you can see its sweet face through the glass.

3. Unpot and place the rock tassel fern to the left and front of the lady's slipper, allowing the fronds to curve up the sides of the vase to frame the lady's slipper. Unpot and plant the oncidium orchid to the right and in front of the lady's slipper, where it will provide a bit of fluff.

4. Unpot the remaining plants, placing the pilea at the center front of the arrangement, and the ferns to either side. Add a bit of moss to polish it off. Keep it moist by watering about once a week, taking care not to let water settle at the bottom of the vase. Snip the orchid blossoms when they fade, and enjoy the arrangement for many months.

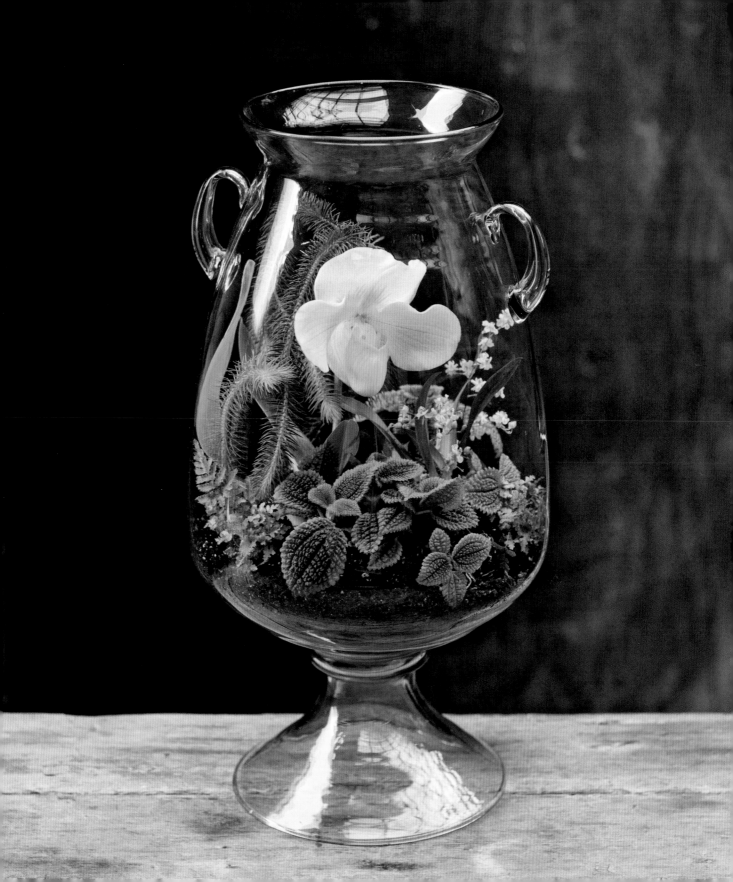

LICHEN

PLANT TYPE: algae and fungus

SOIL: none; it grows on branches

WATER: misting is okay

LIGHT: dependent on the variety

Lichen is a family of epiphytes, containing both algae and fungus. Intrigued? Not only can lichen be found growing on trees, it is often packaged loose and sold commercially in plastic bags or on branches. It's beautiful in container gardens because it attaches itself to branches and rocks, adding an almost iridescent, indestructible element to arrangements.

PLANTS

3 varieties of lichen-covered
branches, 2 to 6 inches each

CONTAINERS

3 small jars

1. Break the branches into smaller pieces and set them into
 the jars, one type per jar.

2. Arrange the jars so that they look like one structure.
 This arrangement will last and last, with no care required.

PLANTS

A few lichen-covered branches

One 4-inch tongue fern (*Pyrrosia sheareri*)

One 4-inch mini moth orchid
(miniature *Phalaenopsis*)

One 2-inch tropical pitcher plant
(*Nepenthes*)

Two 3-inch air plants with a pink tint
(*Tillandsia capita* 'Peach' and
T. velutina are nice)

One 2-inch wispy air plant
(*Tillandsia fuchsii gracillis* or *T. filifolia*)

CONTAINER AND MATERIALS

Shallow earthenware pot, 8 inches
in diameter and 3 inches tall

1-inch square of screen

Glue gun

1 cup of potting mix

1 cup of orchid bark

Set the pot on a table. Cover the drainage hole with the screen. Break apart the lichen-covered branches into 3-inch pieces. Use the branches to build and glue a frame around the pot.

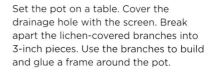

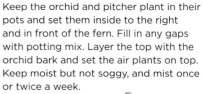

2 Remove the fern from its pot and shake off any excess soil. Set it in the center of the pot.

3 Keep the orchid and pitcher plant in their pots and set them inside to the right and in front of the fern. Fill in any gaps with potting mix. Layer the top with the orchid bark and set the air plants on top. Keep moist but not soggy, and mist once or twice a week.

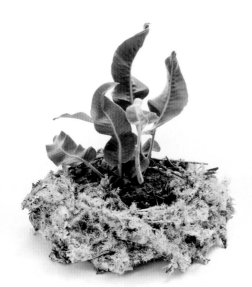

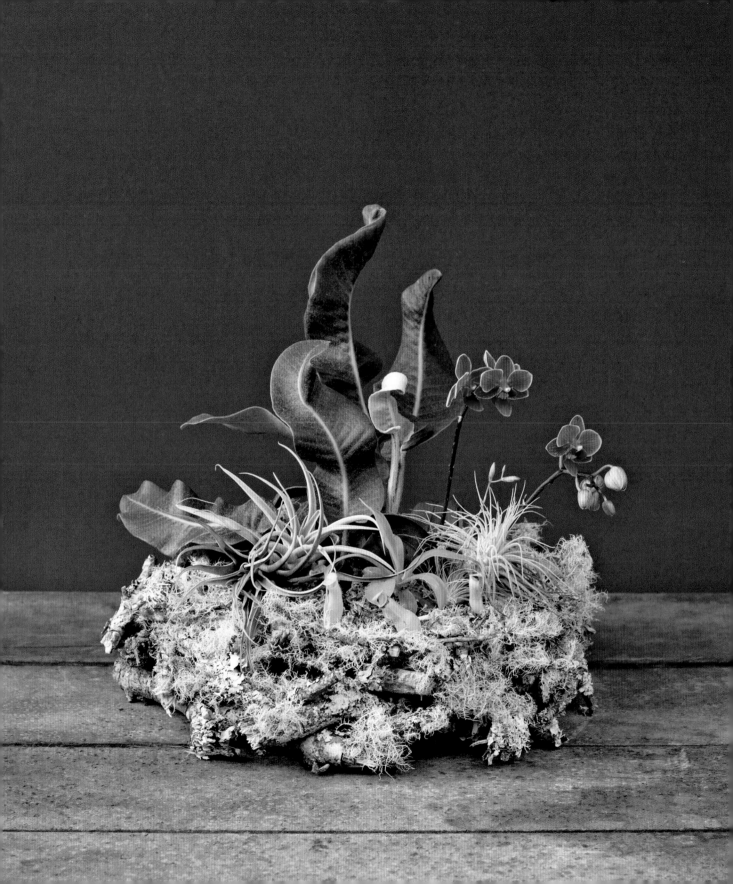

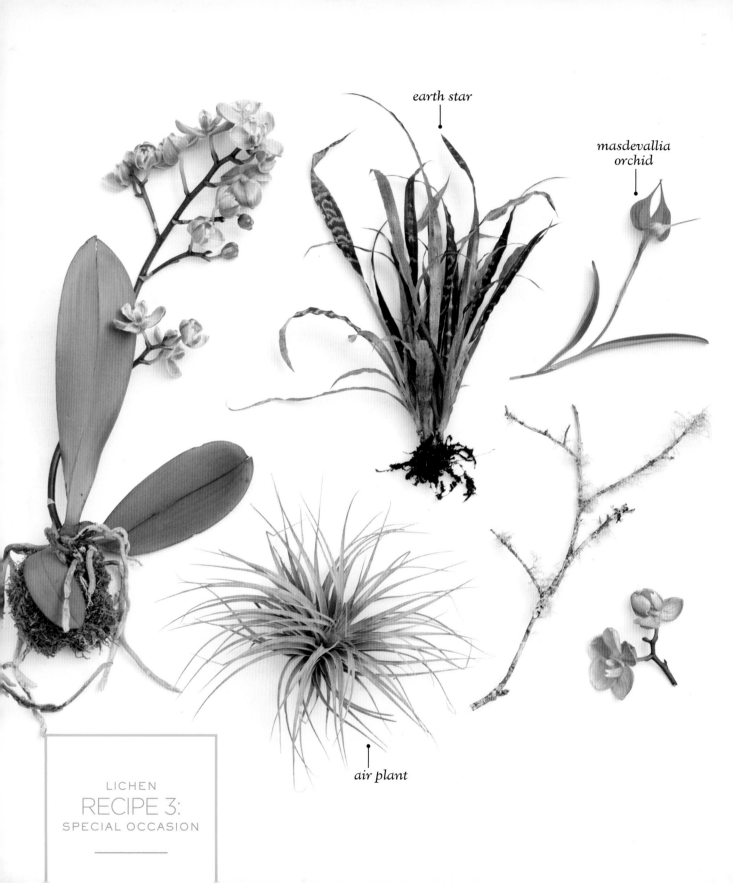

earth star

masdevallia
orchid

air plant

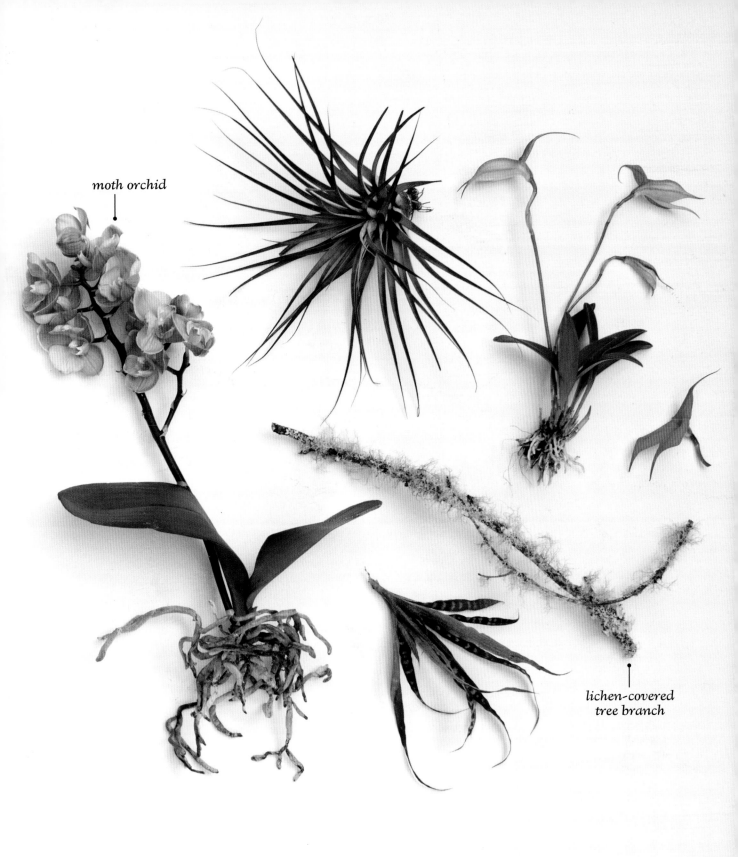

moth orchid

*lichen-covered
tree branch*

RECIPE 3:
SPECIAL OCCASION

PLANTS

One 6-foot lichen-covered tree branch

Two 4-inch moth orchids (*Phalaenopsis*)

Two 4-inch masdevallia orchids (*Masdevallia*)

Two 4-inch earth stars (*Cryptanthus* 'Black Mystic')

Three 8-inch air plants (*Tillandsia oaxaca, T. aeranthos* 'Purple Giant', and *T. stricta* are good choices)

MATERIALS

22 feet of fishing line or florist wire

Six 12-inch squares of sheet moss

1 Lean the branch against a wall. Secure it in a heavy vase, or hang it from the ceiling with a few hooks and fishing line.

2 Unpot and wrap the roots of every plant except the air plant in a moss ball (see page 17).

3 Tuck the plants into the branch's natural niches, securing them, if needed, with fishing line or wire. The orchids will eventually attach themselves to the tree.

4 Spray the arrangement with a water bottle two to three times a week. Put the whole tree in the shower once a week for a full drench, or dismantle the arrangement biweekly to give the plants a good soak.

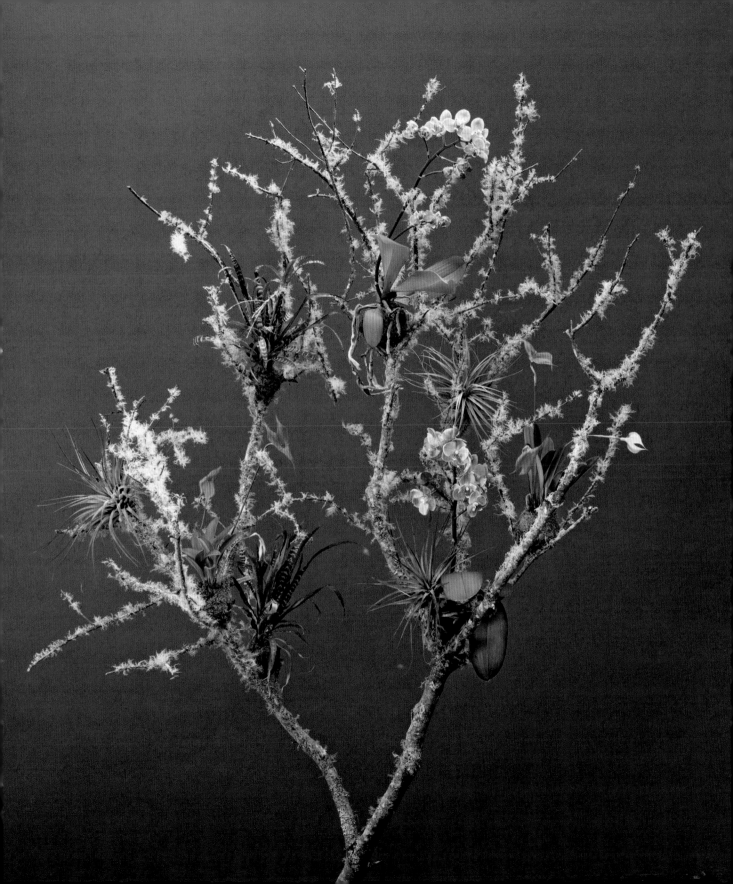

LILY *(Lilium)*

PLANT TYPE: flowering bulb

SOIL: potting mix

WATER: keep moist

LIGHT: bright indirect

Easy to find and lovely to behold, these bold, beautiful flowers look right at you. From stargazers to trumpets, lilies provide a huge pop of color—and some can fill a room with fragrance. Choose a plant with various stages of blooms; just as they begin to open, pluck off the pollen-filled anthers to avoid staining.

LILY
RECIPE 1:
ON ITS OWN

PLANT

One 6-inch double-flowered
oriental lily (*Lilium*)

CONTAINER AND MATERIALS

Fruit bowl, 10 inches in diameter

Cloth napkin

Cellophane

Rubber band

12 inches of kitchen twine

1. Choose a fruit bowl and a fancy patterned cloth napkin to use for the vessel.

2. Keep the lily in its original pot and wrap it loosely in cellophane. Place the rubber band around the pot to keep the cellophane in place.

3. Wrap the fabric over the cellophane and loosely tie the top to cover most of the soil.

4. Set the wrapped pot inside the fruit bowl.

5. Once or twice a week, unwrap the arrangement and set it in the sink to water. Let drain thoroughly, rewrap, and replace.

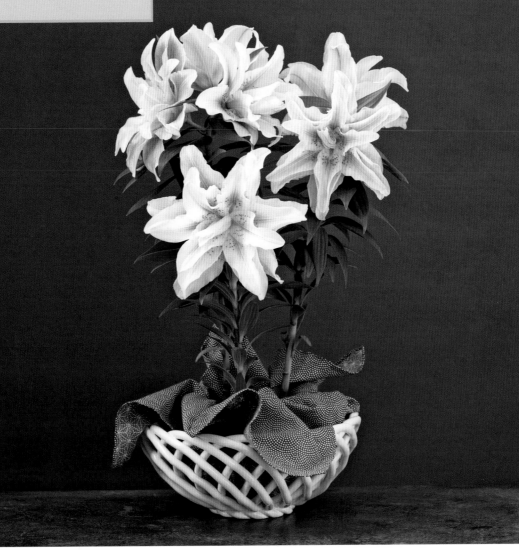

LILY

RECIPE 2:
WITH COMPANY

PLANTS

One 6-inch lily (*Lilium*)

One 6-inch star-of-Bethlehem
(*Ornithogalum dubium*)

Two 4-inch baby rubber plants
(*Peperomia obtusifolia* 'Variegata')

CONTAINER AND MATERIALS

Colorful bowl, 10 inches in diameter
and 6 inches tall

5 cups of potting mix

Set the plants around the bowl to determine how much potting mix you'll need to add so that the crowns of the plants will be flush with the rim of the bowl. Unpot the plants and arrange them so that the tall plants are in the back and the shorter ones are in the front.

2 Add the appropriate level of potting mix and plant the lily.

3 Plant the star-of-Bethlehem and angle it up and over the edge of the bowl in front and to the right of the lily. Place the baby rubber plants to fill in the space in front and to the left, tilting them forward a bit to help them drape over the rim of the bowl. Slightly tug at the leaves of the baby rubber plants to give their compact form a bit of life. Keep the arrangement moist. Replant or compost the lily and star-of-Bethlehem once they fade.

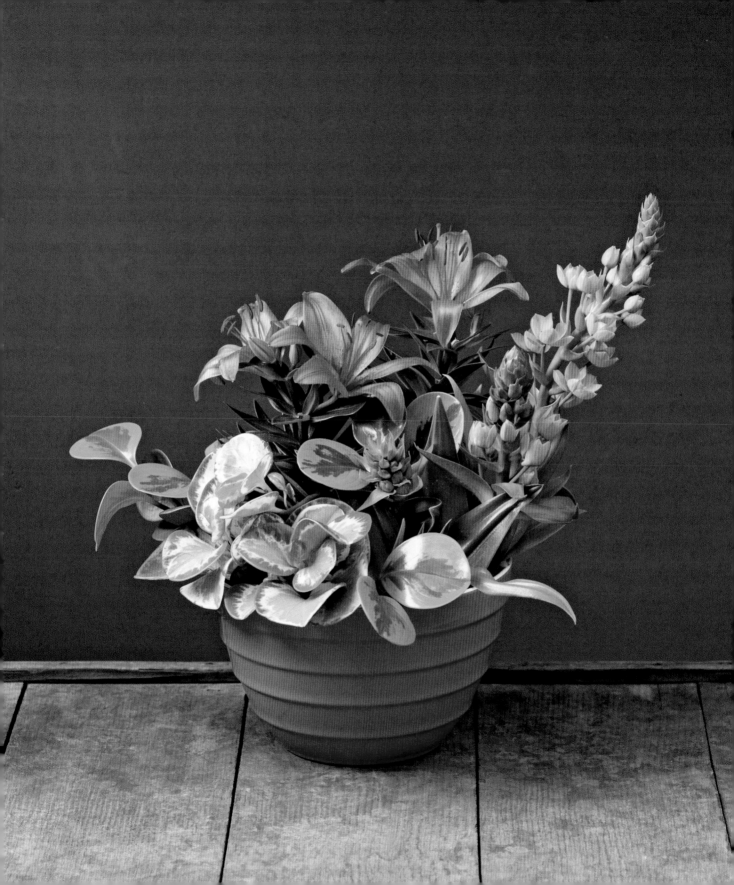

LIPSTICK PLANT

(*Aeschynanthus radicans*)

PLANT TYPE: vine

SOIL: potting mix

WATER: allow the surface soil to dry between waterings; misting is okay

LIGHT: bright indirect

It might be the trumpet-like flowers that you recognize first, but the long, cascading stems will keep your interest going. Let this vine, sometimes called a basket vine, crawl across a table or arch downward from a hanging vase. When it blooms inter-mittently throughout the year, it drips with tubular flowers that look as if they are coming out of their very own lipstick cases, but I love the dependable foliage most of all.

RECIPE 1:
ON ITS OWN

PLANT
One 6-inch twisted lipstick plant
(*Aeschynanthus radicans* 'Rasta')

CONTAINER AND MATERIALS
Black bamboo vase,
at least 4 inches in diameter

1-inch square of screen

Basket with large gaps for the vine to
flow through, 8 inches in diameter

Plastic liner,
to match the bamboo vase

1. Drill a hole into the base of the vase so that the plant will drain. Lipstick plants are said to produce flowers more prolifically when the roots are bound (and the pot is small), but you don't want it to be sitting in water. Cover the hole with the screen.

2. Unpot the vine, loosen its roots, and tuck it into the bamboo vase.

3. Place a low plastic liner in the bottom of the basket and set the vase inside. This will help protect the basket from moisture.

4. Weave the stems through the basket holes for added interest and to make it look as if it's grown there for ages. Remove the vase from the basket to water it, and allow all the water to drain before returning it to the basket.

PLANTS

One 4-inch lipstick plant
(*Aeschynanthus lobbianus* 'Variegated')

One 4-inch mock orange (*Philadelphus*)

One 4-inch basket vine
(*Aeschynanthus* 'Black Pagoda')

One 4-inch rabbit's foot fern
(*Humata tyermannii*)

CONTAINER AND MATERIALS

Candle lantern, 6 inches by 15 inches

Cellophane

1 cup of potting mix

Select a candle lantern with a door and vents at the top. Add a layer of cellophane and a 1-inch layer of potting mix along the bottom. Unpot the lipstick plant and place it at the back of the lantern. Gently pull the vine stems up through the top vents and let them drape.

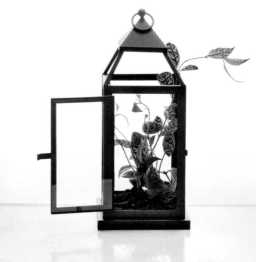

2 Unpot and add in the white-flowering mock orange, placing it in the back on the left.

3 Finish with the basket vine and the rabbit's foot fern, allowing them to drape out of the front of the open lantern. Gently tug the roots of the fern out and let them wrap along the edge of the lantern; or hang the lantern and watch the vine grow up it as if on a trellis. Replant the mock orange when the blooms fade.

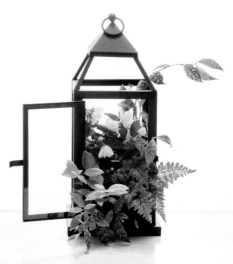

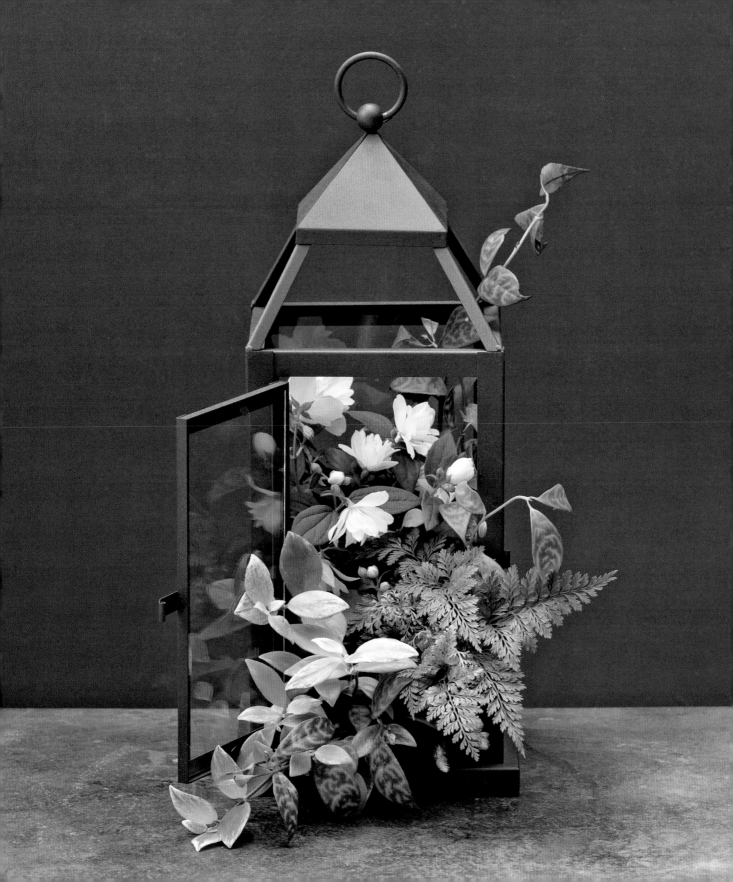

MAMMILLARIA

PLANT TYPE: cactus

SOIL: cactus mix or a mixture of perlite, sand, and soil

WATER: allow the surface soil to dry between waterings

LIGHT: bright direct

Mammillaria is one of the largest genera in the cactus family. The auburn glow of the spikes make the *Mammillaria bombycina* especially intriguing. But—ouch!—watch out. Some have hooks, so if you do get pricked they are a bit challenging to remove from your finger. When in bloom, this small plant, which only reaches about 2 inches in height, has beautiful little flowers.

PLANTS

Two 4-inch rabbit ear cacti
(*Opuntia microdasys*)

Three 4-inch silken pincushions
(*Mammillaria bombycina*)

One 4-inch Indian corncob
(*Euphorbia mammillaris* 'Variegata')

One 4-inch crested cactus (look for a
crested *Opuntia*)

One 4-inch succulent
(*Crassula* 'Morgan's Pink')

CONTAINER AND MATERIALS

Black walnut box, 12 inches square

Cellophane

4 cups of cactus mix

2 cups of black sand

1. Line the box with cellophane. To protect the wood completely, make sure the cellophane covers the sides of the box as well.

2. Pour in the cactus mix until it reaches about 1 inch below the rim.

3. Carefully unpot and plant the plants, arranging them close to one another in the middle of the box, as if they are part of a community. Vary the heights and set similar plants at an angle.

4. Pour the sand over the entire top layer. Use a funnel to get close to the plants, but be sure not to bury them. Jostle the box lightly to smooth out the sand. Water very sparingly once a week, and cut the *Crassula* blooms when they fade. Enjoy for many months.

PLANTS

One 4-inch cactus (*Mammillaria*)

Two 2-inch silken pincushions
(*Mammillaria bombycina*)

CONTAINERS AND MATERIALS

Serving bowl, 8½ inches in diameter
and 4½ inches tall

Matching ceramic cup,
3 inches in diameter and 3 inches tall

1 cup of small lava rock

5 cups of cactus mix

1 cup of white sand

Skewer

Decorative stone

Add a layer of lava rock to the bowl and the cup. Pour the cactus mix over the top, leaving 1 inch of space before the top of the rim. Unpot and plant the mammillaria and one of the silken pincushions in the bowl and the other silken pincushion in the cup. Use thick paper to protect your fingers from the prickly hooks if necessary. Add a touch of water.

2 Add a layer of sand to cover the cactus mix. Take care not to bury the base of the cacti. Gently shake the vases to even out the sand and create a smooth surface.

3 Use a skewer to draw a design in the sand. Add the decorative stone to the bowl as a final touch. Water about once a week, letting the arrangement dry thoroughly in between.

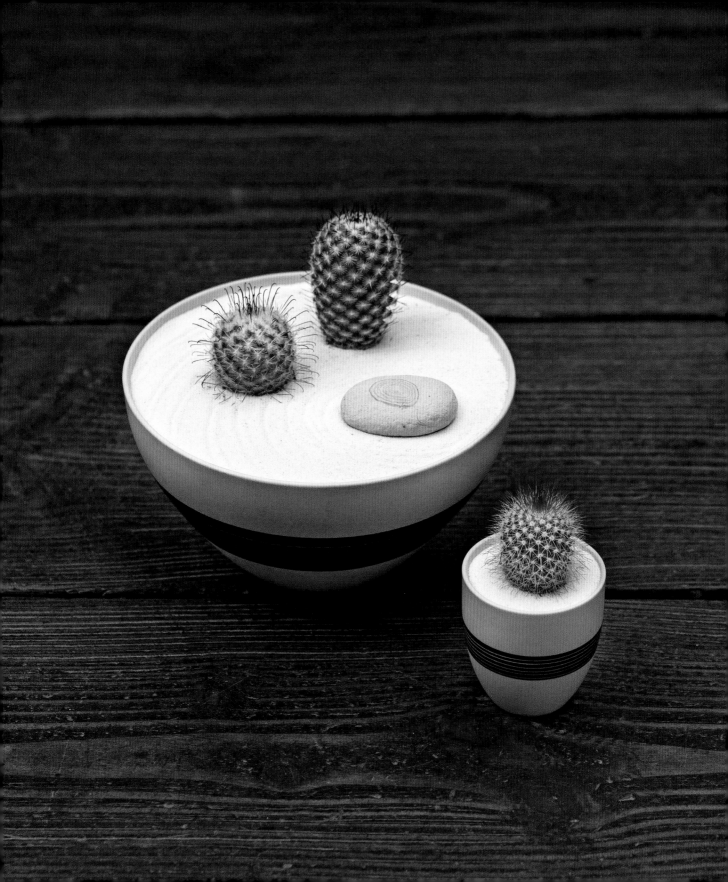

MASDEVALLIA ORCHID

PLANT TYPE: orchid

SOIL: potting mix or orchid mix

WATER: keep just moist

LIGHT: low to bright indirect

These animated, bat-like flowers have arching necks and dancing heads that dangle atop their skinny stems, making them look like bird beaks as the pods grow. Keep these plants cool and well watered. Dry heat is a no-no.

PLANTS

Two 4-inch masdevallia orchids
(*Masdevallia*)

One 6-inch blue flax lily (*Dianella caerulea*)

Three 4-inch earth stars
(*Cryptanthus* 'Black Mystic')

Four 4-inch nerve plants (*Fittonia*)

CONTAINER AND MATERIALS

Scalloped clay pot, 10 inches in diameter and 18 inches tall

1-gallon container

Plastic liner, 7 inches in diameter

1. This is a large staged arrangement in which the plants remain in their original pots. Measure the plant heights in comparison to the decorative pot (see page 17). Place the gallon container upside down in the pot, and then set the liner on top in order to catch water and keep it from dripping out.

2. Begin staging the plants. Set the tall orchids on top of the liner. Make sure the rims of the pots rest slightly below the rim of the decorative pot.

3. Set the blue flax lily in between and slightly behind the orchids.

4. Add in the earth stars around the center-placed plants, then place the nerve plants in the center front of the arrangement. Let the orchids flow and dangle through and around the arrangement. Keep each plant moist.

PLANTS
One 6-inch and three 4-inch orchids
(*Masdevallia*)

CONTAINER AND MATERIALS
Ceramic bowl, 13 inches in diameter

3 cups of orchid mix

3 feet of coated wire

One 12-inch square of sheet moss

Choose a two-tone shallow container. You'll be able to see both the inside and outside colors of the bowl. Mound the orchid mix in the center of the bowl, making sure the inside color is visible. Unpot the biggest orchid and place it in the center of the bowl. Gently pat down the orchid so that it will stay put.

2 Fill in with the remaining orchids. They'll want to flop, so gently tamp the soil to keep them upright.

3 Unroll the coated wire and wrap it around the base of your plants. This will help them stay upright. Put the final touches on the plants by pushing and pulling them into place. Wrap a smooth layer of moss around the base so that it forms a perfect circle. Keep the arrangement moist and cool.

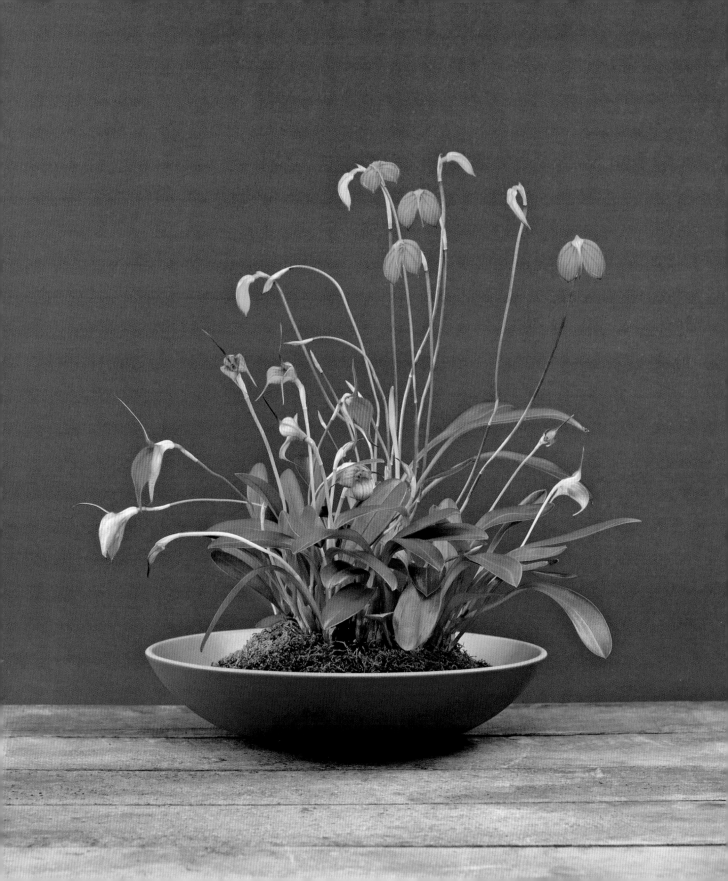

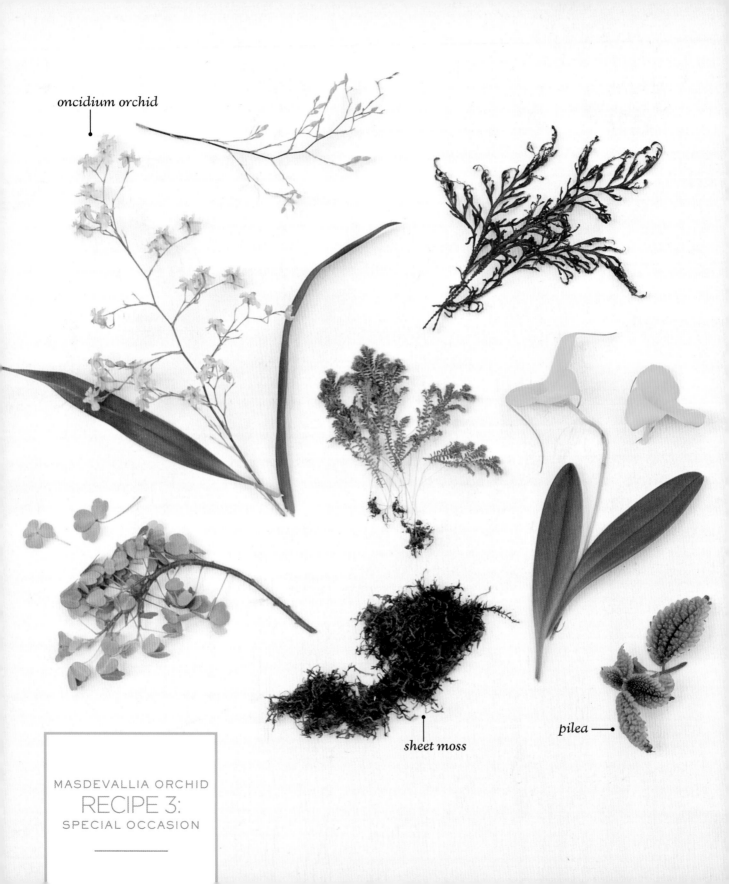

oncidium orchid

sheet moss

pilea

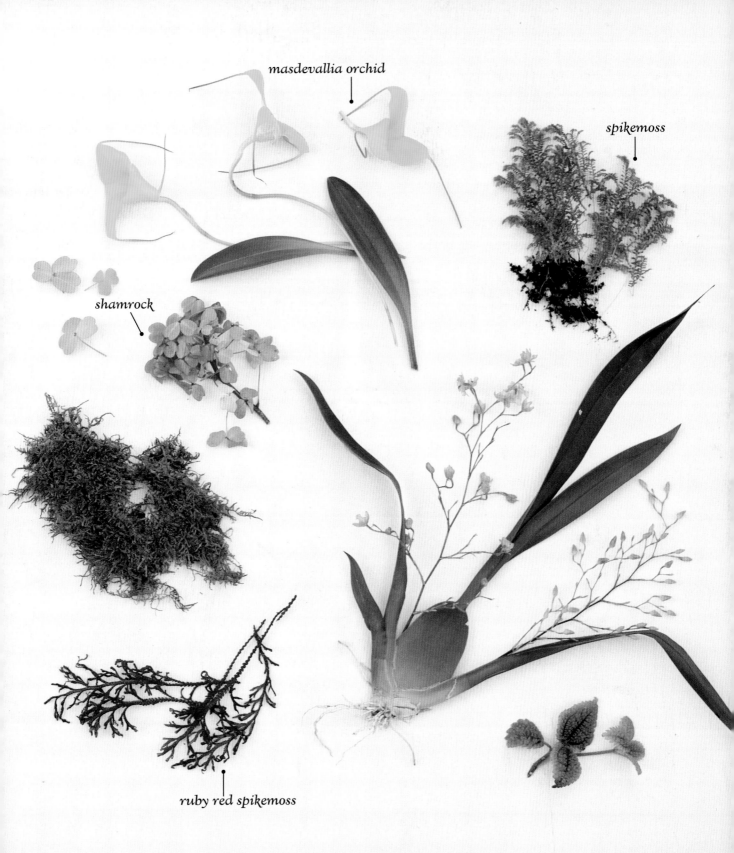

masdevallia orchid

spikemoss

shamrock

ruby red spikemoss

RECIPE 3:
SPECIAL OCCASION

PLANTS

One 4-inch shamrock (*Oxalis siliquosa* 'Sunset Velvet')

One 6-inch ruby red spikemoss (*Selaginella erythropus*)

Four 4-inch spikemosses (*Selaginella kraussian,
S. apoda,* and *S. canaliculata* are recommended)

Two 4-inch pileas (*Pilea* 'Moon Valley')

One 6-inch masdevallia orchid (*Masdevallia*)

One 4-inch oncidium orchid (*Oncidium* 'Twinkle')

CONTAINER AND MATERIALS

Large handblown glass terrarium,
with a 10-inch opening and 18 inches tall

5 cups of decorative gravel

½ cup of charcoal

3 handfuls of sphagnum moss

10 cups of potting mix

1 Pour the decorative gravel into the terrarium as a base layer. Add a layer of charcoal and a layer of sphagnum moss. Scoop and pour potting mix over the top. A 4-inch layer, mounded in the center, is plenty.

2 Unpot the shamrock, spikemosses, and pileas. With long arms and a gentle touch, tuck them into the soil around the perimeter of the terrarium. Keep the soil level as even as possible for a more polished side view through the glass.

3 Leaving the masdevallia orchid in its original pot, place it in a nicely dug hole in the center mound. Keep the blooming heads several inches below the opening of the terrarium as you tilt it gently forward. Repeat with the oncidium. Choose one with tight blooms and watch them explode over the next few weeks. Many oncidiums are fragrant, too.

4 Intertwine the airy foliage of the spikemosses through the orchids. Arrange the masdevallia flowers so that they appear to be swirling in the terrarium.

5 Keep this arrangement moist, and remove the orchids once they are past their bloom. New orchids or other flowering plants can be introduced once the original orchids have been removed. The arrangement will grow and change for months or even years (though the shamrocks and spikemosses may take over!).

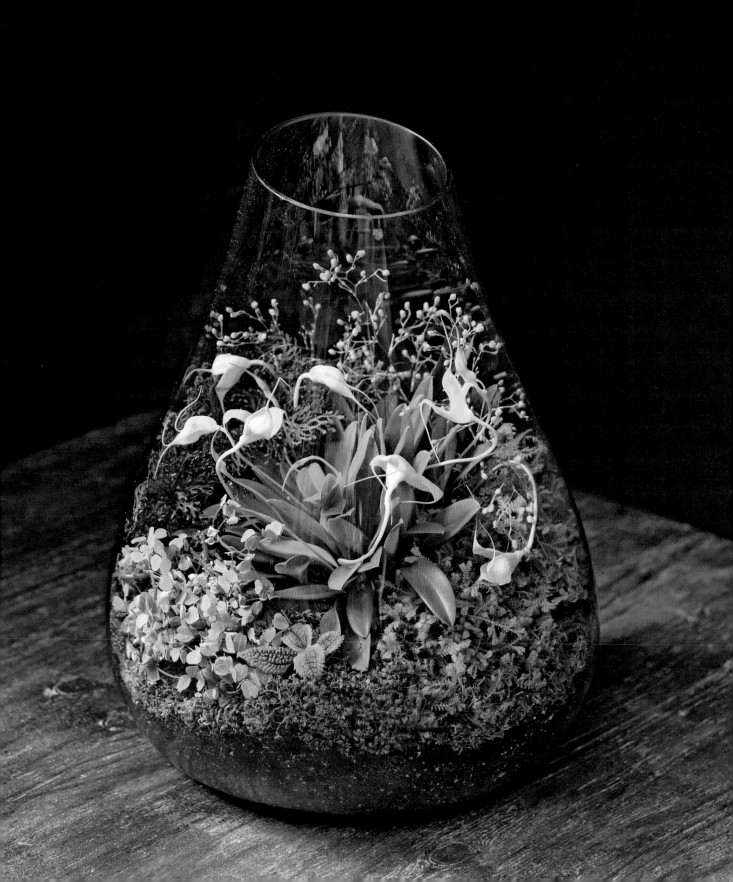

MOSS

PLANT TYPE: spore-producing plant

SOIL: none

WATER: keep moist

LIGHT: low/shade

On a log, on a pot, or in a dish, moss is squishy, squashy, and malleable yet tough. And though it's usually a background player, these recipes give moss a starring role. Have fun with all the varieties out there—some are ferny, some are tiny, while others are more spongy. Moss is also a great solution for a dark room, since it doesn't love light the way most other plants do. Stick it in a jar and close the lid, or paint it on your flowerpot and watch it grow.

PLANTS
3 clumps or groupings of moss:
cushion (*Leucobryum*), mood
(*Dicranum*), haircap (*Polytrichum*),
sphagnum—any kind will do

CONTAINER
3 stackable glass vases,
4 inches in diameter and 3 inches tall

1. Find jars that stack and have a closed top. Moss doesn't need an opening and will thrive just as it is.

2. If the moss is dry and hard, give it a spray or soak it in water, squeezing out any excess water when you are done.

3. Measure out the amount of moss you will need—one layer of moss should fit in each jar. Make sure it doesn't bunch up on the sides and that no gaps are left around the edges.

4. Stack the jars and set them well out of the way of direct sunlight. Add a touch of water as needed (a closed container will hold in moisture).

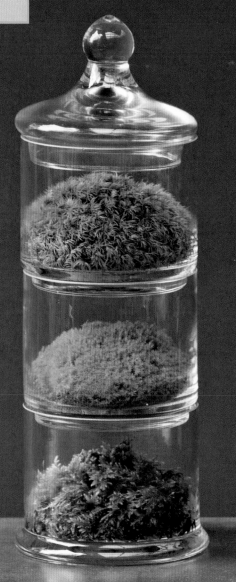

PLANTS
Two 4-inch spikemosses
(*Selaginella*), low-growing variety

One 4-inch masdevallia orchid (*Masdevallia*)

CONTAINERS AND MATERIALS
Recycled glass vase with lid,
6 inches in diameter

2 cups of potting mix

Terra-cotta flowerpot, 4 inches in diameter

Glass vase, at least 6 inches in diameter

Pour 1 inch of potting mix into the lidded vase.

2 Plant the spikemosses all the way to the edge of the vase and make sure the plants' tops rest well below the rim. The profile through the glass should show more green moss than brown soil.

3 Moss the terra-cotta pot (see page 17). Mist the pot weekly and keep it out of direct sunlight. Remove any stakes that are holding up the orchids. Unpot and plant the orchid into the mossed pot, then carefully place the mossed pot inside its glass vase. Let the leaves rest on the rim of the vase and allow the flowers to drape over the edge naturally. Some flowers will fade, while others will continue to bloom. Keep moist.

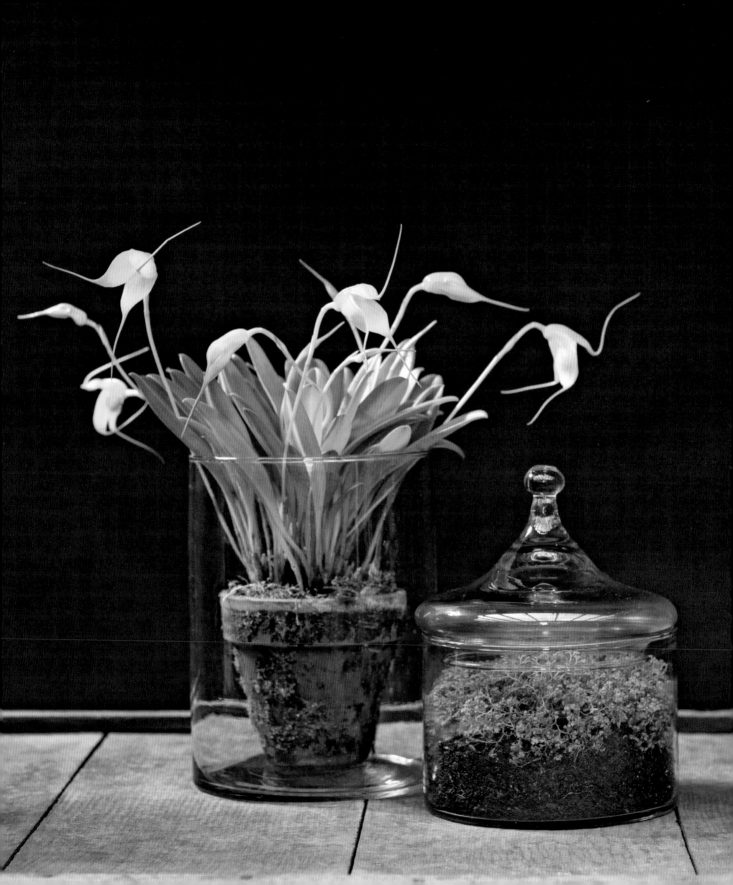

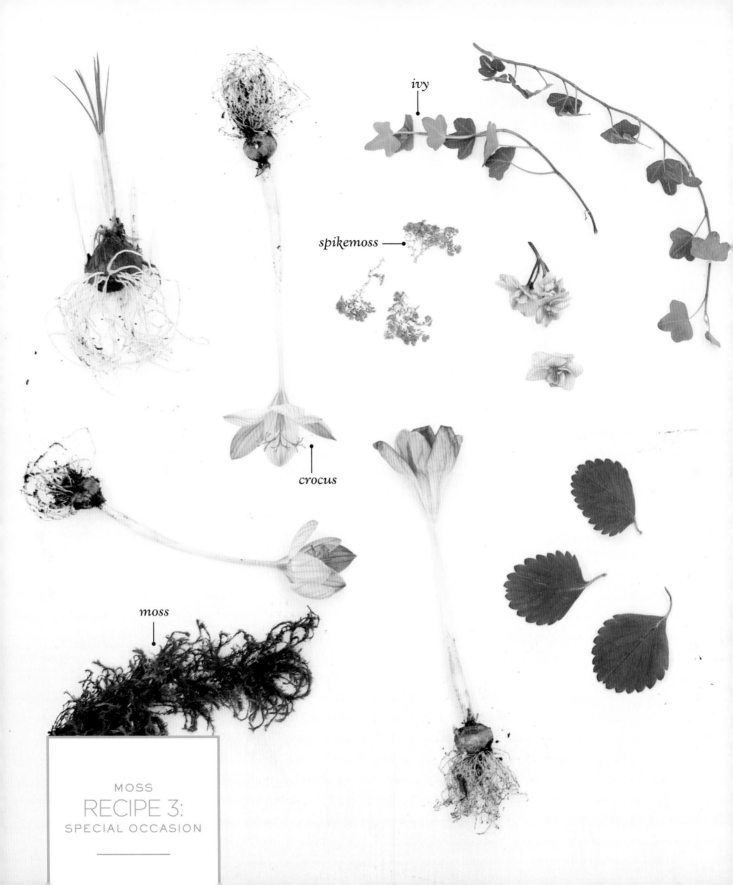

ivy

spikemoss

crocus

moss

MOSS
RECIPE 3:
SPECIAL OCCASION

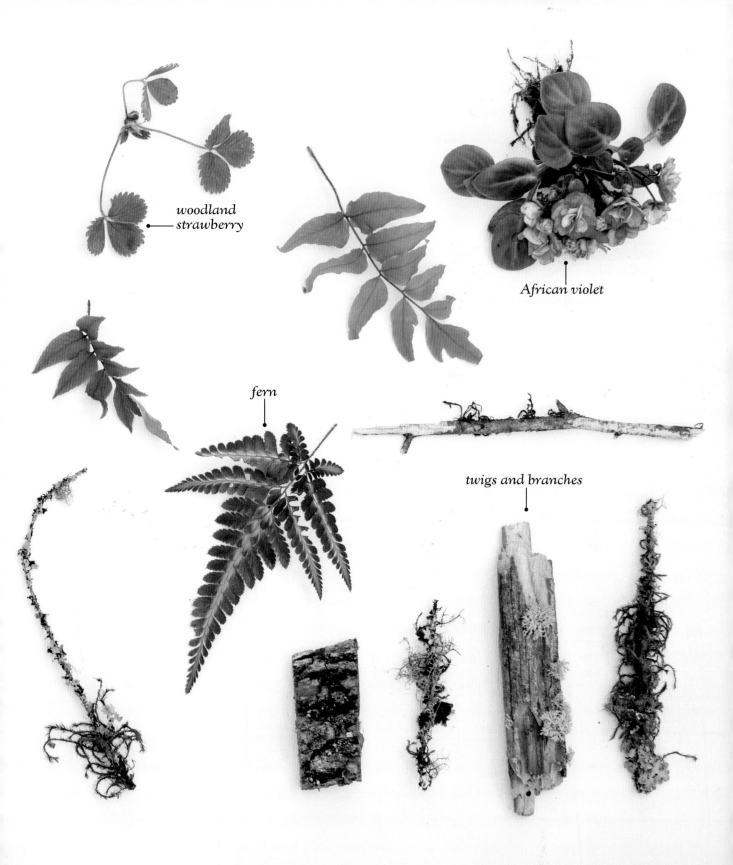

woodland
strawberry

African violet

fern

twigs and branches

MOSS
RECIPE 3:
SPECIAL OCCASION

PLANTS
5 clumps or handfuls of moss—any variety will do

Three 2- to 4-inch ferns (*Arachniodes simplicior*,
Lygodium japonicum, or *Polystichum* will work nicely)

Two 4-inch African violets (*Saintpaulia*)

One 4-inch spikemoss (*Selaginella*), compact variety

One 4-inch ivy (*Hedera helix* 'Duck Foot')

One 2-inch woodland strawberry (*Fragaria vesca*)

One 4-inch crocus (*Crocus longiflorus*)

MATERIALS
A large piece of a branch or chunk of bark, 2 to 3 feet long

Two 12-inch square sheets of foil

1. Soak the mosses to soften them if they're dry. Lay them across the top of the branch.

2. Build the arrangement using the branch as the center and on a tabletop. Unpot all the plants, lightly shake, and wrap their roots and a bit of soil in foil. This will protect the tabletop. Tuck the plants on each side of the branch and into the nooks and crannies.

3. Add in the ferns, African violets, spikemoss, ivy, and woodland strawberry as if they were growing out of the branch. Top it off with the crocus.

4. Moss over any exposed foil. Mist and enjoy this ephemeral arrangement for less than a week before replanting the ferns and flowers in more permanent pots.

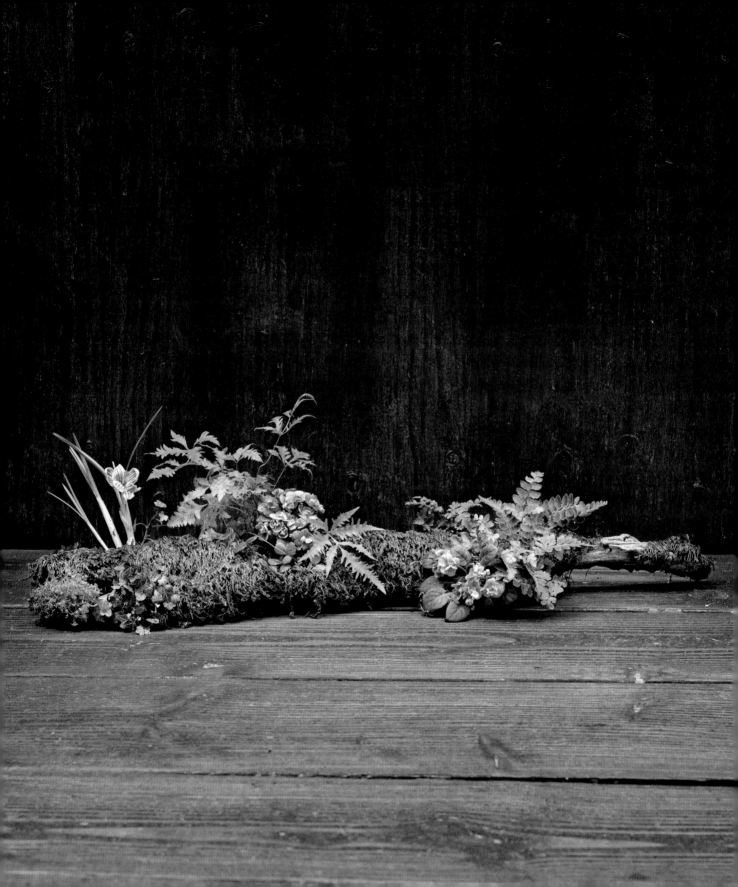

MUSHROOM *(Lentinus)*

PLANT TYPE: fungus

SOIL: special growing-medium mix that comes with the mushroom kits—sometimes wood chips

WATER: keep under a tent while they grow, and mist twice a day for high humidity

LIGHT: low to bright indirect

Kits for growing mushrooms can be found online, in natural food stores, and even in some supermarkets. With daily misting and a little patience, you'll be able to grow a few to eat or just to admire. Though fleeting in an arrangement, they are quite the conversation starter as a centerpiece.

RECIPE 1:
ON ITS OWN

PLANTS
1 shiitake mushroom kit
(*Lentinus edodes*)

CONTAINER AND MATERIALS
Log vase, 10 inches in diameter
and 6 inches tall

Plastic liner to fit the vase

Clear plastic bag

1. Cut a section of the mushroom kit medium that will fit in the log vase. Follow the instructions that come with the mushroom kit to get it started.

2. Set the mushroom medium in the plastic liner. Allow the mushroom to breathe from the sides by allowing space between the liner walls and the medium. Place it in the log vase.

3. Cover the arrangement with a clear plastic bag with holes and mist twice a day. Keep out of direct sun and watch the mushrooms grow.

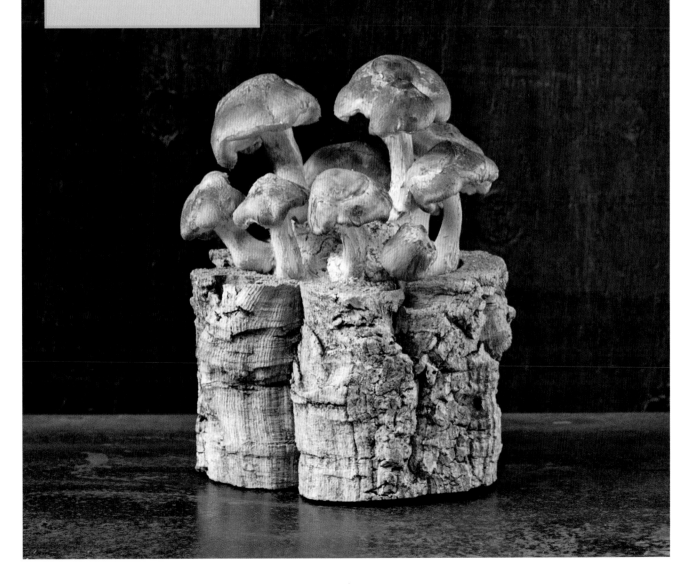

PLANTS

1 shiitake (*Lentinus edodes*) fully or mostly grown mushroom log kit, cut into 2 pieces

One 4-inch satsuki azalea (*Rhododendron* 'Chiyo-No-Tsuki')

One 4-inch sedge (*Carex albula* 'Frosty Curls')

One 4-inch brass buttons (*Cotula squalida* 'Platt's Black')

One 4-inch blue star creeper (*Laurentia fluviatilis* 'Mini Blue')

MATERIALS

12- to 16-inch square of faux moss, sold on a roll or in sheets

Sheet of foil or cork to protect the tabletop

One 6-inch square of sheet moss

Stone, 1 to 2 inches in diameter

Note: This arrangement must be built on-site. Cut the faux moss into a natural-looking bean shape and place it on top of the foil on the table. Break apart the mushroom log into two pieces. Allowing the mushrooms to remain fairly upright, rest them in the middle of the faux moss. Add a small amount of sheet moss to prop the mushrooms and provide a bit of height for the other plants.

2 Unpot the azalea and place it behind the mushrooms. The flowering dwarf shrub will provide a round backdrop to this scene. For height and wispiness, plant the sedge snugly next to the azalea. Allow the blades to mingle into the shrub and float above the rest of the arrangement.

3 Fill in with the tiny brass buttons, the stone, and the blue star creeper. Mist twice a week; after the first week, dismantle the arrangement and repot the plants.

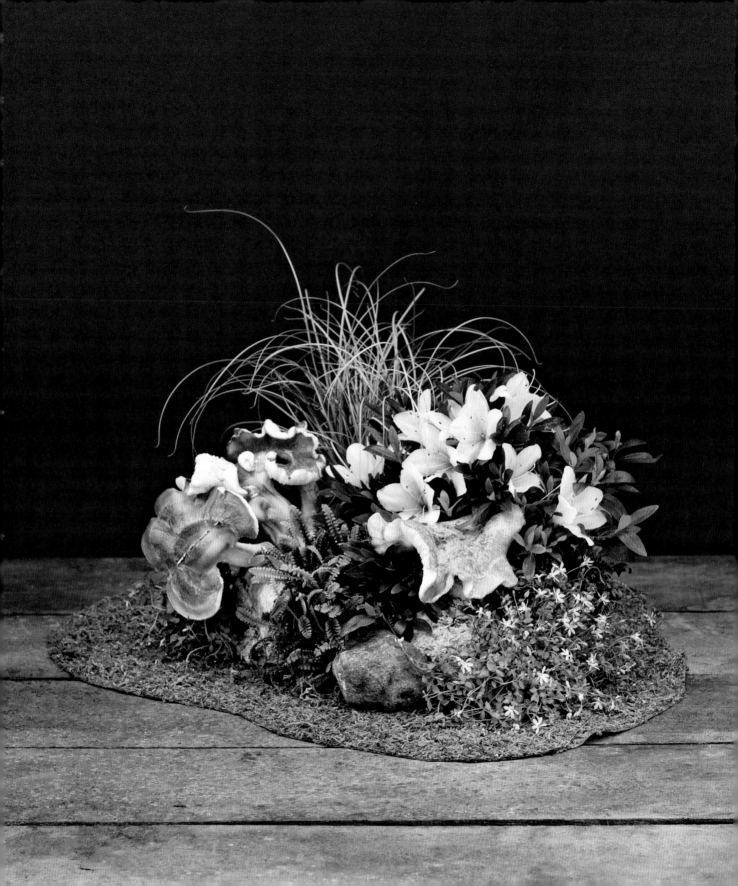

NERVE PLANT

(*Fittonia*)

PLANT TYPE: perennial
SOIL: potting mix
WATER: keep moist; it loves high humidity
LIGHT: low

Nerve plants are readily available but a bit harder to grow than some other foliage plants. They like a tropical rainforest and therefore love a terrarium. Their bright veins—red, pink, or white—are what make this plant irresistible. The leaves will crawl along a surface, stretching out horizontally. In some stores you may see them called by their botanical name, *Fittonia*.

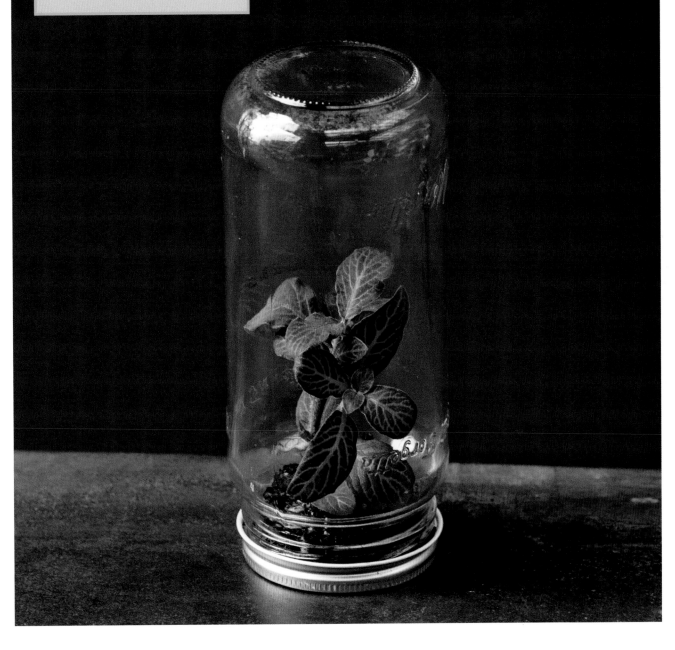

NERVE PLANT
RECIPE 1:
ON ITS OWN

PLANT
One 2-inch nerve plant (*Fittonia*)

CONTAINER
Clear glass jar with lid

1. Choose a jar that will easily accommodate the height and the width of the plant.

2. Water the nerve plant to make sure it is moist, then unpot it and set it on the jar lid with a little of its soil intact.

3. Attach the jar—upside down over the plant—to the lid and screw it on tight. Water the plant only if it begins to wilt. Nerve plants should remain moist, happy, and healthy for months in this closed environment.

NERVE PLANT
RECIPE 2:
WITH COMPANY

1 Look for a box with a golden tone to complement the plants' rich, fall-colored foliage. Line the box with cellophane.

PLANTS
One 4-inch rosy maidenhair fern
(*Adiantum hispidulum*)

Two 4-inch nerve plants (*Fittonia*)

One 4-inch flaming Katy
(*Kalanchoe blossfeldiana*) with peach flowers

CONTAINER AND MATERIALS
Vintage box about 9 inches by 5 inches
and 3½ inches tall

Cellophane or a small plastic bag

2 Place the fern in its grow pot in the center of the box.

3 Flank the fern with the nerve plants and place the flaming Katy in the back to the left of center also in their grow pots. Lightly tug at the foliage to extend the leaves and to make the arrangement look a little more wild. Keep moist and this will last long after the blooms fade—the flaming Katy might even rebloom!

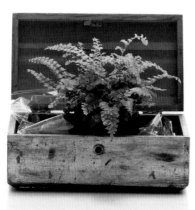

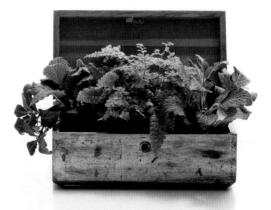

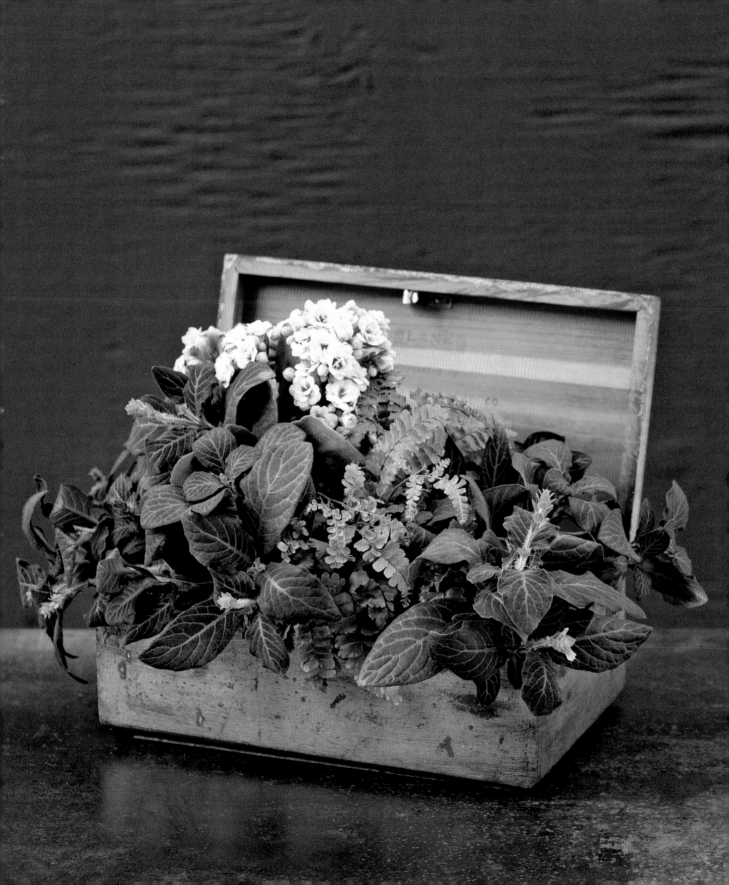

PITCHER PLANT

(*Sarracenia*)

PLANT TYPE: carnivorous

SOIL: carnivorous mix: a 50–50 mix of peat moss and horticultural sand

WATER: keep wet; use pure, distilled, reverse osmosis, or rainwater

LIGHT: bright; at least 6 hours of direct light per day

Pitcher plants will reel you in with their intriguing hooded heads. They are also carnivorous and that is pretty cool, too (once the insects venture in, they slide down that slippery slope and get stuck). Show them to kids for some *oohs* and *aahs*. Be patient in the early winter; they go dormant (and hide) for a few months. Don't worry—they'll come back to catch more flies when the days get longer.

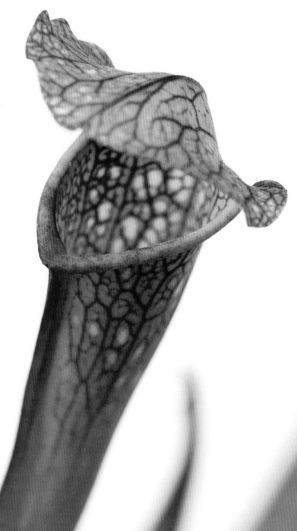

PITCHER PLANT
RECIPE 1:
ON ITS OWN

PLANT
One 6-inch pitcher plant
(*Sarracenia*)

CONTAINER AND MATERIALS
Vintage metal vase, 5½ inches
in diameter and 9 inches tall

3 cups of peat moss and horticultural
sand mixture

10 cups of pure water (distilled,
reverse osmosis, or rainwater)

A handful of sphagnum moss,
enough to go around the
base of the plant

1. Add the peat-and-sand mixture to the vase until it is about two-thirds full or so that once you plant, the soil level is 1 inch below the rim of the vase.

2. Unpot the pitcher plant, carefully holding on to the original soil mixture, and set all of it inside the vase.

3. Pour in enough water so that the plant is soggy but not swimming. The water should barely reach the top of the soil.

4. Place a handful of sphagnum moss on top, covering all the soil. Keep this arrangement very wet.

PLANTS

One 4-inch and one 6-inch pitcher plant
(*Sarracenia purpurea*, *S. flava*, and
S. leucophylla are good choices)

One 4-inch sundew (*Drosera*)

One 4-inch shamrock
(*Oxalis deppei* 'Iron Cross')

One 1-gallon horsetail rush
(*Equisetum hyemale*)

One 1-gallon dwarf papyrus
(*Cyperus isocladus*)

One 1-gallon little umbrellas pennywort
(*Hydrocotyle verticillata*)

One 1-gallon benni silk stocking arrowhead
(*Sagittaria australis*)

One 2-inch tropical pitcher plant
(*Nepenthe talangensis*)

One 4-inch lysimachia
(*Lysimachia nummularia* 'Goldilocks')

One 3-inch and two 2-inch water lettuces
(*Pistia stratiotes*)

CONTAINER AND MATERIALS

Sturdy shallow brass bowl,
21 inches in diameter

½ cup of carnivorous mix

Plastic liner

1 cup of charcoal

1 cup of distilled water

8 cups of black pebbles

2 The gallon pots are too large to place,
so unpot those plants and remove much
of their soil. Start with the larger and
taller water plants—the horsetail rush
and dwarf papyrus. Add pebbles to fill in
gaps and help prop the plants upright.

Make sure your bowl is strong, as this
container garden will be heavy. Unpot
and group the pitcher plants, sundew,
and shamrock and plant them in the
plastic liner using carnivorous soil mix
and a touch of charcoal. Set the liner in
the front center of the bowl. Water the
liner pot with the distilled water.

3 Fill in around the edges with the lower
larger-leafed plants, like the pennywort
and the arrowhead. When you are done
planting, add enough pebbles to cover
all the containers and the soil. Set the
tropical pitcher plant and lysimachia on
the pebbles in order to keep their roots
out of the water. Add enough water to
create a moat (about ½ gallon), then
add the water lettuces. Keep in a pool of
water, and this arrangement will last for
months.

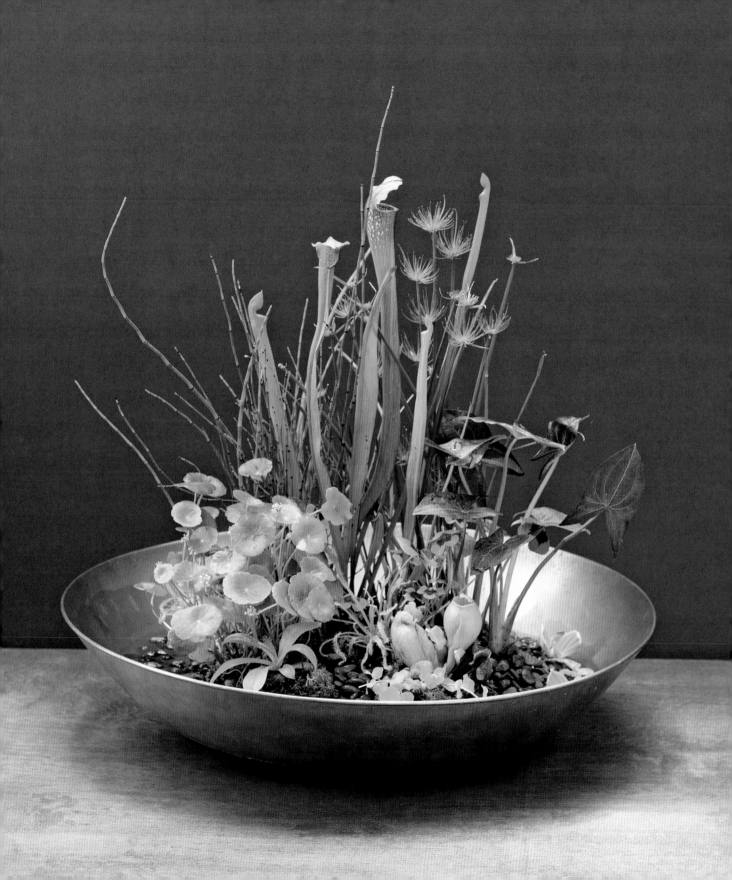

PRIMROSE *(Primula)*

PLANT TYPE: perennial

SOIL: potting mix

WATER: keep moist

LIGHT: bright indirect to low

These sweet flowers have a delightful old-fashioned look that always reminds me of an English country garden. Why not bring that classic garden feeling home? To make this spring bloomer happy, keep it moist and in the shade.

RECIPE 1:
ON ITS OWN

PLANT
One 4-inch primrose
(*Primula polyantha*
'Victoriana Gold Lace Black')

CONTAINER AND MATERIALS
Cylindrical pot 3 inches in diameter

1-inch square of screen

½ cup of potting mix

¼ cup of mini fir bark mulch
or orchid bark

1. Choose a small pot with a drainage hole. The combination of white and yellow on this one adds some whimsy.

2. Set the screen over the pot's drainage hole and add the potting mix.

3. Unpot the primrose and plant it in the pot.

4. Add a layer of mulch. This will make it feel like it's a real garden plant. Pinch the spent blooms to encourage them to rebloom. Keep moist. And keep smiling.

PRIMROSE
RECIPE 2:
WITH COMPANY

PLANTS

One 4-inch ivy (*Hedera helix*); choose one with yellow variegated leaves

One 4-inch rhizomatous begonia (*Begonia*) with dark leaves

Two 4-inch primroses (*Primula* 'Angelo Hayes' and *P.* 'Cowslip')

CONTAINER AND MATERIALS

Copper pot with handle, 6 inches in diameter and 8 inches tall

5 to 8 cups of potting mix

Add potting mix to the copper pot until it is two-thirds full. Unpot and plant the ivy at the front left edge of the pot, wrapping a bit of the vine around the pot's handle.

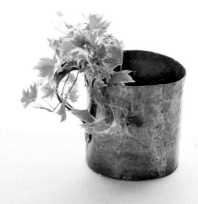

2 Unpot and plant the begonia on the opposite side, allowing the leaves to drape over the rim.

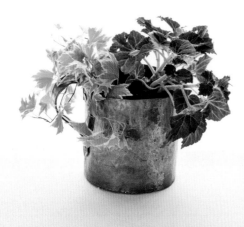

3 Unpot and plant the 'Angelo Hayes' primrose in the center of the pot, then the 'Cowslip' in the back to the right. If needed, add more potting mix to create a mound so that the blooms, particularly those of the 'Angelo Hayes' primrose, rise above the leaf line. Keep just moist by watering once or twice a week. The begonia and ivy will live long after the primrose blooms fade.

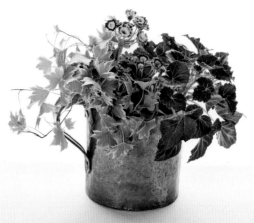

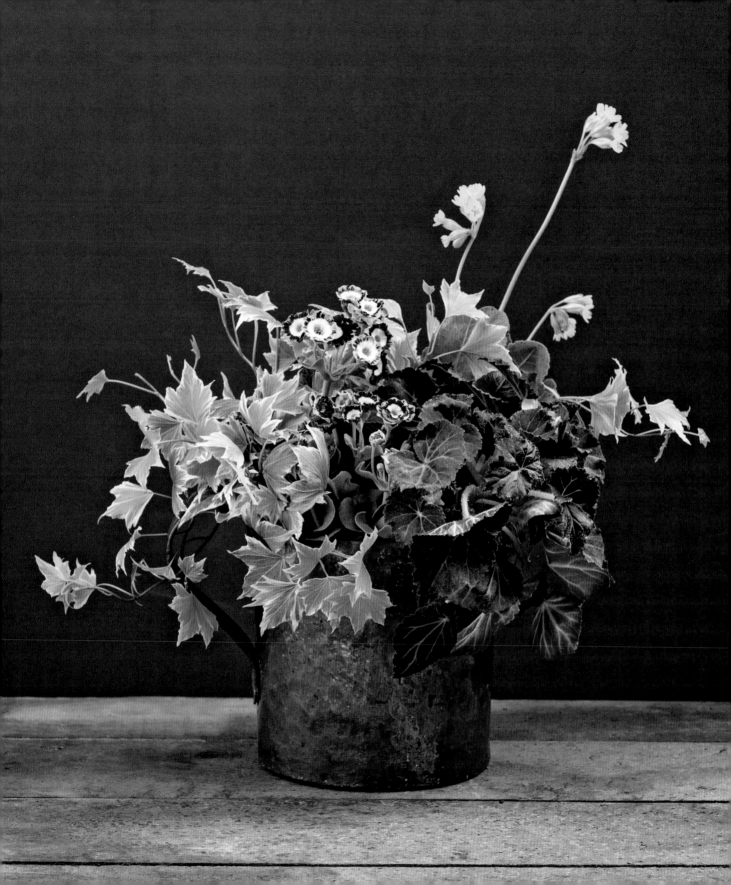

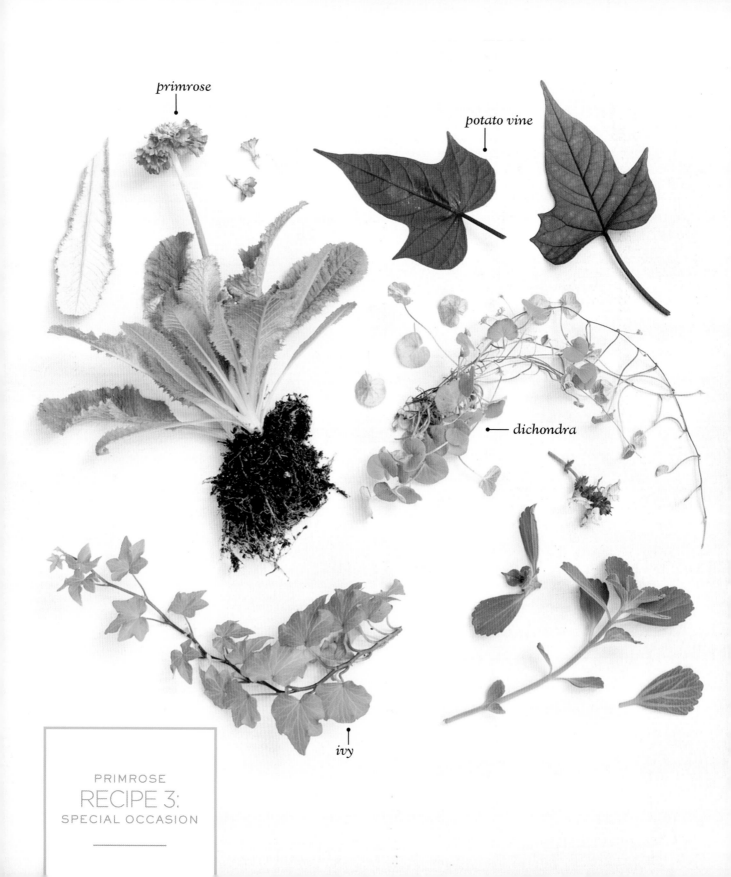

primrose

potato vine

dichondra

ivy

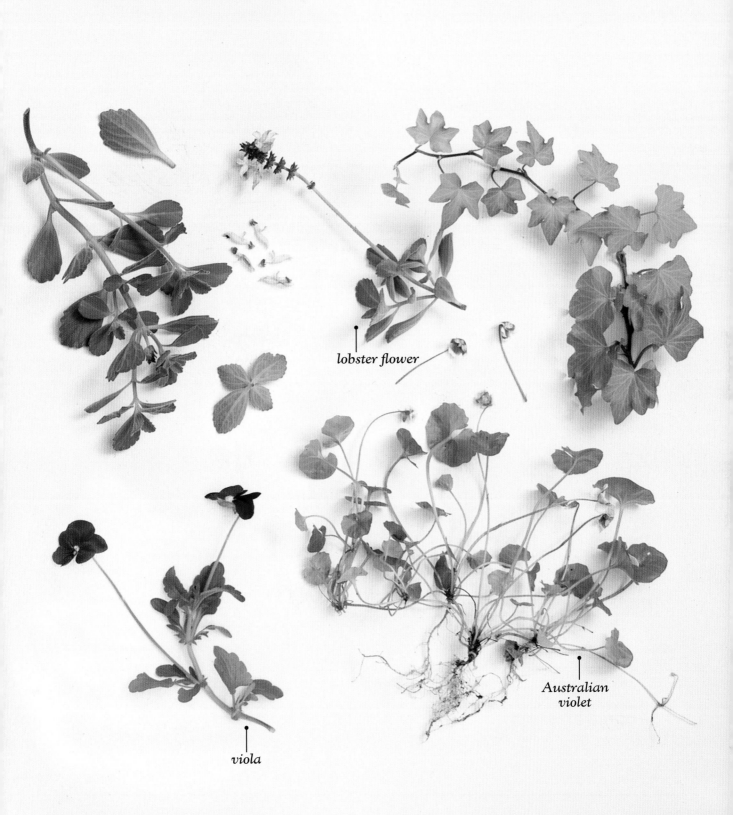

lobster flower

viola

Australian
violet

RECIPE 3:
SPECIAL OCCASION

PLANTS
One 4-inch ivy (*Hedera helix*)

One 4-inch dichondra (*Dichondra repens* 'Emerald Falls')

One 4-inch lobster flower (*Plectranthus neochilus*)

One 4-inch primrose (*Primula capitata* ssp. *mooreana*)

One 4-inch potato vine (*Ipomea* 'Bright Ideas Rusty Red')

One 4-inch Australian violet (*Viola hederacea*)

Six 4-inch violas: 3 *Viola* 'Frosted Chocolate'
and 3 *V.* 'Sorbet Raspberry'

CONTAINER AND MATERIALS
Vintage metal toolbox, 19½ inches
by 8 inches and 2 inches tall

1 cup of potting mix

1 Add a layer of potting mix to the toolbox.

2 Unpot and plant the ivy along the front edge of the box and the dichondra on the front right corner. Drape both plants off the edges. Unpot and plant the lobster flower and the primrose in the back left corner.

3 Unpot and plant the potato vine for contrast in the middle of the box, stretching its vine across the center front to back.

4 Fill in any gaps with the violet and the violas. Let the potato vine and dichondra grow long, and prune the primrose to encourage it to rebloom.

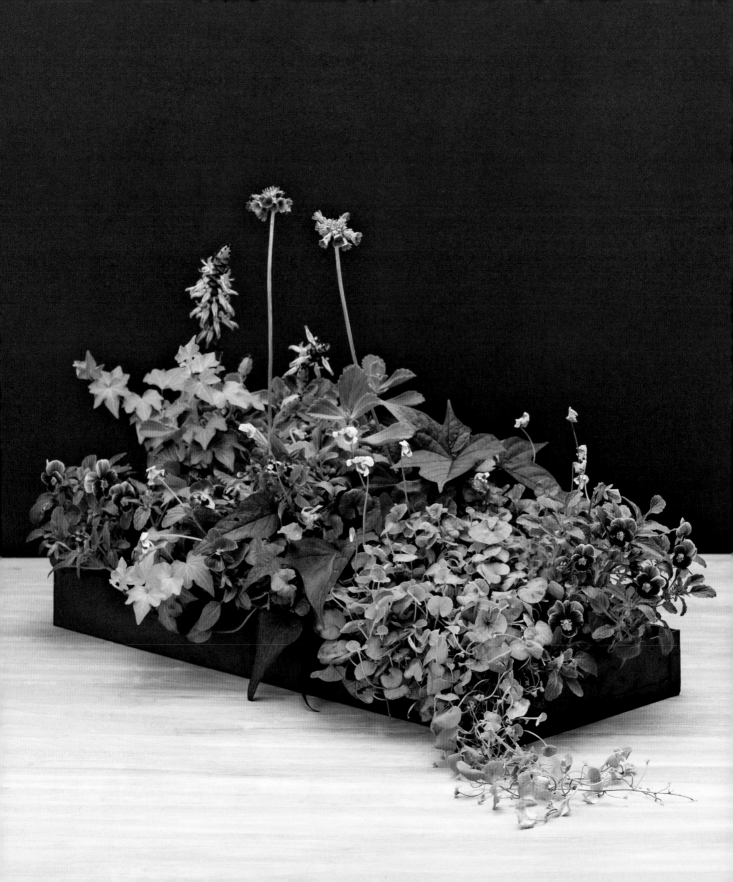

SANSEVIERIA

PLANT TYPE: foliage houseplant

SOIL: any

WATER: keep just moist; allow the surface soil to dry between waterings

LIGHT: bright indirect to low

Also known as mother-in-law's tongue (ouch!), this tough plant never quits. It's easy to care for and sharp-looking, too. The thick, leathery leaves come in a variety of colors, including the copper color shown in Recipe 3. Another variety, spear plant, has the same qualities but comes in a cylindrical shape.

RECIPE 1:
ON ITS OWN

PLANT
One 8-inch sansevieria
(*Sansevieria trifasciata*)

CONTAINER AND MATERIALS
Bowl at least 8 inches in diameter

Water-tolerant stuffing,
such as Bubble Wrap

3 cups of decorative gravel

1. This contemporary arrangement works well in any home or office. Compare the pot holding the sansevieria to the bowl to determine how much stuffing will be needed to ensure that the edge of the grow pot is level with the bowl's rim.

2. Place waterproof stuffing in the bottom of the bowl as a prop as needed.

3. Set the plant inside the bowl, adjusting it so that the rim of the grow pot is even with that of the bowl. Add more stuffing around the container to create a more level surface.

4. Cover the stuffing and soil with the decorative gravel until the bowl is full. Water sparingly, about once a week.

PLANTS
One 4-inch spear plant
(*Sansevieria cylindrica*)

One 4-inch peperomia (*Peperomia* 'Hope')

One 4-inch rhipsalis (*Rhipsalis capilliformis*)

CONTAINER AND MATERIALS
Canvas decorative bag,
about 6 inches in diameter

Plastic liner

½ cup of small lava rock

Water-tolerant stuffing, such as Bubble Wrap

Make sure the plastic liner fits snugly in the canvas bag and that it is almost as tall as the bag. Pour the lava rock into the liner and set it into the bag. Size up the plants. Add a layer of waterproof stuffing under the liner, if necessary, so that the top of the plant's soil will be flush with the rim of the bag.

2 Unpot the spear plant and place it in the center, slightly to the right.

3 Unpot and add the low peperomia in front of the spear plant, then unpot and place the rhipsalis to the left of the spear plant, encouraging it to drape over the edge by gently guiding its airy stems downward and outward. Let dry between waterings about once a week.

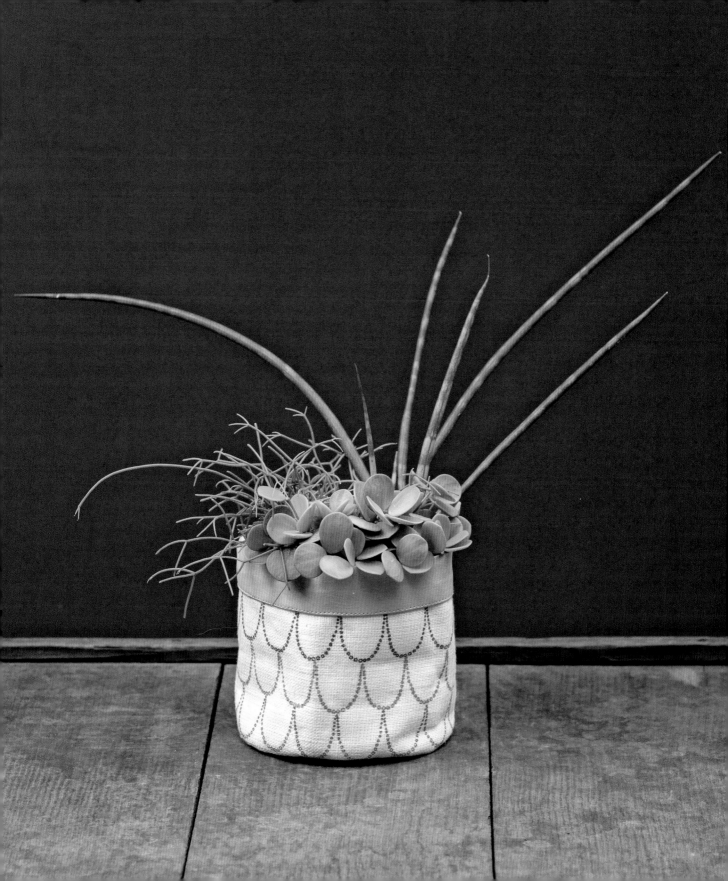

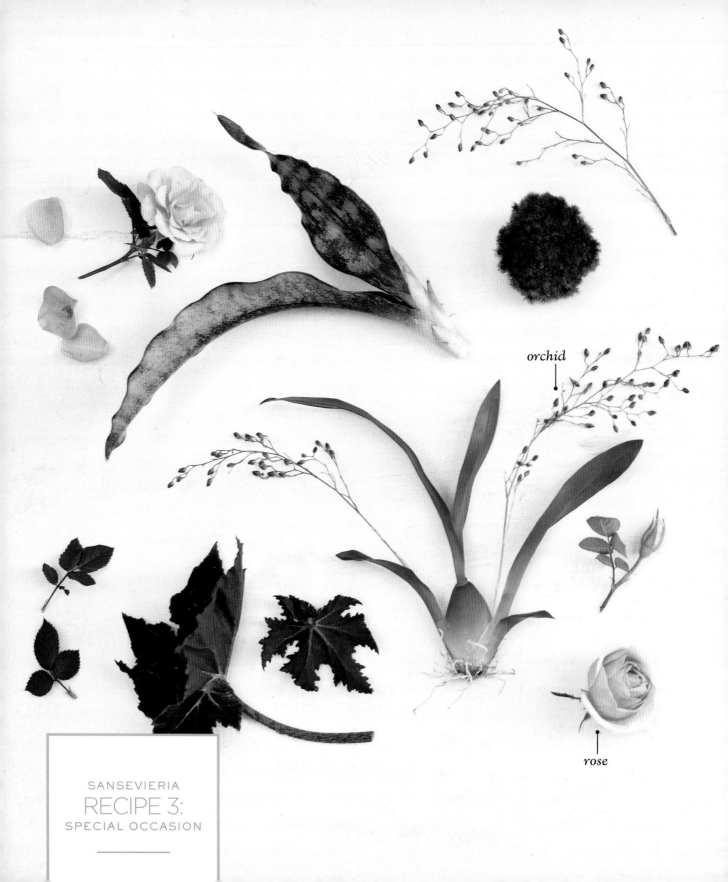

orchid

rose

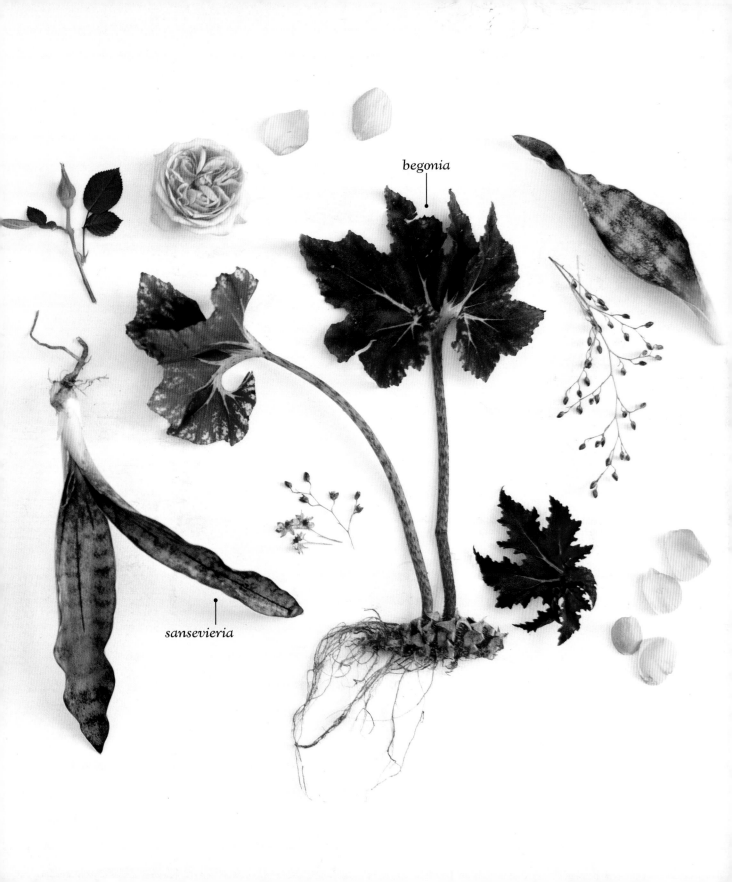

begonia

sansevieria

RECIPE 3:
SPECIAL OCCASION

PLANTS

One 6-inch sansevieria
(*Sansevieria kirkii pulchra* 'Copper')

One 4-inch orchid (*Oncidium* Twinkle 'Red Fantasy'),
about to bloom

One 6-inch begonia
(*Begonia* 'Black Coffee' is a nice choice)

One 4-inch miniature rose (*Rosa*)

CONTAINER AND MATERIALS

Large copper bowl, 18 inches in diameter

2 cups of potting mix

One 12-inch square of sheet moss

1 Add the potting mix to the bowl. Lay out the plants and unpot all but the orchid.

2 Start with the sansevieria, planting it at an extreme, almost horizontal, angle, on one side of the bowl. You may use the entire plant or just a section of it, as it may split when unpotted.

3 Repeat with the potted orchid on the opposite side, then fill in the back area with the begonia.

4 Snugly plant the rose in between the sansevieria and the orchid so that its full blossoms are front and center. Fill in any gaps with the moss to cover up the soil. Gently tug the begonia leaves so that they intermingle with the other plants.

5 While the rose's blooms will be fleeting, the orchid will bloom and the blossoms will last for months. Let the arrangement dry between waterings about twice a week. Avoid soggy roots.

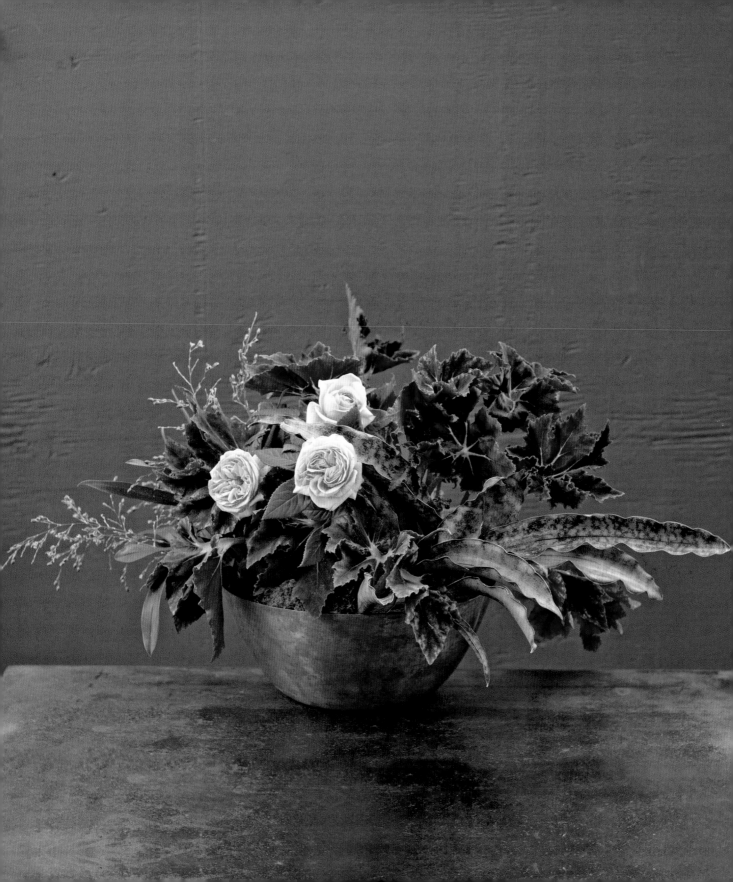

SEDUM

PLANT TYPE: succulent

SOIL: cactus mix

WATER: allow the surface soil to dry between waterings

LIGHT: bright indirect to bright direct

The burro's tail and its close relative *Sedum burrito* have fat, succulent leaves that overlap like a thick woven rope and drape over the edge of a container and downward. They are heavy, but be careful: those little leaves detach with the lightest touch. Fret not if some fall off, though, because each tiny fraction will root if placed in soil. Other sedums aren't quite as fragile.

SEDUM
RECIPE 1:
ON ITS OWN

PLANTS
One 6-inch and one 4-inch
burro's tail (*Sedum morganianum*)
or *S. burrito*

CONTAINER AND MATERIALS
Octagonal vase, 9 inches in diameter

2 cups of cactus mix

1. Select a planter that tips and turns but stays steady. One with many flat sides allows it to be set at various angles without tipping over. The idea here is to let your sedum spill out as if pouring out of a tipped vase.

2. Add cactus mix until the vase is one-third full, angling the mix along the shape of the open vase.

3. With extreme care, touching only the soil and the roots, remove the plants from their containers.

4. Place the biggest plant with the longest "tails" in the vase first, at the lowest part of the vase. Plant the smaller, shorter-tailed sedum above it. Gently arrange the tails so that they pour out of the container. Water sparingly, making sure the plants are thoroughly dry between waterings. And resist the urge to move the arrangement around.

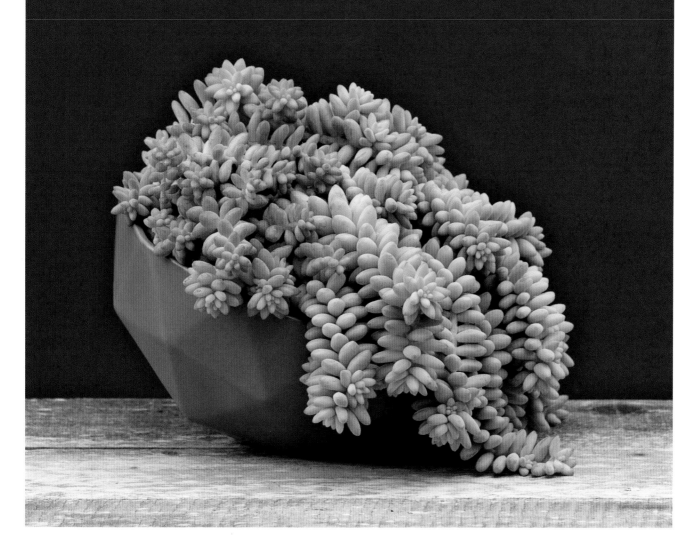

PLANTS

One 4-inch burro's tail
(*Sedum morganianum*) or *S. burrito*

Nine 4-inch houseleeks:
2 *Sempervivum tectorum*,
5 *S. arachnoideum*, and 2 *S. calcareum*

Nine 4-inch echeverias:
2 *Echeveria* 'Imbricata', 2 *E.* 'Domingo',
2 *E.* 'Dondo', 2 *E.* 'Pulidonis', and 1 *E.* 'Lola'

Two 4-inch Catalina live-forevers
(*Dudleya hassei*)

Two 4-inch pachyphytums
(*Pachyphytum hookeri*)

Two 2-inch ghost plants
(*Graptopetalum paraguayense*)

One 4-inch *Sedum oaxacanum*

CONTAINER AND MATERIALS

Faux concrete bowl,
15½ inches in diameter and 8 inches tall

1-inch square of screen

2 cups of small lava rock

8 to 10 cups of cactus mix

1 Cover the drainage hole in the pot with the screen, then pour a 1-inch layer of lava rock into the pot. Add in the cactus mix until the pot is about two-thirds full. Set some aside to create a mound in the center if needed. Unpot and lay out the plants.

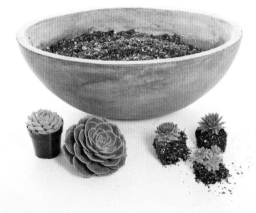

2 Start planting in the center of the pot. Choose the biggest plants to go in first. Add more cactus mix, if needed, so that the center plants sit higher than those near the rim of the pot.

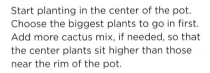

3 Fill in with the smaller and draping succulents. Make sure that they are planted level with the rim of the pot and that the succulents are free to drape over the edge. Let the arrangement dry between waterings.

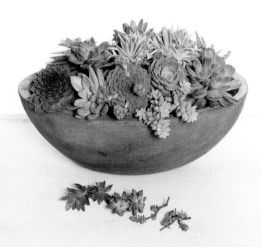

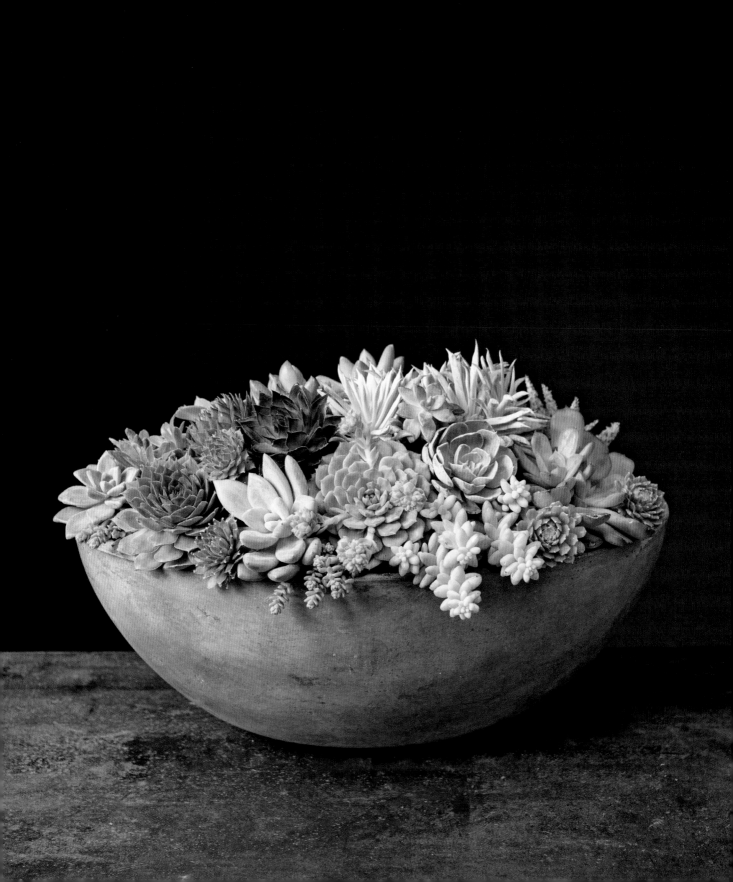

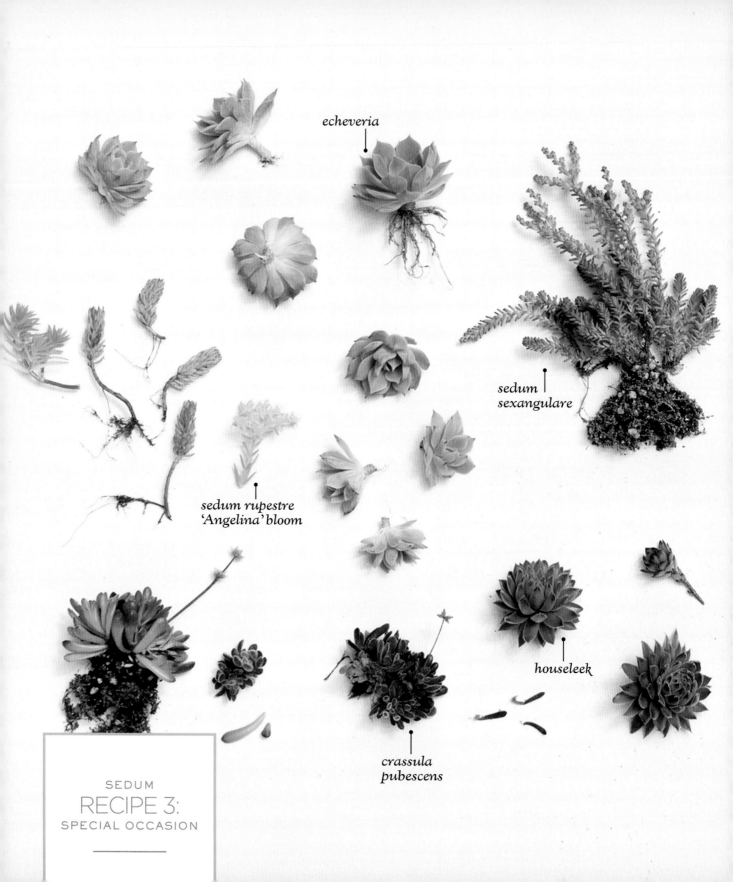

echeveria

*sedum
sexangulare*

*sedum rupestre
'Angelina' bloom*

*crassula
pubescens*

houseleek

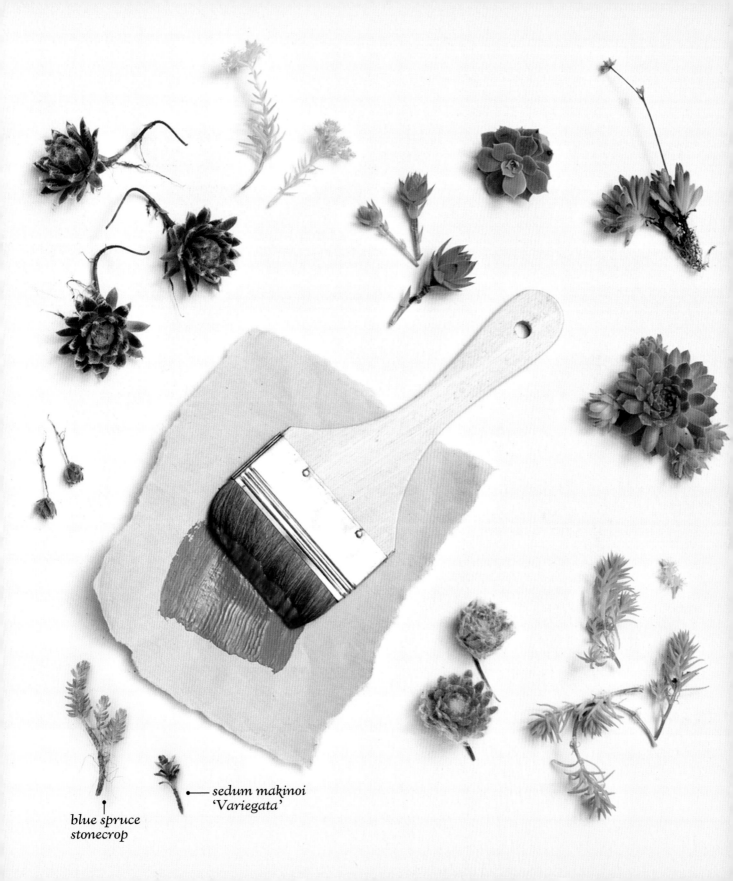

blue spruce
stonecrop

sedum makinoi
'Variegata'

PLANTS

Four 4-inch stonecrops (*Sedum rupestre* 'Angelina', *S. acre* 'Elegans', and *S. sexangulare* are good choices)

Two 2-inch variegated Japanese stonecrops (*Sedum makinoi* 'Variegata')

One cutting blue spruce stonecrop (*Sedum reflexum* 'Blue Spruce')

Eight 2-inch (or two 4-inch) Dwarf Rubies (try *Crassula pubescens* or *C. subsessilis*)

Three to four 2-inch houseleeks (*Sempervivum arachnoideum* and *S.* 'Sunset' are nice choices)

Ten 2-inch echeverias (*Echeveria secunda*)

CONTAINER AND MATERIALS

Wood shutter box, 11 inches by 20 inches

8-quart bag of cactus mix

2 cups of decorative gravel

1. This is a repurposed shutter with a sturdy box built on its back. (I painted mine red.) Drainage holes on the bottom and hooks on the back allow for easy removal and watering. The slats of the shutters hold in both the soil and the plants remarkably well.

2. Lay the shutter box flat on its back. Use a trowel and a funnel to pour cactus mix inside, until the box is almost full. Gently jostle the shutter to allow the mix to settle evenly.

3. Begin with the potted succulents. Unpot them, divide them into smaller pieces if necessary, and slip them inside the slats, making sure their soil and roots have fully entered the box. Gently tap down the soil. Next, slip in any cuttings. Make sure they penetrate the cactus mix so that they will root and take hold.

4. Let the shutter lie flat for one week to keep the plants in place and encourage them to root.

5. Tip the shutter vertically and, using a spoon, add decorative gravel to fill in any gaps. With care, hang the shutter on the wall. The plants will continue to root and spread to fill in the gaps, spreading along the frame. Water with a watering spout once a week and let drain, and this will grow, evolve, and last for years.

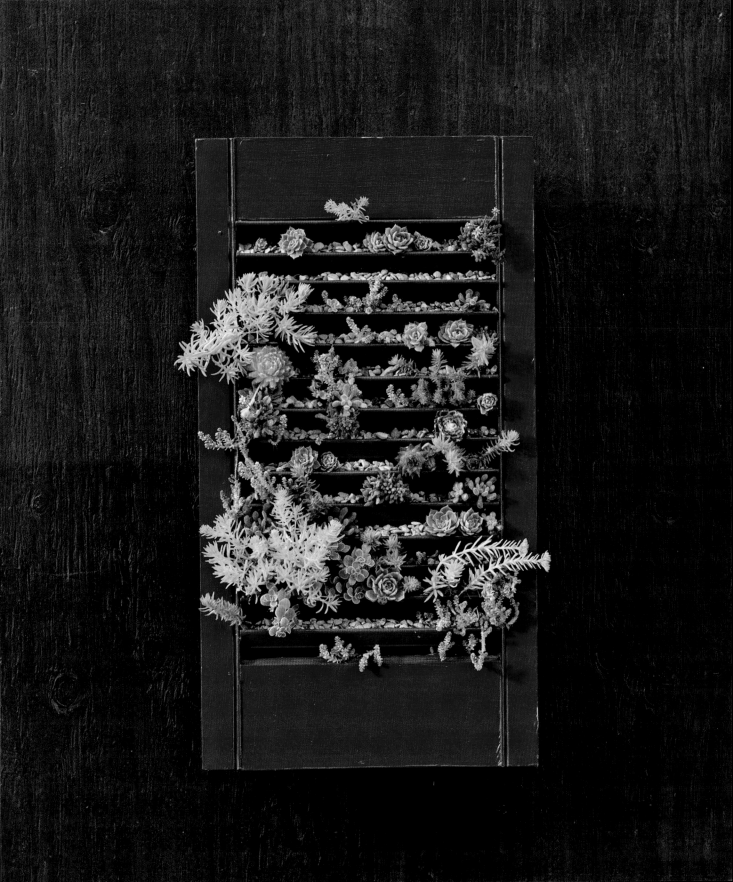

SEMPERVIVUM

PLANT TYPE: succulent

SOIL: cactus mix

WATER: allow the surface soil to dry between waterings

LIGHT: bright direct

I love setting sempervivum on a windowsill. Its rosettes are small enough to rest on the narrow ledge, and they love to soak up the sun. They are sometimes called houseleeks or hens and chicks (yes, just like some species of *Echeveria*). Some varieties grow cobwebs of a weird white film, a trait that's not for everyone but which can be used to great, if eclectic, effect in the right container.

SEMPERVIVUM
RECIPE 1:
ON ITS OWN

PLANTS
Seven 2-inch houseleeks
(*Sempervivum* 'Icicle', *S.* 'Kalinda',
S. 'Silver', and *S.* 'Queen'
are nice choices)

CONTAINERS AND MATERIALS
7 vintage gelatin molds about
2 inches in diameter

1 cup of cactus mix

7 tablespoons of decorative gravel

50–50 mixture of glue
(like Elmer's) and water

Decorative platter, 12 inches
in diameter

1. Gelatin molds are the perfect size for one perfectly grown sempervivum rosette in a 2-inch pot. Be mindful that some molds have narrow bottoms and therefore might tip over more easily.

2. Unpot each succulent and set it inside a mold. Gently massage the roots if the plant is too tall for the pot—it will flatten out the root ball to make it fit.

3. Fill in around the edges with more cactus mix if needed, so that it fills the container and is flush with the rim.

4. Cover the cactus mix with a layer of decorative gravel. For extra protection, squirt about a tablespoon of the glue mixture evenly across the top of the gravel in each mold. This will hold the gravel in place should a mold tip over. Set the molds on the platter.

5. Use a tablespoon to water the plants about once a week, and gently tip the molds to release extra water. The arrangement will last for months and months.

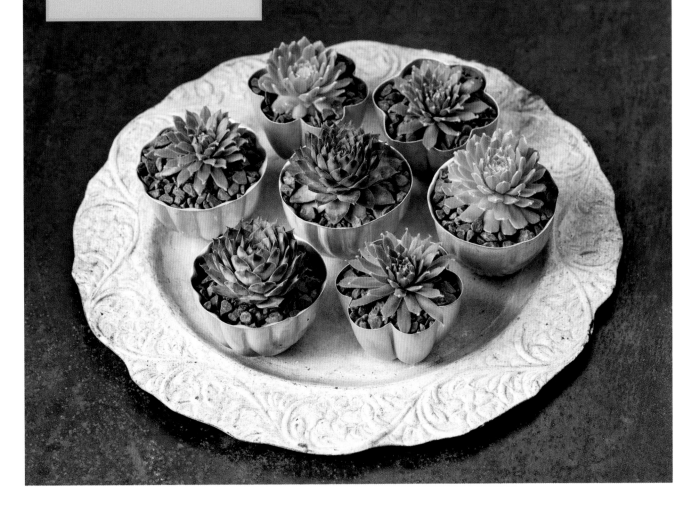

PLANTS

Two 4-inch aeoniums: 1 *Aeonium* 'Ballerina'
and 1 *A*. 'Sunburst' or 'Kiwi'

Seven 2-inch aeoniums (*A*. 'Sunburst')

One 2-inch crassula (*Crassula pubescens*)

Fourteen 2-inch echeverias:
2 *Echeveria* 'Domingo', 1 *E*. 'Doris Taylor',
6 Mexican snowballs (*E. elegans*),
2 hens and chicks (*E. secunda*),
2 *E*. 'Pinwheel', and 1 *E*. 'Lola'

Five 2-inch stonecrops:
3 *Sedum dasyphyllum* and
2 *S. rupestre* 'Angelina'

Four 2-inch houseleeks
(*Sempervivum* 'Carmen')

Two 2-inch strings of pearls
(*Senecio rowlyanus*)

Two 2-inch Cuban oreganos
(*Plectranthus amboinicus*)

CONTAINER AND MATERIALS

Dried date palm, with a split, 56 inches long

5 cups of cactus mix

Choose a dried date palm or a large oval-shaped container with a long, narrow split and enough room inside for 2-inch plants. If there are no "closers" on the ends, make foil barriers with a moss backing and set them inside so that the cactus mix won't come spilling out. To keep this container steady, you may need to glue on tiny legs of wood blocks. Use a funnel to pour in the cactus mix until the palm is about two-thirds full. Mound the mix in various sections to create rolling hills in the design. Once the plants grow in, tipping the palm to the side makes it look even more fabulous (and once the plants root, they won't fall out).

 Unpot all of the succulents and line them up along the side of the vessel. Play with the design: place groups of smaller succulents together for more impact, and allow single, large succulents to stand alone. Add in a blooming succulent for some height; tuck the smallest succulents in the very narrow edges of the opening.

3 Plant the succulents snugly so that they sit in a tight-knit group. Drape the string of pearls over the edge so that it will eventually grow out and down onto the table. Let the arrangement dry out between waterings once a week. With proper grooming, this will grow on for years.

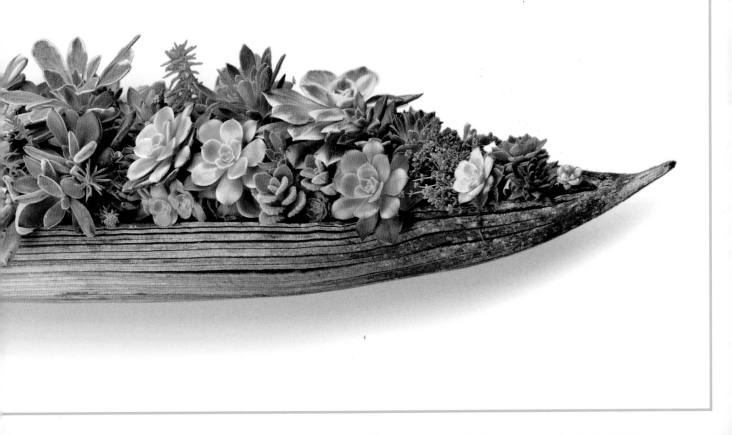

SHAMROCK *(Oxalis)*

PLANT TYPE: annual, perennial, bulb

SOIL: potting mix

WATER: keep moist

LIGHT: bright

A shamrock is said to bring good luck, but say "oxalis" and some gardeners may shudder—that's a weed! While it can be invasive, it's also a fun, happy-go-lucky plant also known as a wood sorrel. Keep it moist and make sure it gets a bit of light to keep its leaves dancing upright.

PLANT

One 4-inch shamrock
(*Oxalis deppei* 'Iron Cross')

CONTAINER AND MATERIALS

Small glass vase,
about 4½ inches in diameter
at the base and 6 inches tall

¼ cup of charcoal

2 cups of potting mix

1 cup of decorative gravel

1. Add a very thin layer of charcoal to the bottom of the vase.

2. Funnel in the potting mix. Allow for several inches of space at the top.

3. Unpot and plant the oxalis. Then use a funnel or a spoon to cover the soil with the decorative gravel. Dark gravel, like the black gravel used here, complements the dark centers of the oxalis.

4. Gently tug at the leaves to untangle them and drape them over the rim of the vase. Keep moist but not soggy.

PLANTS

One 4-inch primrose
(*Primula* 'Victoriana Gold Lace Black')

One 4-inch fiber-optic grass (*Isolepis cernua*)

One 4-inch strawberry begonia
(*Saxifraga stolonifera*)

One 4-inch shamrock
(*Oxalis deppei* 'Iron Cross')

CONTAINER

Milk glass pedestal vase 6¼ inches
in diameter and 5 inches tall

Unpot the blooming primrose and set
it inside the vase. Unpot and place the
grass behind the primrose to add some
fun movement to the arrangement.

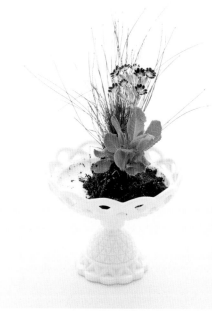

2 Unpot and place the begonia at the
front and to the left of center, allowing
the foliage to drape over the edge of
the vase.

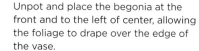

3 Finally, unpot and place the oxalis at the
front and to the right of center. Untangle
the leaves and let them dance off the
edge of the vase. This arrangement
should last a couple of months. When it
begins to fade, disassemble it. Choose
the begonia or shamrock to live solo in
the vase, and repot all the other plants.

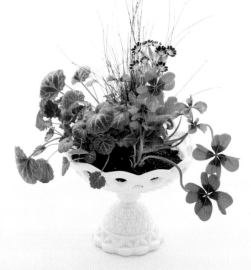

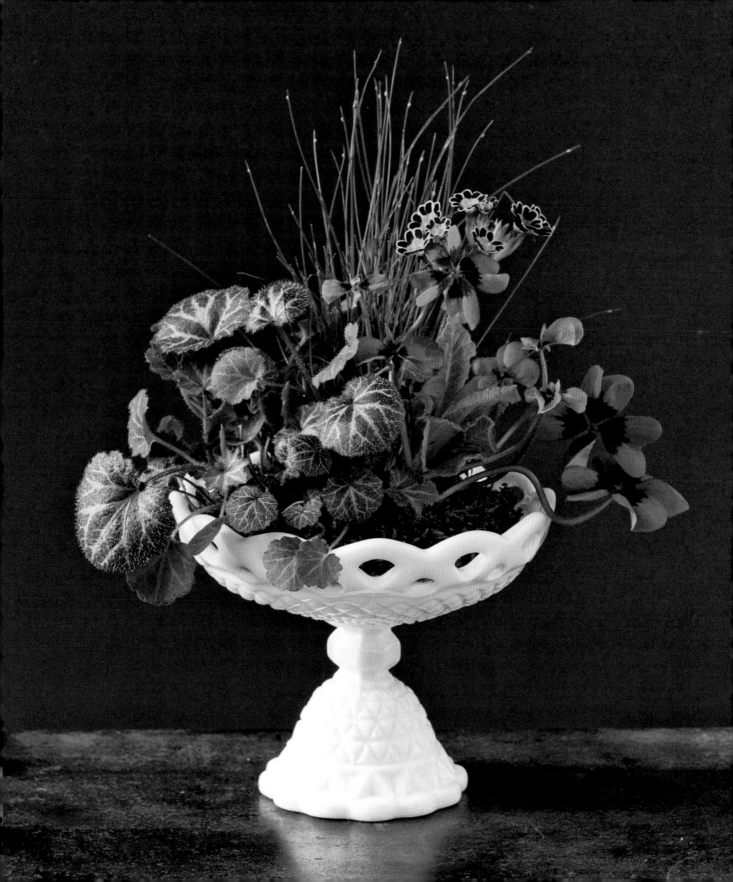

SPIKEMOSS *(Selaginella)*

PLANT TYPE: fern relative

SOIL: potting mix

WATER: keep moist

LIGHT: shade to low to bright indirect

This lace-like plant is moisture-loving and shade-loving, making it perfect for rooms without direct sunlight. There are many forms to choose from—some are low, while others crawl up a bit higher, so growth habit matters here to get the right effect.

PLANTS

Four 2-inch spikemosses
(*Selaginella*), compact form

CONTAINER AND MATERIALS

Colorful box, about 5 inches square

Cellophane or foil

1. Select a low box with loads of color. Orange is a fabulous match with bright green. This simple plant looks best with some pop!

2. Line the box with cellophane or foil to add a layer of waterproofing.

3. Unpot the plants and place them in the box. Plant them snugly together, but take care not to squish their delicate leaves. Eventually the four plants will grow into one united mound of spikemoss. Keep moist.

PLANTS
One 2-inch Argentine sword
(*Echinodorus argentinensis*)

One 2-inch waterweed (*Egeria densa*)

Three 2-inch spikemosses: 1 mounding form
(*Selaginella*) and 2 peacock ferns
(*Selaginella wildenowii*)

Two 2-inch mondo grasses
(*Ophiopogon japonica*)

1 cutting of ruby red clubmoss
(*Selaginella erythropus* 'Sanguinea')

CONTAINERS AND MATERIALS
3 glass terrariums, 4 inches in diameter and
of various heights

⅓ cup of charcoal

1 cup of decorative gravel

1 cup of sandy potting mix

1 cup of aquarium gravel

2 rocks, 1 to 2 inches in diameter

Though spikemoss is sold as an aquarium plant at pet stores, it does not have a long life underwater. The other plants will outlive it, but it is still fun to enjoy for a short while. Add one spoonful of charcoal to each container, followed by a ¼-inch layer of decorative gravel. Unpot the plants. The aquarium plants may be sold in a white water-holding "soil." Be sure to remove all of that before planting. The mondo grass can be separated and used in two of the terrariums.

2 Add the potting mix to the containers. With a long spoon, dig a small hole in the soil and plant each plant. Cover them lightly with additional soil, then add a layer of aquarium gravel on top. Use the long leaves of the red clubmoss cutting for a temporary higher-floating plant.

3 Carefully place the rocks to add visual interest and to anchor the design. With a long tool (I use long tweezers), intertwine the plants and drape them over the rocks. Fill the container by pouring water down the side of it so as not to disturb the soil and cloud the water. As the spikemoss fades, the other plants will flourish. **Note:** Algae will develop; gently flush the water as needed to keep it clear.

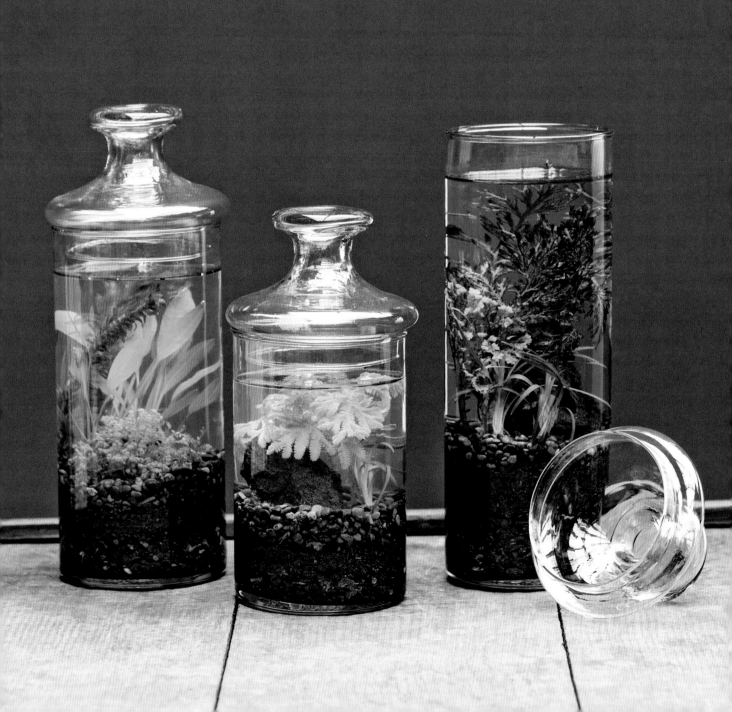

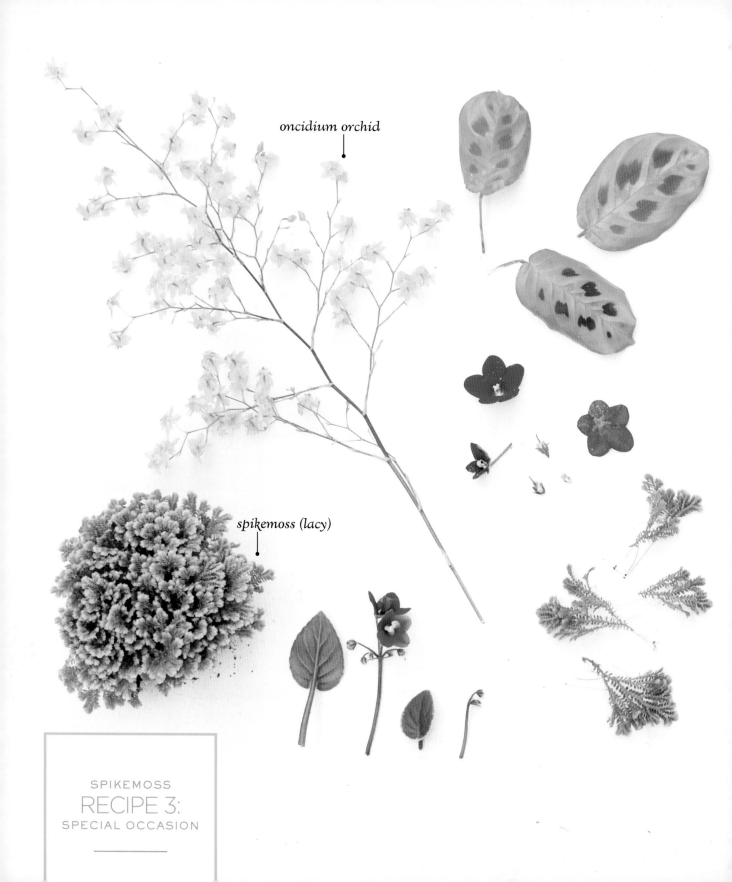

oncidium orchid

spikemoss (lacy)

SPIKEMOSS
RECIPE 3:
SPECIAL OCCASION

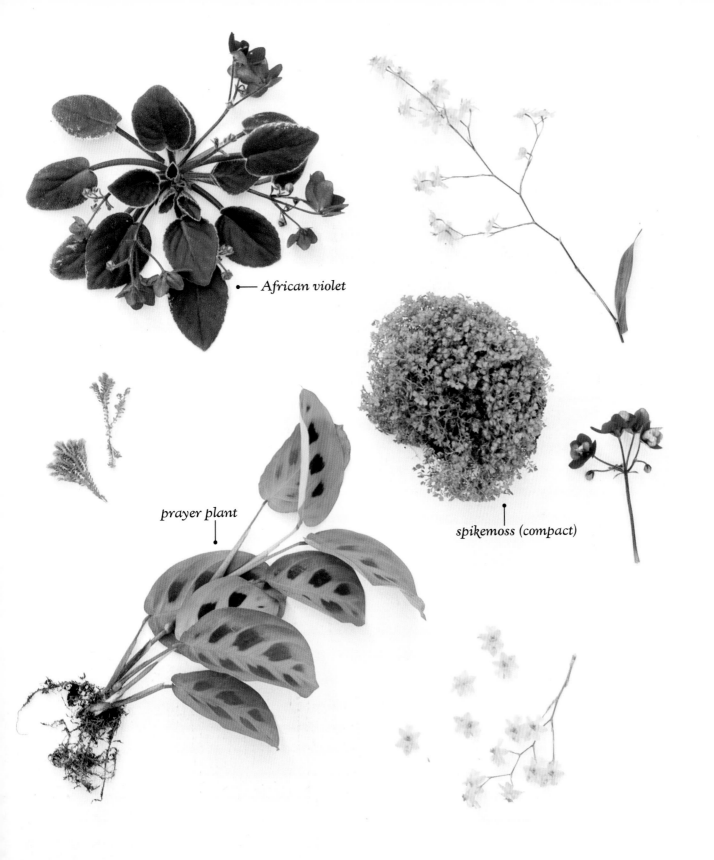

African violet

prayer plant

spikemoss (compact)

RECIPE 3:
SPECIAL OCCASION

PLANTS
One 6-inch prayer plant (*Maranta*)

One 4-inch orchid (*Oncidium* 'Twinkle')

One 4-inch spikemoss (*Selaginella*), lacy form

One 2-inch African violet (*Saintpaulia*)

One 2-inch spikemoss (*Selaginella*), compact form

CONTAINERS
Pedestal vase, 12 inches in diameter

Pedestal vase, 4 inches in diameter

1 Choose mercury pedestal vases for a fancy look.

2 Plant the prayer plant in the larger vase. Keep the orchid in its grow pot and prop it inside of the prayer plant, letting its tall blooms flare out.

3 Tuck in the unpotted lacy-form spikemoss along the edge, allowing it to drape over the side.

4 Plant the small vase with the African violet and the compact spikemoss.

5 Keep this arrangement moist, and remove the orchid when it's finished blooming.

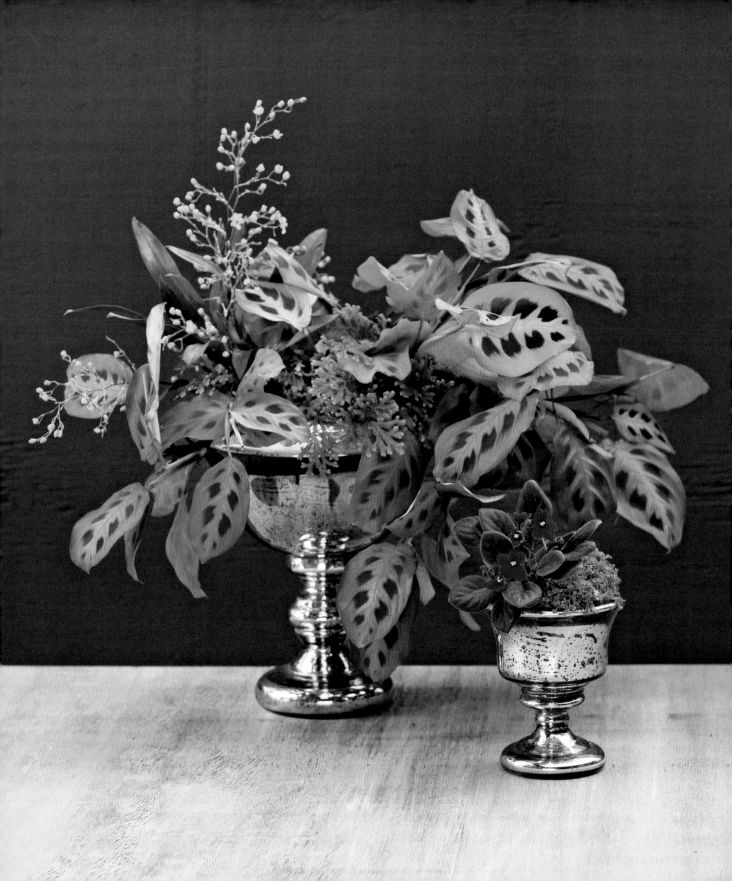

STAGHORN FERN

(*Platycerium*)

PLANT TYPE: epiphytic fern

SOIL: none

WATER: allow the surface soil to dry between waterings

LIGHT: low to bright

The antler-like leaves on the aptly named staghorn fern aren't the only reason they seem fit to mount on the wall. They're epiphytes, which means that they don't need any soil, and they like to grow on branches or trees or, one presumes, on a wall if you let them. Be careful with their furry leaves—touching them can wipe off the delicate fuzzy layer.

RECIPE 1:
WITH COMPANY

PLANTS

One 6-inch staghorn fern
(*Platycerium bifurcatum*)

One 4-inch wandering Jew
(*Tradescantia zebrina*)

One 6-inch rex begonia (*Begonia*)
with pink and silver leaves

CONTAINER AND MATERIALS

Wood pedestal vase,
10 inches in diameter

Cellophane or foil

Plastic liner to fit the vase

1. Line the vase with cellophane, then set the plastic liner inside. The plants will be planted in the liner.

2. Unpot all the plants. Place the staghorn fern at an extreme angle, letting the fronds drape horizontally and over the edge of the vase.

3. Set the wandering Jew on the opposite side of the vase and angle it in the same manner.

4. Tuck the begonia into the center. Carefully blend its fabulously patterned leaves in with the other two plants to make this design look as though it grew in together as one. Keep just moist, and replant after a few weeks.

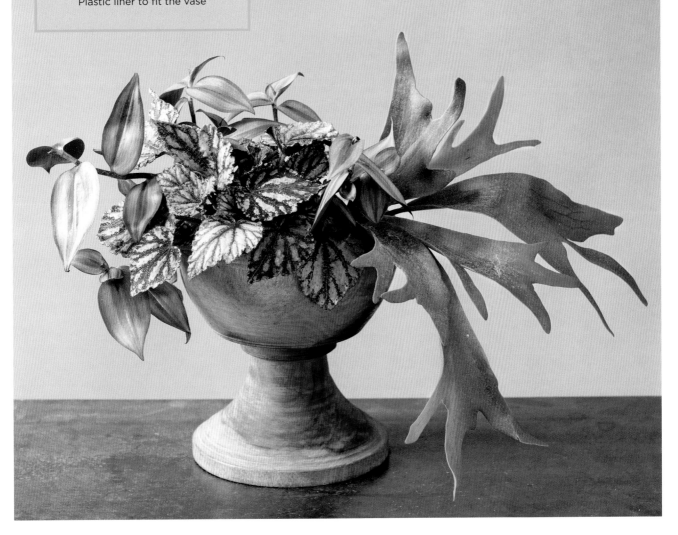

RECIPE 2:
ON ITS OWN

PLANT
One 6-inch staghorn fern
(*Platycerium bifurcatum*)

CONTAINER AND MATERIALS
Shallow wood bowl, 18 inches in diameter

2 large handfuls of sphagnum moss

5 mounds of cushion moss

Wax or wood oil

Coated wire

Any piece of wood will do, but this mahogany bowl with a very shallow dip seemed perfect to host a mounted fern. Attach a hanging mechanism to the back of the bowl before you start working with the fern (a picture-hanging kit works; just make sure it can hold the weight of this soon-to-be-heavy arrangement). Coat the wood with melted wax or wood oil to help protect it from splitting.

2 Soak both types of moss in water, separately. Unpot the fern and wrap the root in sphagnum moss (see page 17), and then wrap the moss with the wire to hold it in place. Place it on top of the bowl and mark the moss ball's two outer edges. Remove the plant and drill two holes.

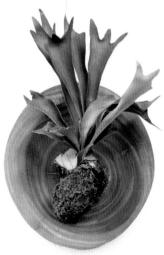

3 Replace the plant and set the cushion moss on top in a tight round form, wrapping it with wire. Then loop the wire through the holes drilled through the board. Secure the plant and moss to the bowl and hang it in a shady area. Mist one to three times a week and remove and soak facedown in a bucket of water once a week, and this will last for years.

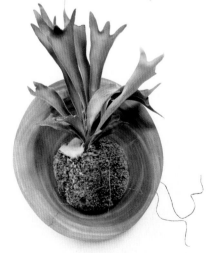

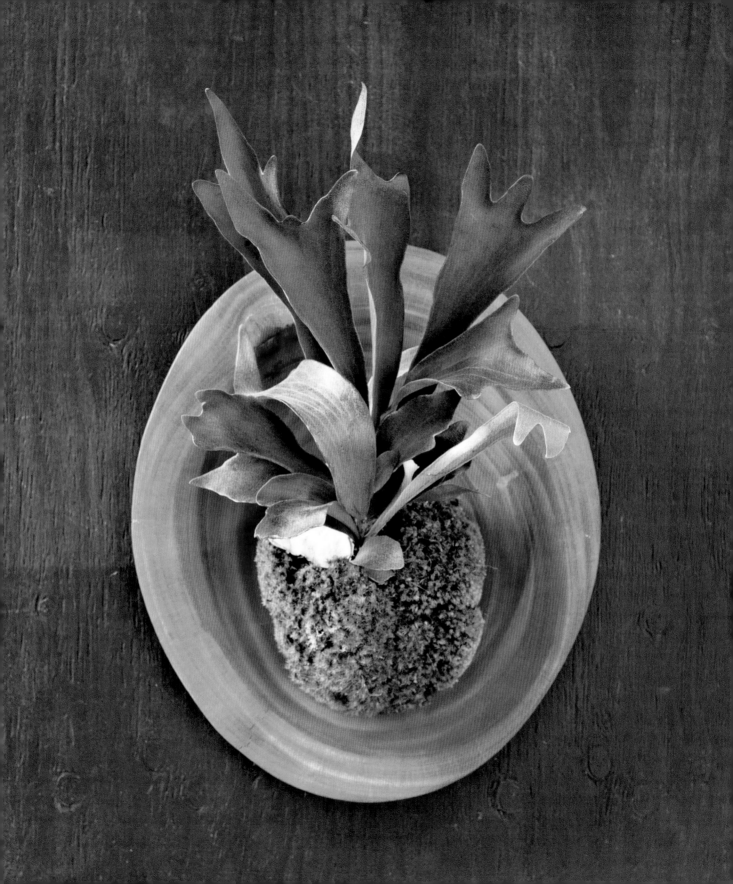

THYME *(Thymus)*

PLANT TYPE: herb

SOIL: potting mix

WATER: keep just moist

LIGHT: bright direct

Thyme isn't just wonderfully fragrant, it's beautifully airy and easy-looking, too. It comes variegated or in solid green. Brush against the tiny leaves and take a whiff. It's not just a powerhouse of scent; you can eat it!

PLANT
One 4-inch thyme
(*Thymus vulgaris* 'Lime')

CONTAINER AND MATERIALS
Small ceramic bowl,
6 inches in diameter

1 cup of small lava rock

Suede hand-cut pouch

1. Remember the macramé hangers from way back when? They're back, with a twist. This orange suede one is easy to hand-cut yourself (or you can also buy leather ones online).

2. Keep the thyme in its grow pot. This will make it easier to remove and water in the sink.

3. Add the lava rock to the bowl to keep the plant's roots out of sitting water.

4. Set the thyme in the decorative bowl and fluff the leaves around the strings. Place the bowl in the pouch, and hang it in a window. Keep the plant moist by watering one to three times a week. Snip and enjoy.

PLANTS

One 4-inch rosemary
(*Rosmarinus officinalis* 'Barbeque')

Two 4-inch nasturtiums (*Tropaeolum majus*)

One 4-inch mint (*Mentha* 'Sweet Salad')

One 4-inch oregano
(*Origanum vulgare* 'White Anniversary')

One 4-inch thyme
(*Thymus vulgaris* 'Transparent Yellow')

One 4-inch lemon basil
(*Ocimum basilicum* 'Mrs. Burns')

Three 4-inch sages: 2 pineapple sages
(*Salvia elegans*) and 1 *S.* 'Grower's Friend'

CONTAINER AND MATERIALS

Vintage fruit box, roughly 13 inches by
11 inches and 6 inches tall

1 roll of landscaping fabric,
cut into a 3-foot section

8-quart bag of potting mix

4 tiny blocks

Line the box with landscaping fabric,
which will allow the water to drain, but
not the mix. Add enough potting mix for
the plants to rest at the top of the box.
Add a protective lining first if you will be
setting this on a water-sensitive surface.
Unpot the plants. Begin by planting
the rosemary, as the tallest plant, in one
corner. Place the nasturtiums on two other
corners. Let one dangle over the edge and
encourage the other to remain upright.

 Add in the mint. Mint likes to spread,
so keep it in its pot as a not-altogether-
foolproof way to contain it.

3 Create a stream-like effect with creamy
yellow and white variegated oregano
and thyme running down the center and
dripping over the edges. Fill in with the
basil, pineapple sage, and sage around
the edges. Lift and place in the kitchen
sink to water about twice a week. Return
to the countertop after it has drained,
making sure it dries in between waterings.

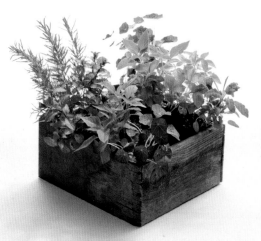

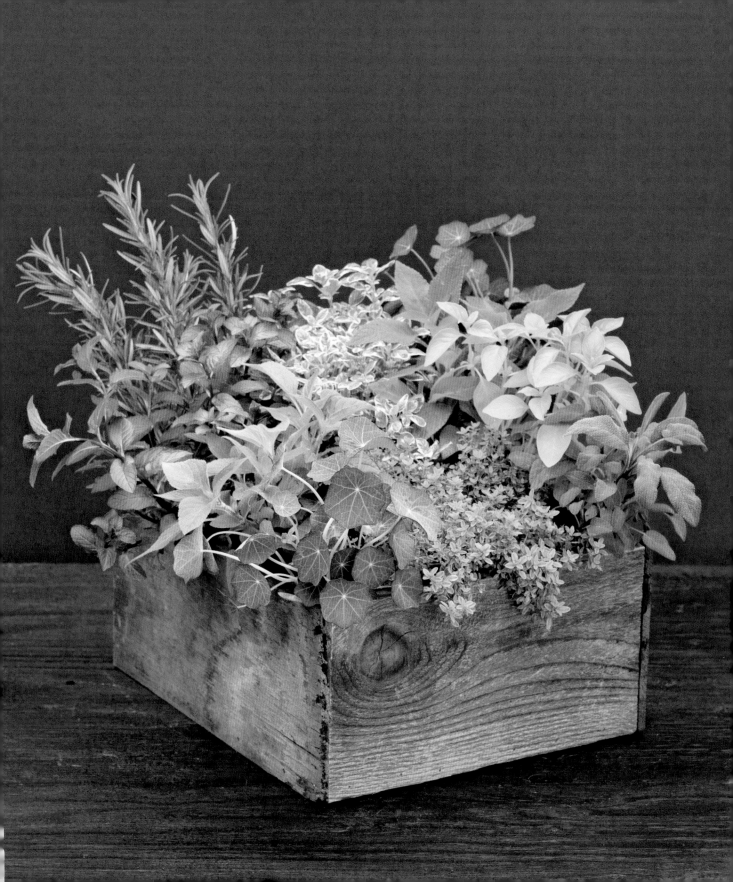

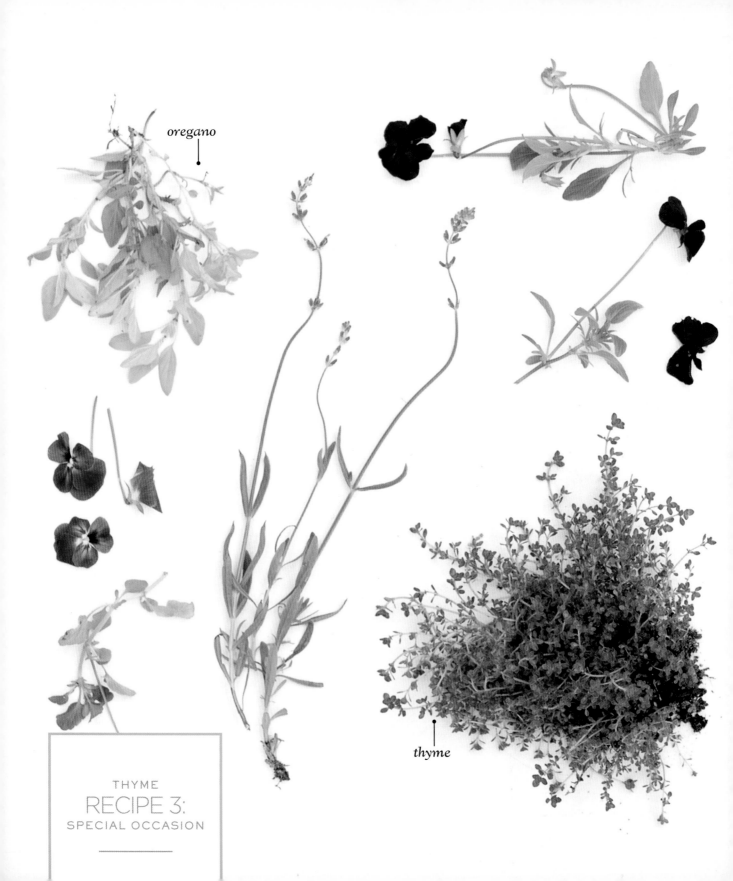

oregano

thyme

THYME
RECIPE 3:
SPECIAL OCCASION

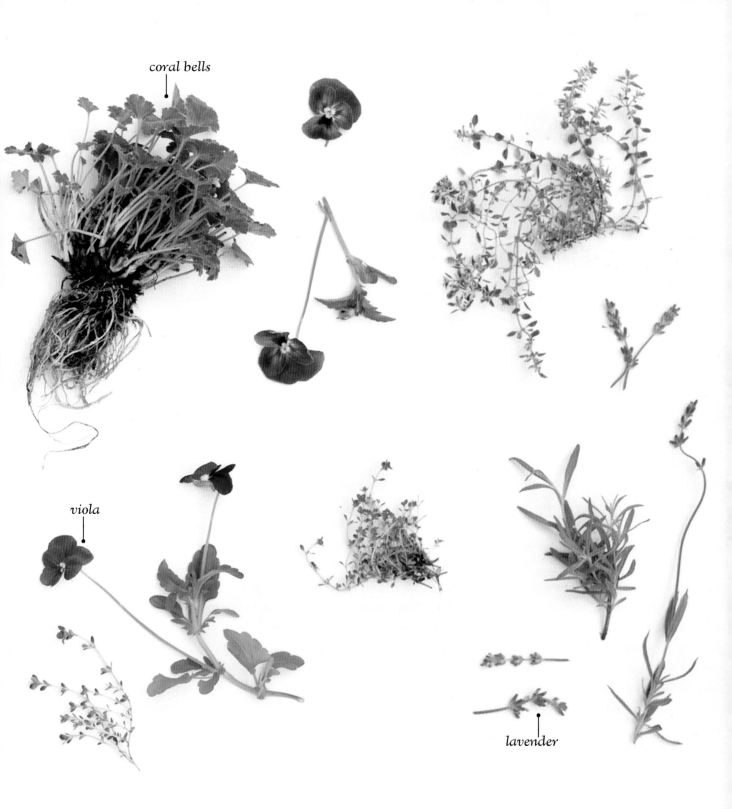

coral bells

viola

lavender

RECIPE 3:
SPECIAL OCCASION

PLANTS

Four 4-inch thymes: 1 *Thymus serpyllum* 'Pink Chintz',
2 *T. serpyllum* 'Elfin', and 1 lemon thyme (*T.* 'Lemon')

One 4-inch viola (*Viola cornuta* 'Black Magic')

Four 2-inch violas (*Viola* 'Sorbet Raspberry')

One 4-inch golden creeping oregano
(*Origanum vulgare* 'Aureum Prostratum')

One 4-inch coral bells (*Heuchera* 'Canyon Duet')

Two 4-inch lavenders (*Lavandula angustifolia* 'Hidcote')

CONTAINER AND MATERIALS

Copper vertical planter kit, 16 inches by
5 inches and 24 inches tall

15 cups of potting mix

1 Set the frame flat on the table and fill two-thirds full with potting mix.

2 Unpot all the plants and set them aside. Lay out the design. Plant thyme along the edges so that it grows across the top of the frame, softening the edges and making a shadow pattern on the shiny surface.

3 Fill in the center section with the flowering violas. Slip in the oregano and coral bells. Plant lavender on the top so that it reaches for the sky, crossing over the frame.

4 Water evenly one to three times a week. The frame has a reservoir at the bottom to hold extra water and protect your home. Hang in a window. Cut and enjoy.

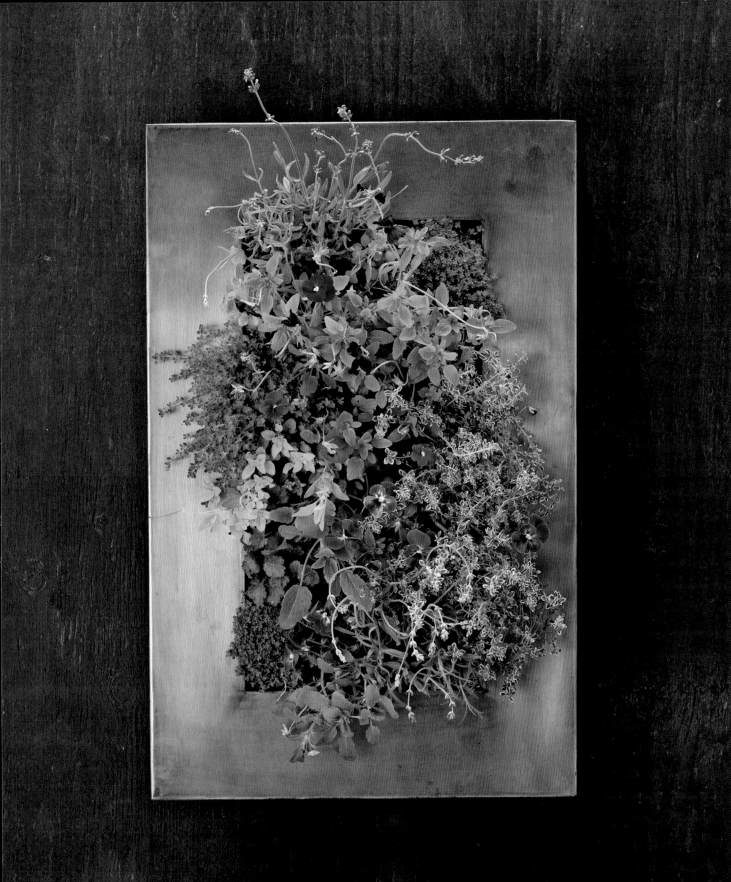

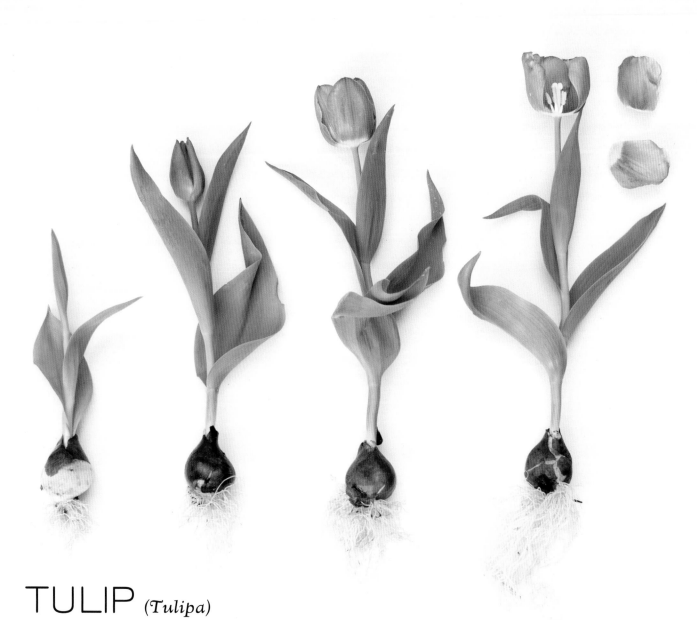

TULIP *(Tulipa)*

PLANT TYPE: bulb

SOIL: potting mix

WATER: keep just moist to moist

LIGHT: bright

These ephemeral bursts of color are easy to find in grocery stores and nurseries in spring and early summer. Their long stems and blossoms evolve and change daily as they reach for the sky, then pop, stretch some more, and finally droop and fade away.

PLANTS

Two 4-inch coral bells
(*Heuchera* 'Fire Alarm')

Three 6-inch flowering tuberous
begonias (tuberous *Begonias* are
usually found in the summer months
filled with loads of blooms)

Three 6-inch tulips (*Tulipa*)

CONTAINER AND MATERIALS

Tin vase, 12 inches in diameter

Metal cake stand,
12 inches in diameter

5 cups of potting mix

1. Place the vase on top of the metal cake stand. It creates height, which is important to this design.

2. Add potting mix to the vase until it is three-quarters full. Unpot the plants and set them aside. Begin with the coral bells, placing them at the front edge of the vase on the left, positioning the burnt-orange leaves so that they drape over the rim. Place the blooming begonia next to the coral bells, on the right, letting its rosettes float over the right edge.

3. Mound the back center of the vase with more potting mix. Then fill in the back of the tin with the tulips, which will now sit above the plants in front. Separate the bulbs if necessary to spread out the blooms, but be careful to keep the flowers' roots intact. Gently warm up and massage the tulip stems to make them turn in a desired direction. You may add a hidden stake with twine if more aggressive manipulation is necessary.

4. The tulips will fade quickly. When they do, disassemble the arrangement, compost the tulips, and repot the begonias, which will bloom all summer long.

RECIPE 2:
ON ITS OWN

PLANTS

8 tulip (*Tulipa*) bulbs of varying heights,
beginning to bloom

CONTAINER AND MATERIALS

Low metal tray, 10 inches long

½ cup of small lava rock

3 cups of potting mix

1 cup of decorative gravel

Select tulip bulbs that have begun to
sprout but have not yet fully bloomed.
Part of the wonder is watching them
grow. Pour a thin layer of lava rock into
the tray, then add a sprinkling of the
potting mix.

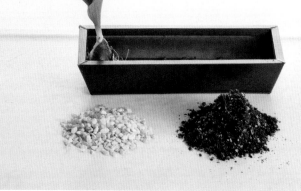

2 Unpot the bulbs and carefully separate
and plant them in a line across the tray.
Add more potting mix if needed to
partially cover the bulbs.

3 Scoop on the decorative gravel so
that it slightly covers the bulbs and
completely covers the potting mix.
Keep moist and cool.

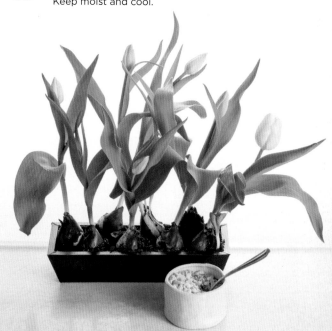

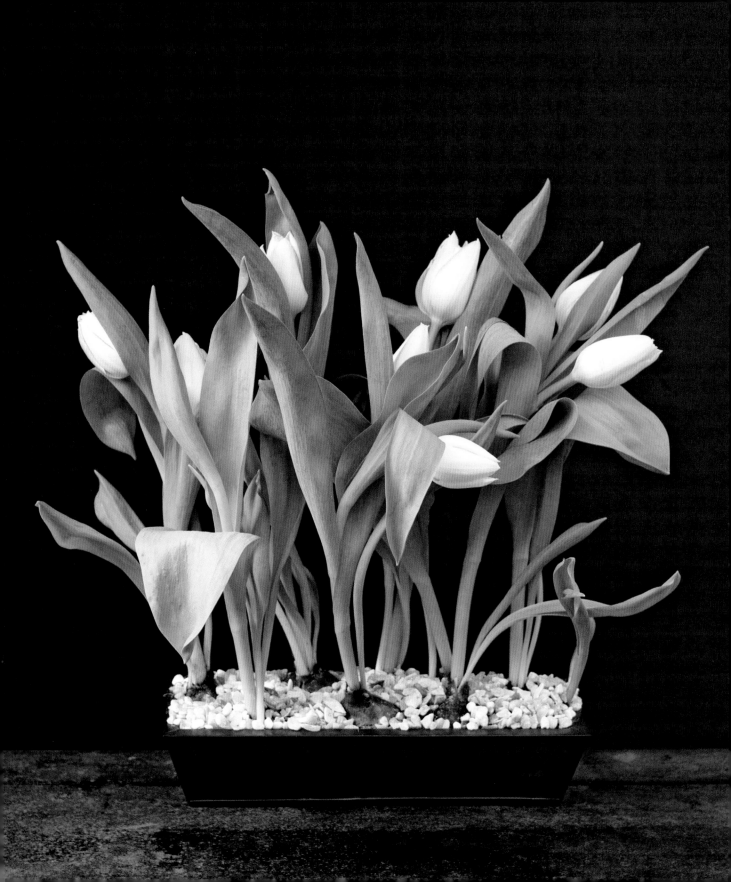

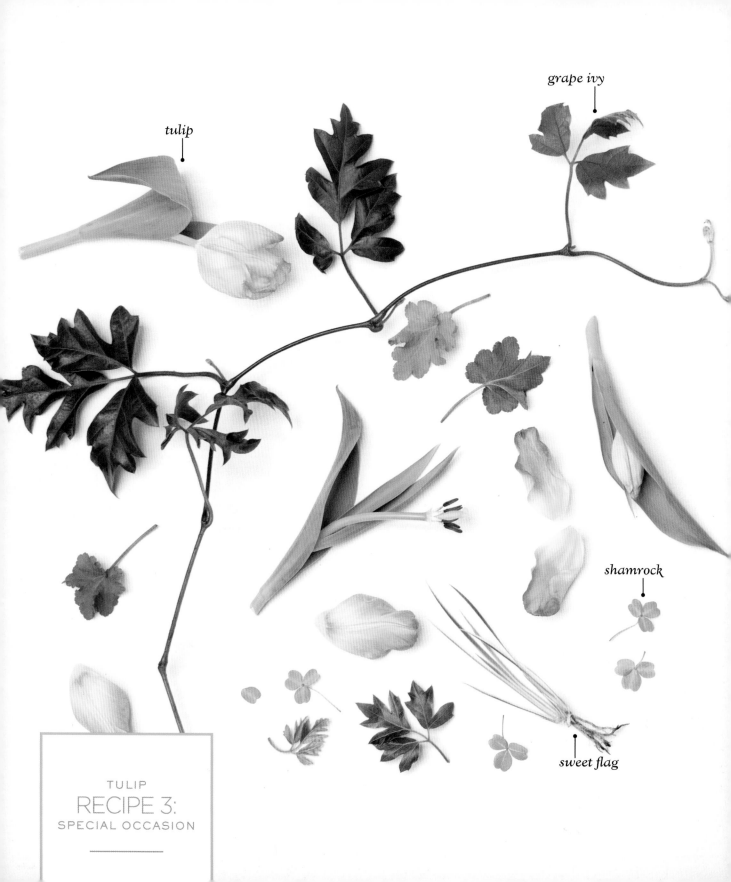

tulip

grape ivy

shamrock

sweet flag

TULIP
RECIPE 3:
SPECIAL OCCASION

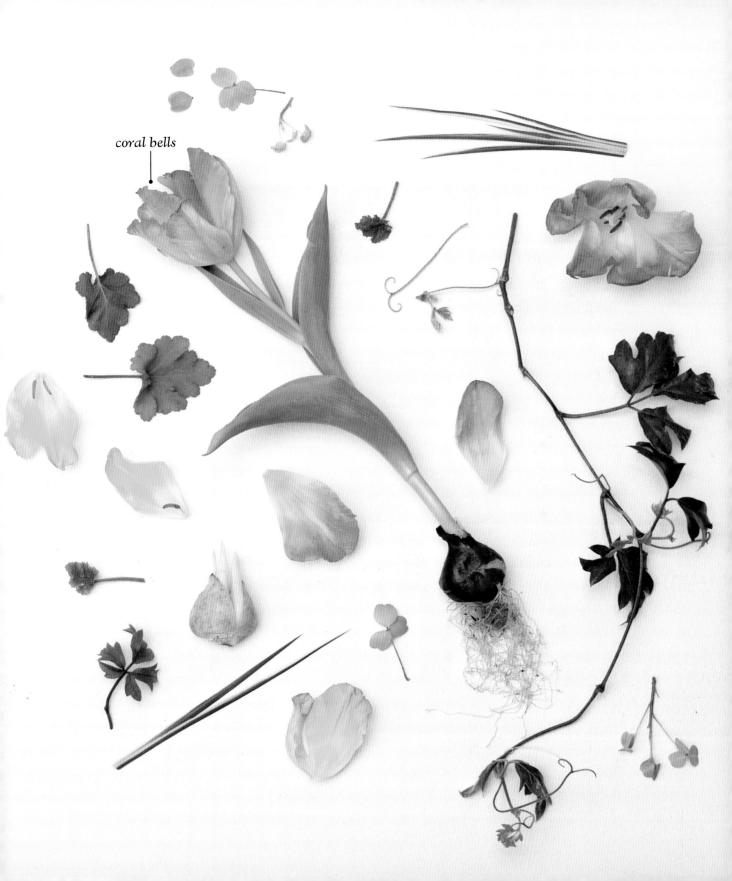

coral bells

TULIP
RECIPE 3:
SPECIAL OCCASION

PLANTS
One 1-gallon coral bells (*Heuchera*) in apricot
(look for one with "peach" or "caramel" in the name)

One 6-inch grape ivy (*Cissus rhiombifolia*)

Two 4-inch golden variegated sweet flags
(*Acorus* 'Ogon' is a good choice)

One 4-inch shamrock (*Oxalis siliquosa* 'Sunset Velvet')

Four 4-inch tulips (*Tulipa*)

CONTAINER AND MATERIALS
Red plastic bowl, 10 inches in diameter and 6 inches tall

5 cups of potting mix

1 Fill the bottom two-thirds of the bowl with potting mix.

2 Unpot all the plants and set them aside. Plant the coral bells along the left edge of the bowl. Plant the grape ivy along the right edge of the bowl, and drape the vines over the edge to get them all out of the way.

3 Split apart the sweet flags and plant the grouping in the center of the arrangement. Tuck the shamrock in the far back and to the right.

4 Keep the tulip bulbs' roots intact and place them in the bowl as a group in the back of the bowl. Vary the heights by mounding or scooping out soil as necessary. Wind the grape ivy vine through the arrangement.

5 This is a short-lived arrangement. After the tulips fade, repot the grape ivy, which makes a fantastic houseplant. The coral bells are beautiful for the garden.

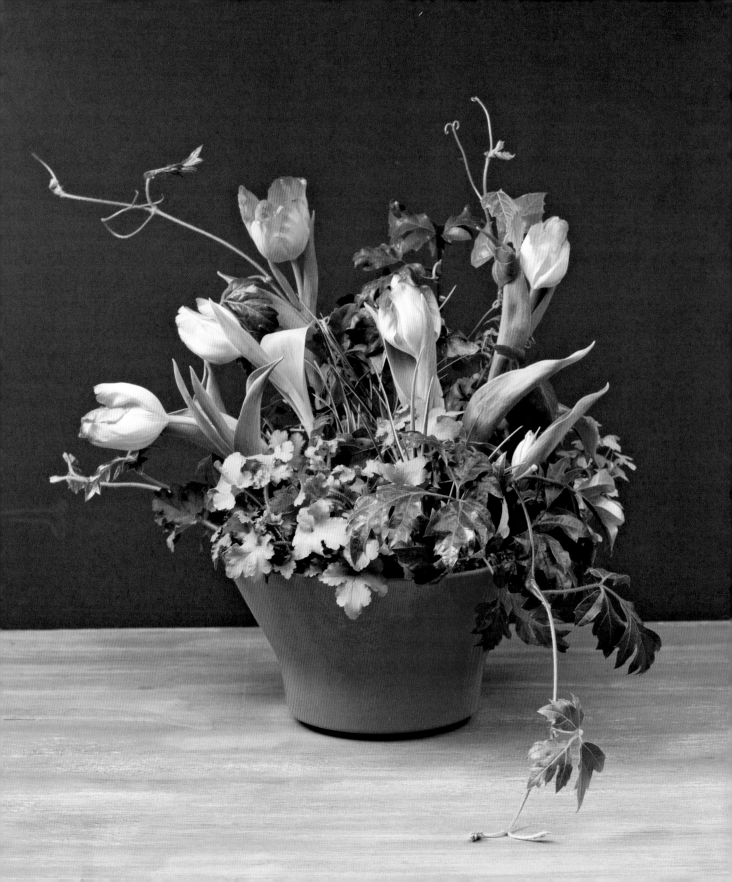

WATER LETTUCE

(Pistia stratiotes)

PLANT TYPE: aquatic plant

SOIL: water

WATER: keep wet (it floats in water)

LIGHT: bright

These summer plants have spiral floating rosettes, but the cool view is down below, at their roots. Their fine, feathered roots sway in water and glisten in the light. Algae shouldn't be a problem as these rosettes outcompete that mucky stuff for nutrients. Keep this one in its container: it's an invasive species in many areas and shouldn't be released into the wild—which includes backyards and gardens.

WATER LETTUCE
RECIPE 1:
ON ITS OWN

PLANTS

Two 4-inch and one 2-inch
water lettuces (*Pistia stratiotes*)

CONTAINER

Handblown glass terrarium with a
long neck and a 4-inch-wide opening

1. Fill the terrarium one-third full with water. Tilt, and secure the round bottom.

2. Gently clean off any dirt on the roots of the plants. Lightly prune the roots to create a more pleasing view.

3. Pluck off any yellow petals and place the water lettuces in the terrarium, allowing them to float on the water's surface. Flush if necessary, and make sure it gets bright but not direct sunlight.

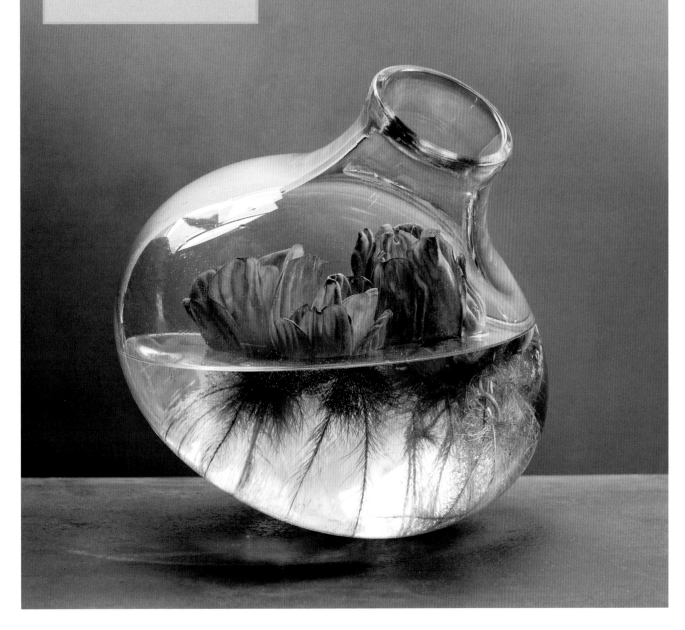

PLANTS
Two 4-inch and one 2-inch water lettuces
(*Pistia stratiotes*)

A handful of duckweed (*Lemnoideae*)

CONTAINER
Shallow ceramic bowl, 13 inches in diameter

Fill the bowl with clean water until the water level is 2 inches below the rim. Gently clean off and prune the water lettuce roots and pluck off any yellow petals. Lay one of the large water lettuces in the bowl, just off of center, and arrange the roots so that they are exposed.

2 Repeat with the other two water lettuces. Rearrange the roots as needed to create a pleasing display from above against the contrasting blue of the bowl.

3 Gently pour the duckweed into the bowl. This tiny plant may stick to your fingers, so just lightly swish your fingers in the bowl or rinse out its container to get as much out as you can. Keep full of water.

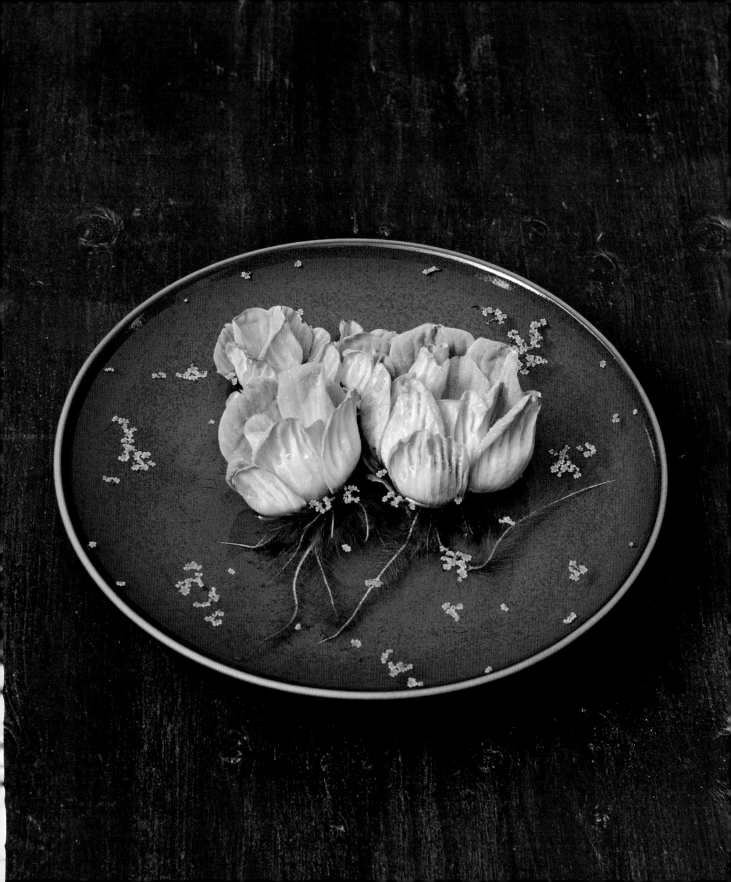

XEROGRAPHICA

(*Tillandsia xerographica*)

PLANT TYPE: epiphyte

SOIL: most need none

WATER: mist and/or soak weekly (it likes rain and dew); allow the surface soil to dry between waterings

LIGHT: bright indirect

This wonder of an air plant is almost like an octopus, with its lovely legs that curl all about. The most amazing thing about it, though, is that it doesn't need soil. Yes, it is true. Set this plant on a table and step back. Soak it once a week, shake off the water, and you're good to go for another week of a soilless arrangement.

PLANTS
Two 5-inch and
one 8-inch xerographicas
(*Tillandsia xerographica*)

CONTAINER
Wood box frame, 12 inches square

1. Set the frame on a table. A bold, solid-color wall as a backdrop will make this arrangement shine.

2. Hold one of the 5-inch xerographicas gently, stretch its legs, and wrap them around the top and right-hand side of the frame so that it hangs in the upper right-hand corner. Then place the second small xerographica in the lower right-hand corner of the frame.

3. Repeat and rest the large xerographica on top of the frame to the left, so that it balances out the weight of the two smaller plants.

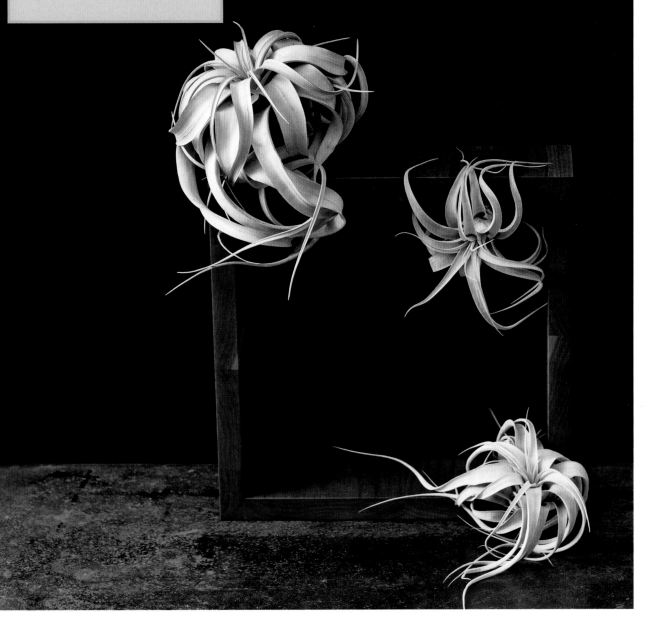

PLANTS

One 4-inch dancing-lady orchid
(*Oncidium* 'Pacific Sunrise Hakalau')

One 1-gallon Japanese painted fern
(*Athyrium niponicum pictum*)

One 8-inch xerographica
(*Tillandsia xerographica*)

CONTAINER AND MATERIALS

Glazed low bowl, 8½ inches in diameter
and 3 inches tall

Plastic liner, 4 inches in diameter

3 cups of potting mix

1 cup of orchid bark

Set the liner into the bowl just off center and toward the back. Fill in with potting mix around the liner. Check the size of the orchid's grow pot. If the grow pot will fit into the liner, simply place the pot in the liner. (This makes the orchid easy to remove, water, and drain before returning to the arrangement weekly.) Otherwise, remove the orchid from its original pot and place it in the liner.

2 Fill in around the orchid with the bark, then scoop a small hole in the soil in front and to the left of the orchid.

3 Unpot the fern and massage its roots to loosen the soil. Set it in the scooped-out hole. Make sure that the plant is level with the rim of the bowl and trim if necessary. Cover the soil with bark, and set the xerographica on top, in front of and to the right of the orchid. Remove and water the orchid and xerographica once a week; water the fern once a week, too.

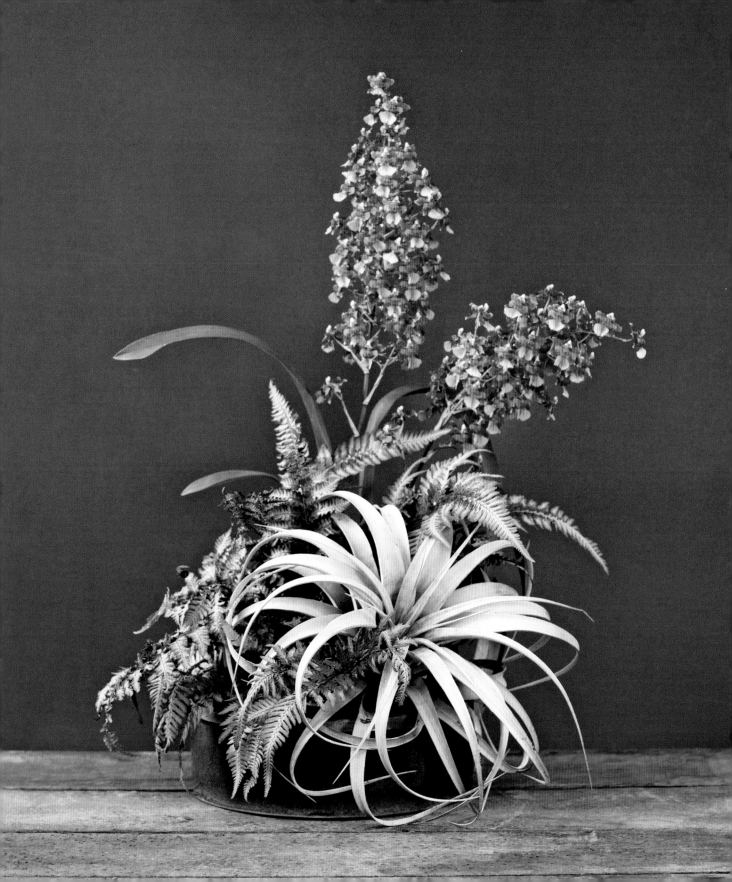

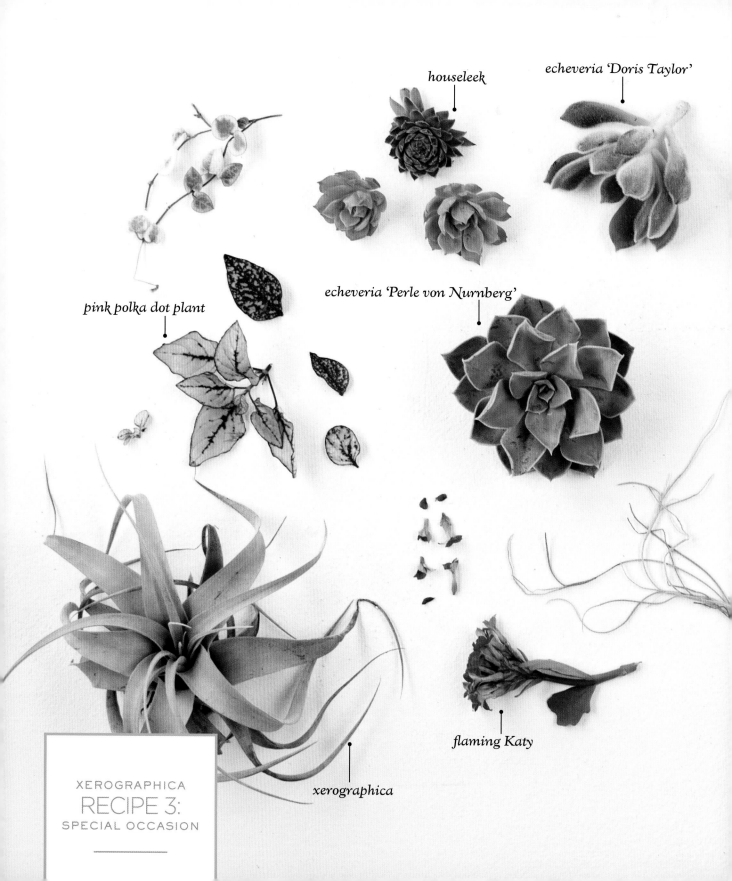

houseleek

echeveria 'Doris Taylor'

pink polka dot plant

echeveria 'Perle von Nurnberg'

flaming Katy

XEROGRAPHICA
RECIPE 3:
SPECIAL OCCASION

xerographica

Spanish moss

rosary vine

air plant

XEROGRAPHICA
RECIPE 3:
SPECIAL OCCASION

PLANTS

Four 2-inch flaming Katys (*Kalanchoe blossfeldiana*)

Three 2-inch pink polka dot plants (*Hypoestes*)

Five 2-inch echeverias or cuttings:
3 in pink (*Echeveria* 'Perle von Nurnberg'),
2 with fuzzy skin (*E.* 'Doris Taylor' is a good choice)

One 1- to 2-inch cutting of houseleek
(*Sempervivum*; look for "red" in the name)

One 2-inch air plant (*Tillandsia ionantha*) in red

One 4-inch rosary vine (*Ceropegia linearis woodii*)

Two 4-inch air plants with blooms
(*Tillandsia* 'Houston' is popular)

Four 6-inch xerographicas (*Tillandsia xerographica*)

1 clump of Spanish moss (*Tillandsia usneoides*)

MATERIALS

7-foot length of furniture webbing

Staple gun

Two 12-inch squares of foil

½ cup of potting mix

Wall or large painted wood piece

1. Spread out the webbing along the wall. Measure 18 inches from the left end of the webbing and staple the piece to the wall, allowing the 18-inch length to hang. Then measure 18 inches from the other end of the webbing, and place that point about 3 feet to the right of the first staple. Let the fabric drape, and staple it to the wall. Next, gather the webbing in the middle, and staple it to the wall, creating scalloped pockets and minishelves. Lift up an 18-inch tail, create a pocket, and staple it to the wall. Repeat with the other tail.

2. Unpot each plant and wrap the soil and roots in foil. This is a temporary display. While the foil will protect the wall and fabric from staining, it will not create a hospitable place for the plant roots to thrive long-term.

3. Fill the pockets with the plants, tucking one tightly against the other. Slip in a soilless air plant, too. Let the rosary vine dangle down one side and along the center's crest.

4. Gently open the xerographica rosettes to let it clamp onto the fabric. Use hot glue or a glue dot or wire if extra hold is needed.

5. Polish the wall arrangement, separating the clumps of Spanish moss and tucking small bits into nooks.

6. As the plants begin to fade (the polka dot plants will likely go first), pluck them out and repot and continue to enjoy the rest of the arrangement. The air plants will likely thrive the longest. Mist one to three times a week; remove and soak the air plants once a week.

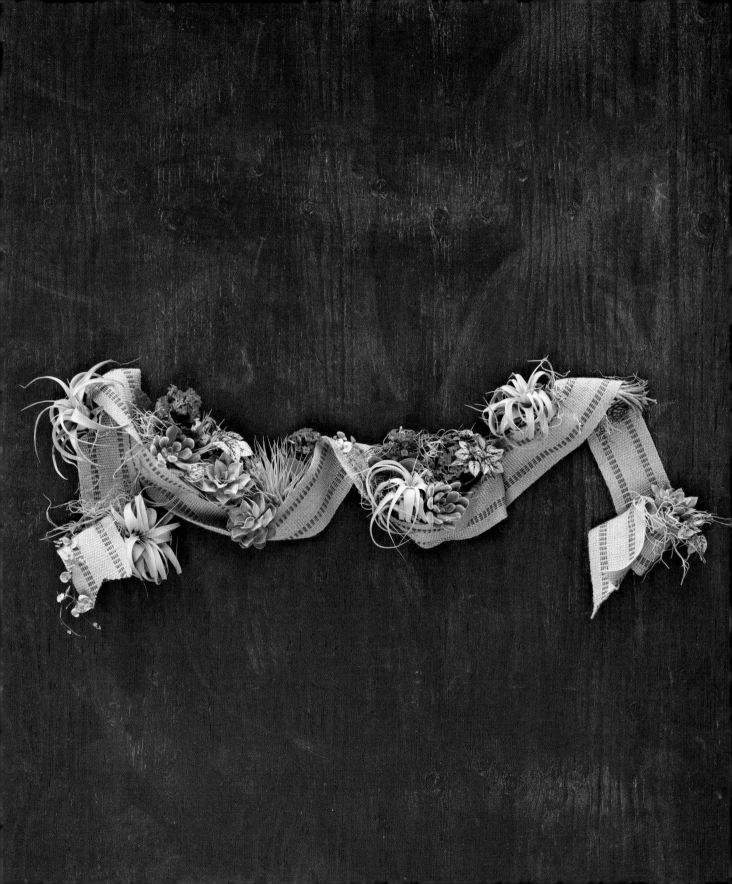

ZEBRA PLANT

(*Haworthia*)

PLANT TYPE: succulent

SOIL: cactus mix

WATER: allow the surface soil to dry between waterings

LIGHT: low to bright to bright indirect; the leaves will become more colorful with more light

Probably the most common variety of haworthia and the easiest to grow is the zebra plant. And for good reason: it has dramatic white lines on the outside of its leaves—although the cathedral window haworthia (*Haworthia cymbiformis*) is almost a clear green. This small plant is slow-growing and easy to keep alive. Like many succulents, it grows its own "pups," like babies, on the side.

PLANT

One 2- to 4-inch zebra plant
(*Haworthia fasciata*)

CONTAINER AND MATERIALS

Fluted ceramic vase, 3½ inches
in diameter and 3 inches tall

½ cup of cactus mix

¼ cup of decorative gravel

1. The white stripes are an intriguing attribute of this plant. A white fluted vase is a nice foil to the succulent's horizontal white stripes.

2. Unpot the zebra plant and place it in the vase. Be sure the level of cactus mix is just a smidgen below the rim of the vase. If it's too low, add more mix; if it's too high, loosen the roots and try again.

3. Use a paper funnel or a spoon to spread the decorative gravel over the top of the soil. Water sparingly about once a week, and pour out any extra water to avoid soggy roots.

RECIPE 2:

PLANTS

One 2-inch stone treecrop
(*Sedum dendroideum*) or stone treecrop
cutting

Three 2-inch houseleeks
(*Sempervivum* 'Icicle', *S.* 'Sunset', and
S. 'Commander Hay' are nice choices)

One 2-inch red carpet (*Crassula pubescens*
ssp. *radicans*), in bloom

1 baby burro's tail (*Sedum* 'Burrito') cutting

One 4-inch haworthia
(try *Haworthia turgida* or *H. cymbiformis*)

1 sedum cutting (try *Sedum dasyphyllum*)

One 4-inch zebra plant (*Haworthia fasciata*)

CONTAINER AND MATERIALS

Glass pedestal bias-cut vase,
7 inches in diameter

1 cup of decorative gravel

1 cup of cactus mix

Two 4-inch-long pieces of grape wood

As a design element and as a way to
monitor the water level (it's easy to see
how much water is in the gravel), pour
three-quarters of the decorative gravel
into the vase.

2 Pour in a layer of cactus mix until it
reaches 1 inch below the lower rim of
the vase. Place the wood elements at an
angle from each other so that they form
a V shape. Unpot all of the succulents
and set them aside.

3 Plant all the succulents as if they were
growing out from under the wood
elements, using them as a prop. Plant
in the zebra plant for a bold focal point.
Use a funnel to get the decorative gravel
into all the nooks and crevices. Gently
rock the arrangement to even out the
gravel. Water evenly with a dropper or a
tablespoon until just moist and allow to
dry between waterings.

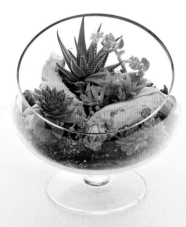

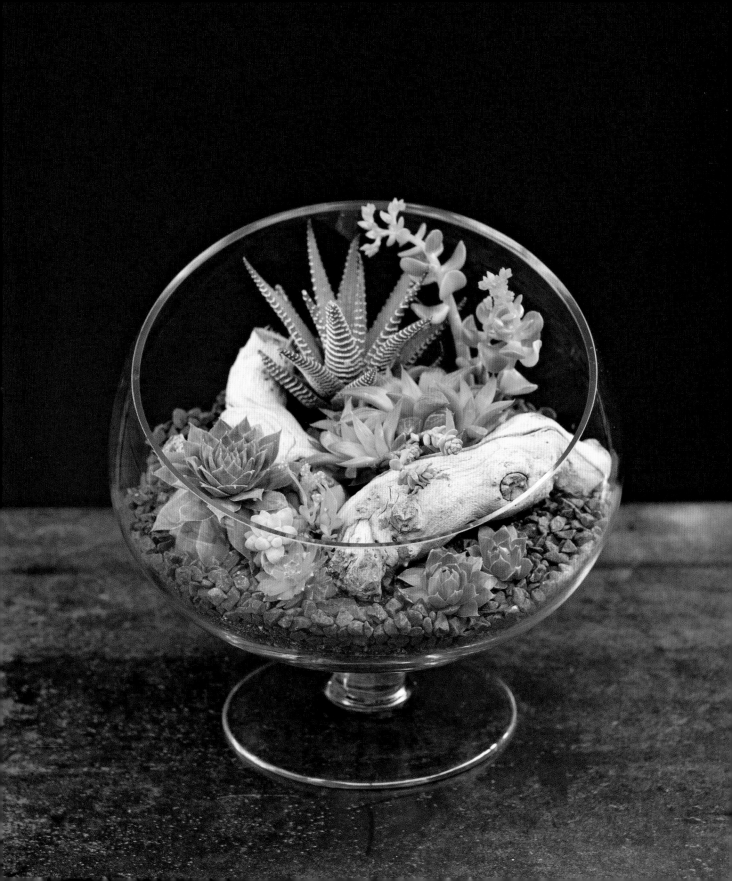

ACKNOWLEDGMENTS

Sophie de Lignerolles's talent shines in so many ways at Lila B.—her work as my right hand in many of these creations was, as always, invaluable. Writing a book and running a business was only possible with the help of Lila B.'s Max Schroder, Cliff Fogle, Shannon Lynn, Brandon Pruett, and Mimi Arnold, who kept our studio rolling and the creativity going while I plugged away at this book.

To Janet Hall, a huge thanks for suggesting my name to Kitty Cowles. Kitty took a project I had dreamed about and made it a reality. I can't thank her enough for her introduction, insight, and support. Thanks to Lia Ronnen for her trust, vision, and patience. With her guidance, this book flourished. And thanks to Michelle Ishay-Cohen and Kara Strubel for their design creativity, and to Keonaona Peterson and Sibylle Kazeroid for their keen eyes on the copy. Paige Green's talent behind the camera is astonishing. Her sense of light, angle, and composition made the arrangements in this book come to life. Thanks to Molly Watson for her magic with words. She has a beautiful knack for keeping my voice while making me sound so much better.

My mom, dad, and sister nurtured me with their kindness, including food, wine, walks, and open ears. Friends Rex Ray and Granville Greene's advice and experienced tales always encouraged me to keep on going. Many thanks to Tom Ortenzi, who has volunteered his time through PCV to help me run my business. To Lawrence Lee, Robin Stockwell at Succulent Gardens, and SF Foliage for their openness to my plethora of plant questions. Del McComb, Lawrence Lee, Emily Morris, Jose Torres, and Jeanne Berry— what a wonderful opportunity to garden alongside them in my early days.

Thanks to everyone at that beautiful and eco-friendly estate for influencing me and my gardening style in such positive ways. To Thomas Lackey at Stable Cafe, a million thanks for graciously hosting our photo shoots in his lovely cafe's courtyard and letting us turn his back garden into our photo studio each week. A piece of his garden and generosity is in every photo.

Finally, my deepest thanks to the kind friends, artists, and businesses who lent me containers for the projects in this book: Rex Ray (pages 53 and 227; Heath vases, pages 119 and 239), Kellie Seringer (Heath vases, pages 95 and 257), Kelly Lamb (page 211), Esther Pottery (page 117), Living Green (Ru Liao pottery, page 55), Lawrence LaBianca (page 255), Lila B. (pages 217 and 239), Pseudo Studios (pages 33, 75, 163, and 175), Old & Board (pages 129 and 201), Miles Epstein (133), Joe Chambers (137), and Williams-Sonoma, Agrarian (page 245).

ABOUT THE AUTHOR

BAYLOR CHAPMAN is the founder and principal designer of Lila B. Design, a green-certified business in San Francisco. She first learned to garden on a farm in Illinois and has since expanded her gardening chops working in environments from the arid mountains of New Mexico to the golden hills of California. She has been a professional gardener and floral designer since 2001. Her designs have been featured in *Sunset* magazine and on PBS, as well as in Banana Republic and Restoration Hardware stores. Baylor spends her days knee-deep in flowers, translating ideas into tangible designs and scouring nurseries for new plant varieties to play with.